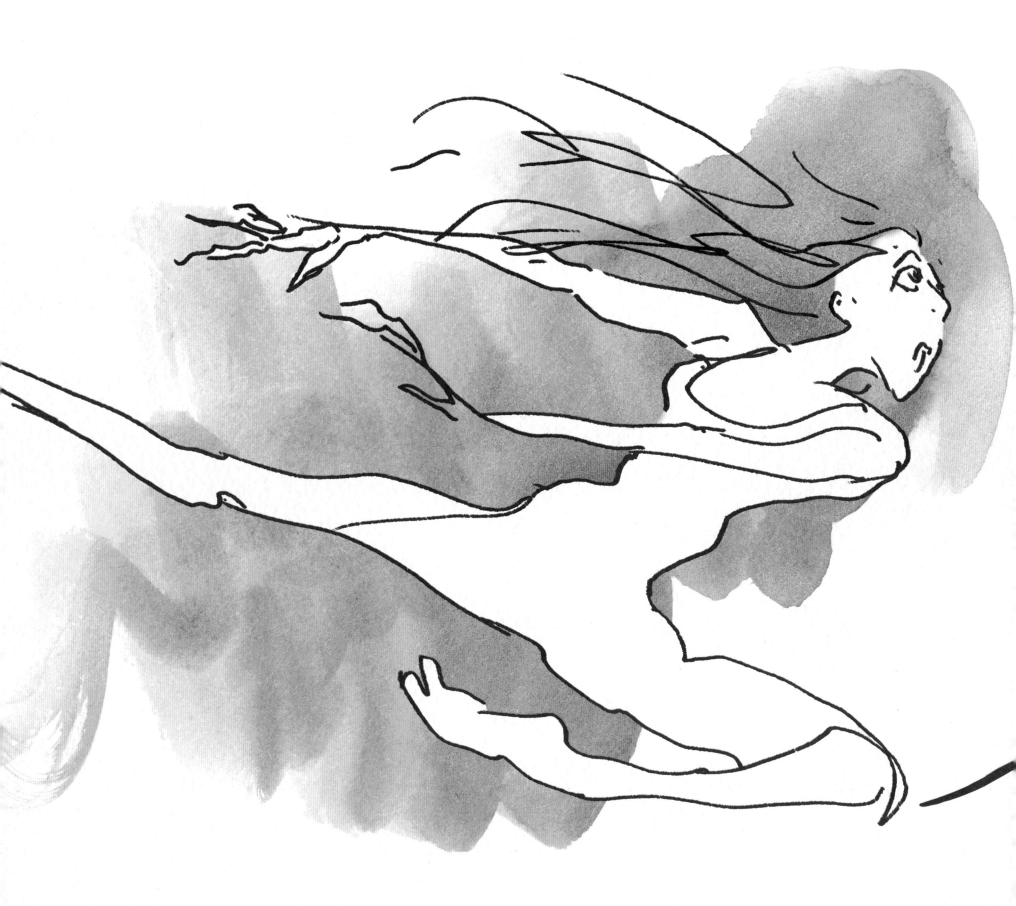

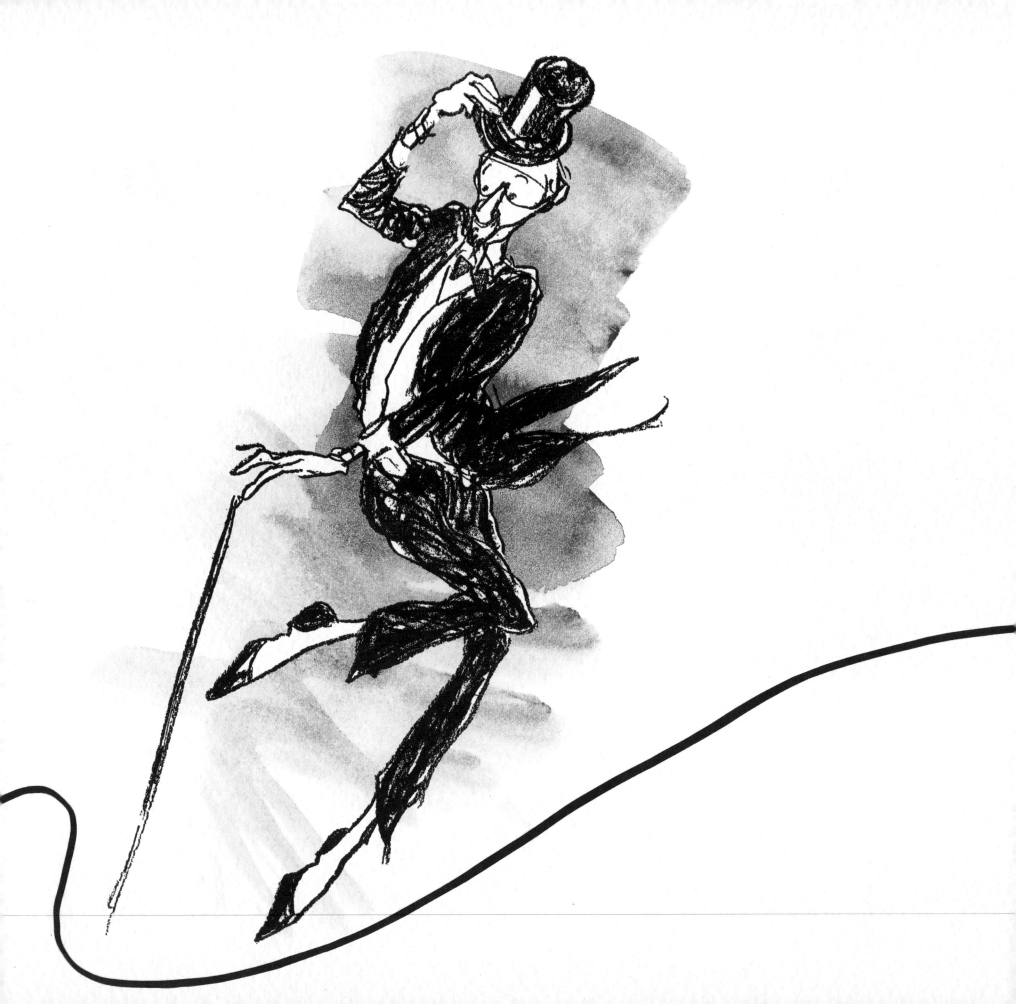

out of Line

THE ART OF JULES FEIFFER

by **Martha Fay**

Introduction by **LEONARD S. MARCUS**
Foreword by **MIKE NICHOLS**

ABRAMS, NEW YORK

CONTENTS

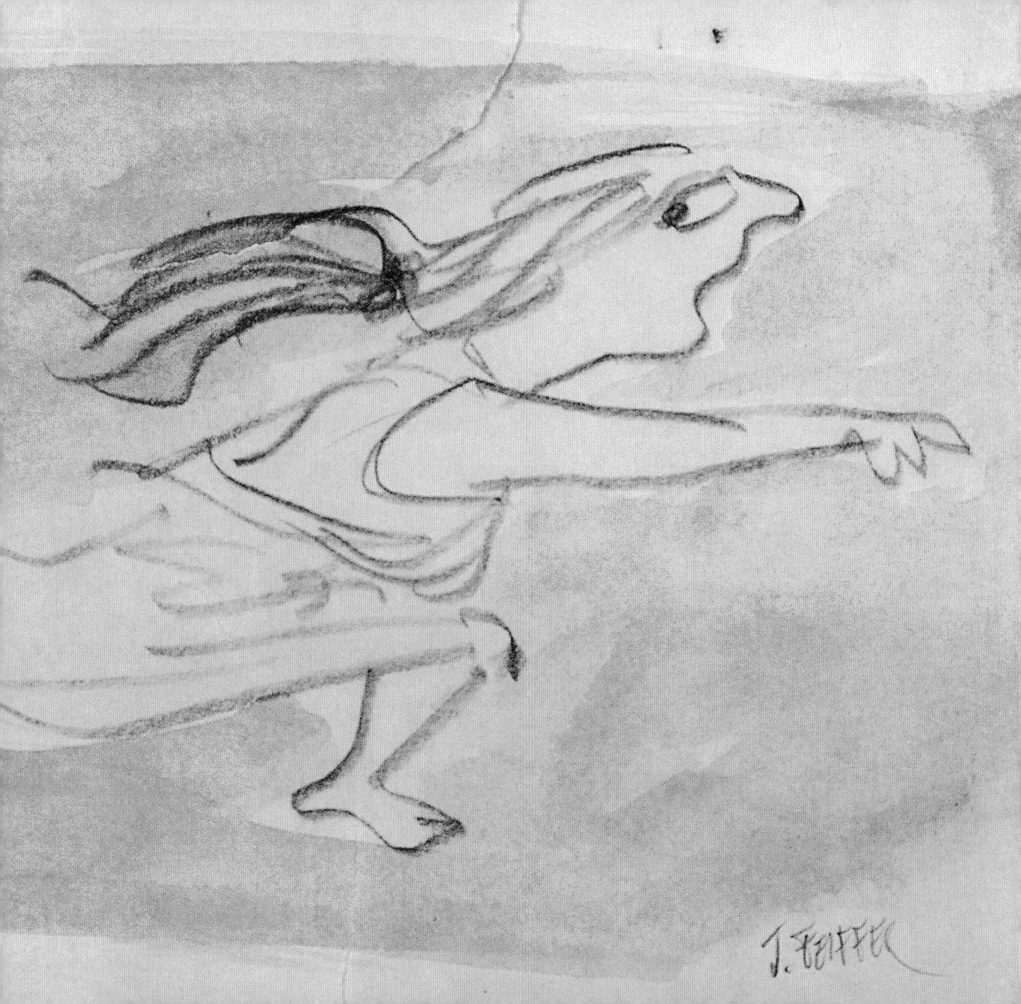

Boy with Pencil, Man with Pen

by **Leonard S. Marcus**

Jules Feiffer is an American original, an artist and writer of breathtaking ambition, fearless honesty, impertinent wit, and unyielding faith in the value of the quintessentially American act of having one's say. For more than forty years, as the creator of the weekly *Village Voice* cartoon strip *Feiffer*, he blithely took the measure of the people in power at every level of our national life: from megalomaniacal presidents to browbeating parents, from buttoned-down corporate types to phony-baloney hucksters and hipsters of every stripe and persuasion. Week after week, as the ultimate anti–Organization Man, Feiffer demolished for readers the psychic distance between his audience and the double-speaking people-in-high-places of the moment, as much as to say, *We're all in this together and so have every right and reason to know the score.* A *Feiffer* strip was a bracing wake-up call. A prompt to keener self- and civic awareness. It was also usually good for a laugh.

Throughout the tumult of the Cold War, Vietnam era, sexual revolution, civil rights struggles, women's movement, and trickle-down Reaganomics, Feiffer kept his satirical cool, reading between the lines of mind-bendingly complex issues with anthropological detachment and a comedian's instincts for incongruity and timing. The short-form cartoon strip format he adopted, averaging six to eight panels per installment, proved to be an ideal perch from which to parse the absurdity— or hypocrisy—of just about anything. A *Feiffer* strip was part Nichols and May stand-up routine, and part breakthrough session on the analyst's couch. It was *Seinfeld* and *The Daily Show* rolled

Detail from *The Man in the Ceiling,* 1993.

catapult Feiffer into the realms of theater and film as well.

First and foremost, *Feiffer* demands to be seen—as it is in the pages that follow—as a worthy contribution to the great Western tradition of satirical illustration, the history-making pictorial commentaries of artist-observer-provocateurs such as William Hogarth, Thomas Rowlandson, James Gillray, Honoré Daumier, George Grosz, and, among Feiffer's contemporaries, David Levine, Edward Sorel, Ralph Steadman, and Ronald Searle. To scan the shelves of art books lined up on Feiffer's studio walls is to quickly recognize that "the gang's all here": that on his way to fashioning one of contemporary satirical drawing's most distinctive graphic styles, Feiffer, ever the autodidact and cultural magpie, did his homework; that, from an art historical point of view, he has always known *exactly* what he was doing.

Feiffer first fell in love with art as an ardent Depression-era fan of the funny papers. To his little-boy pantheon of Sunday supplement super heroes, he soon added the hard-boiled newsprint artists/storymen who created the characters, vowing one day to join their ranks. The lasting impression that masters of the genre, such as Milton Caniff and Feiffer's own eventual mentor Will Eisner, made on him can be felt in the coiled-spring tension and swagger of just about any Feiffer drawing, whether the

into one, with each of those latter-day television cult sensations doubtless owing at least a splash of its initial inspiration to Feiffer's own long-running one-man show: the cartoon for grown-ups as deadpan reality check, rendered in the fast-paced, freewheeling gestural line and sardonic patter of an artist and monologist in perpetual overdrive. It is hardly surprising that a strip built on pithy telegraphed dialogue and dramatic confrontation would, before long,

subject happens to be an anonymous loser or Richard Nixon or Fred Astaire. For all sorts of reasons, Astaire came to occupy a special place in the Feiffer pantheon, not only because he (unlike the notoriously klutzy artist) danced so exquisitely, but also because Astaire (much *like* Feiffer) is known to have worked so insanely hard to achieve the appearance of effortless grace. Over time, dance emerged as a recurring theme both in and out of the weekly strip, and as Feiffer's craft became second nature to him, drawing became *his* way to dance.

There's an intriguing logic to Feiffer's late-in-the-game decision, sometime in the early 1990s, to make writing and illustrating children's books the primary focus of his creative energies. For decades, the drawings he had done on a lark for Norton Juster's uproarious fantasy for children, *The Phantom Tollbooth* (1961), had stood apart from his work as a one-off excursion into a specialized realm he had long ago ceded to his friend Maurice Sendak. Yet during all those years, childhood kept coming up as a theme and even obsession in Feiffer's cartooning, most often for the purpose of exposing the adult world's fears of people more open-minded than themselves, and the cruel and duplicitous behavior toward the powerless young that frequently followed as a consequence. By the mid-1990s, as the *Village Voice* strip was coming to an end and

playwriting was proving to be a far from reliable alternative means of support, memories of his own childhood passion for comics began to beckon, as did the appeal of a greatly expanded juvenile publishing world.

Even so, it was not mere nostalgia—or opportunity—that pointed Feiffer in the direction of creating illustrated stories for kids. It was also an insight into the original impetus behind his work as a satirist, which went something like this: *If you* really *want to change the world, why not start with the people who are most open to change?* Other factors played their part: a friendly rivalry with Edward Sorel, and Feiffer's backlog of home experience as bedtime Scheherazade for his own children. Feiffer had already lived to see the beginnings of an astounding upward cultural reappraisal of comics art—a seismic shift in valuation from throwaway to museum-worthy, which he himself had helped initiate as the author of *The Great Comic Book Heroes* (1965). Now the same thing was happening to children's books and their illustration. Once again, Feiffer had, as he put it in his memoir, *Backing into Forward* (2010), "luck[ed] into the zeitgeist."

Portions of Feiffer's studio resemble the site of an archaeological dig, with shifting stacks of artwork (stored in yellow tattered envelopes) that date from as far back as the early Bronx Age, when as a precocious eleven- or

OPPOSITE The *Village Voice*, October 25, 1976, celebrating Feiffer's twentieth anniversary at the paper.

twelve-year-old he wrote and drew his own comic books and—how priceless is this?—sold them on the street for seven cents instead of the standard ten. It is a lucky thing for us that Feiffer has always been such a devoted pack rat, as there would seem to be hardly a moment in the fitful, zigzag arc of his creative life that cannot be amply documented. Here, then, is that life in full: Jules Feiffer caught in the act of becoming Jules Feiffer!

Leonard S. Marcus

Brooklyn, New York

February 2012

LEONARD S. MARCUS is a historian, biographer, and critic whose award-winning books include *Margaret Wise Brown: Awakened by the Moon*; *Dear Genius: The Letters of Ursula Nordstrom*; *The Annotated Phantom Tollbooth*; and *Maurice Sendak: A Celebration of the Artist and His Work*. He is a regular contributor to the *New York Times Book Review*, writes a column on illustrated books for the *Horn Book* magazine, and is a three-time judge of the *New York Times* Best Illustrated Books of the Year prize. Marcus lectures about his work to audiences throughout the U.S. and around the world and has been featured on numerous programs on television and radio. He is a founding trustee of the Eric Carle Museum of Picture Book Art and teaches a popular course on children's literature and child development at New York University.

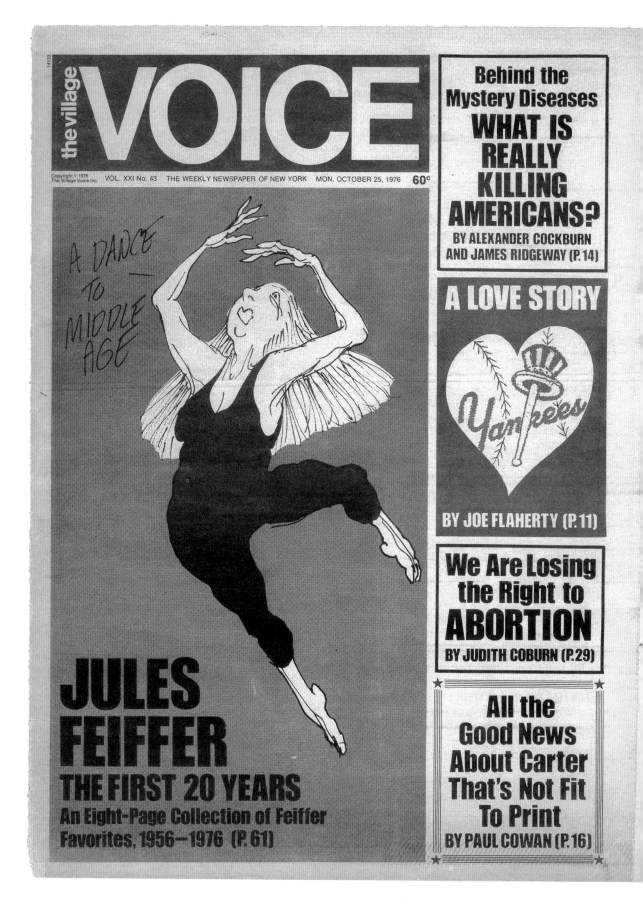

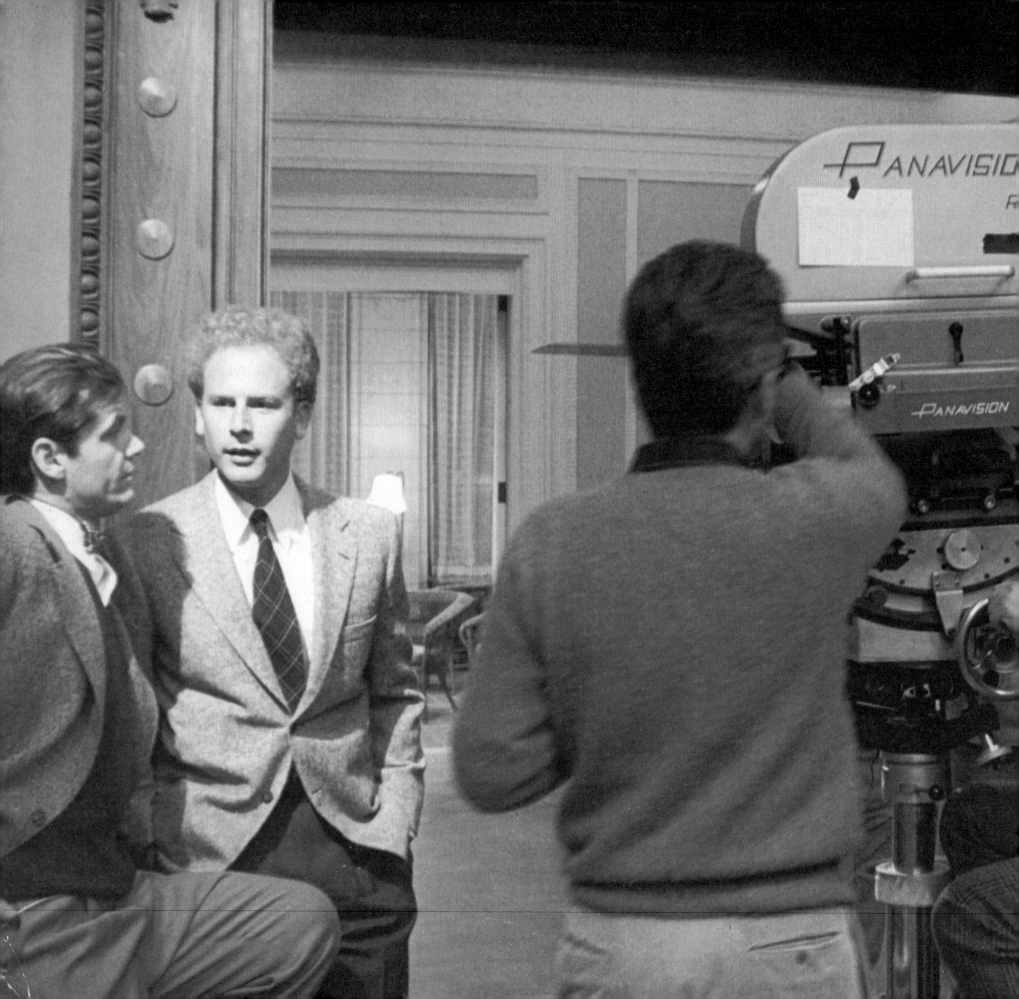

Introducing Jules Feiffer

by **Mike Nichols**

When Elaine May and I came to New York in 1958 (for me, *back* to New York after attending the University of Chicago and then doing stand-up comedy there), we started performing at the Village Vanguard, and after a while moved up to the Blue Angel (both were nightclubs). Jules Feiffer, an early audience member, came backstage and immediately became a friend.

Elaine and I felt a kinship with Jules, and our work seemed almost supernaturally similar or, more accurately, from the same family. Our approach to humor—sex, mothers and fathers, politics, relationships, pretension, fashions (in beliefs and opinions), food, drink, clothes, and drugs—came from a shared sensibility.

Jules and I collaborated on several projects. In fact, he wrote one of the first shows I directed—the summer stock production *The World of Jules Feiffer* (accompanied by incidental music from Stephen Sondheim) in 1962. Jules then wrote "Passionella," which was adapted as the last act of *The Apple Tree*, a three-part musical I directed on Broadway in 1966. I also directed his off-Broadway play *Elliot Loves* in 1990. As a playwright, Jules is a natural because he is a cartoonist who is first and foremost a writer; he takes the dialogue of his cartoons and puts it onstage. It's a technique he has been able to apply to his subsequent novels as well as to his screenplays, making his characters astute observers and apt cultural critics.

Jules made us laugh, and he still does. His drawings of a young hippie girl in a leotard dancing to welcome spring with grace, lust, and pretension (but also with such sweetness, you had to love

her) were a trademark of his work. As were Bernard and Huey on the pages of the *Village Voice*, bullshitting about women, race, class, politics, religion, and who they wanted to be. They weighed difficult decisions and traded insights, as when Huey said to Bernard, "If I had any respect for girls I'd *never* make out."

Bernard and Huey morphed into Jonathan and Sandy for *Carnal Knowledge* (played by Jack Nicholson and Art Garfunkel), written by Jules and directed by me. That 1971 movie and its making are so much a part of me and the people involved—all of us have become lifelong friends—that it's hard for me to write or to talk about the experience and do it any justice. At its simplest, it was like some terrific summer camp where you made friends for life, fell in love, and most of all, became a group. A group whose members (more than forty years later) still check in with one another once a year (at the very least), sometimes once a month, and for a few of us, almost every day.

I guess that's the thing about knowing and loving Jules: He creates a world. A world in which his kids and your kids are friends. A world populated by ex-wives, and occasionally by ex-friends. And you always see each other—either by design or by accident—at the Brooklyn Academy of Music among the other men with burlap ties and women in suede dresses with hand-hammered silver jewelry. Or after

a performance of an Ibsen play directed by Ingmar Bergman.

Jules is, was, and always will be a liberal, therefore he's at his funniest when he's discussing liberals, but also when dissecting Nixon. He was impartial about Kennedy and LBJ, but not about Reagan. In fact, Jules applies the same pen and brush not only to all presidents but to everyone—politicians and civilians, men and women—and isn't that the point?

Don't you think we need him to keep us laughing—but never more than at ourselves? I do.

Mike Nichols
New York City, New York
November 2012

MIKE NICHOLS was a writer, director, producer, and comedian, and one of only twelve people who have won all four major American entertainment awards (EGOT): four Emmys (two apiece for *Wit*, *Angels in America*), a Grammy (*An Evening with Mike Nichols and Elaine May*), an Oscar (*The Graduate*), and nine Tonys (*Barefoot in the Park*, *Luv*, *The Odd Couple*, *Plaza Suite*, *The Prisoner of Second Avenue*, *Annie*, *The Real Thing*, *Monty Python's Spamalot*, and *Death of a Salesman*). Other noteworthy films include *Who's Afraid of Virginia Woolf?*, *Carnal Knowledge*, and *Working Girl*. Among his many honors were the Lincoln Center Gala Tribute (1999), the National Medal of Arts (2001), the Kennedy Center Honors (2003), and the AFI Life Achievement Award (2010).

PREVIOUS PAGE On the set of *Carnal Knowledge*, 1971. Left, Jack Nicholson and Art Garfunkel; right, director Mike Nichols.

OPPOSITE Printer proof for cover of unreleased Nichols and May comedy album, c. 1959.

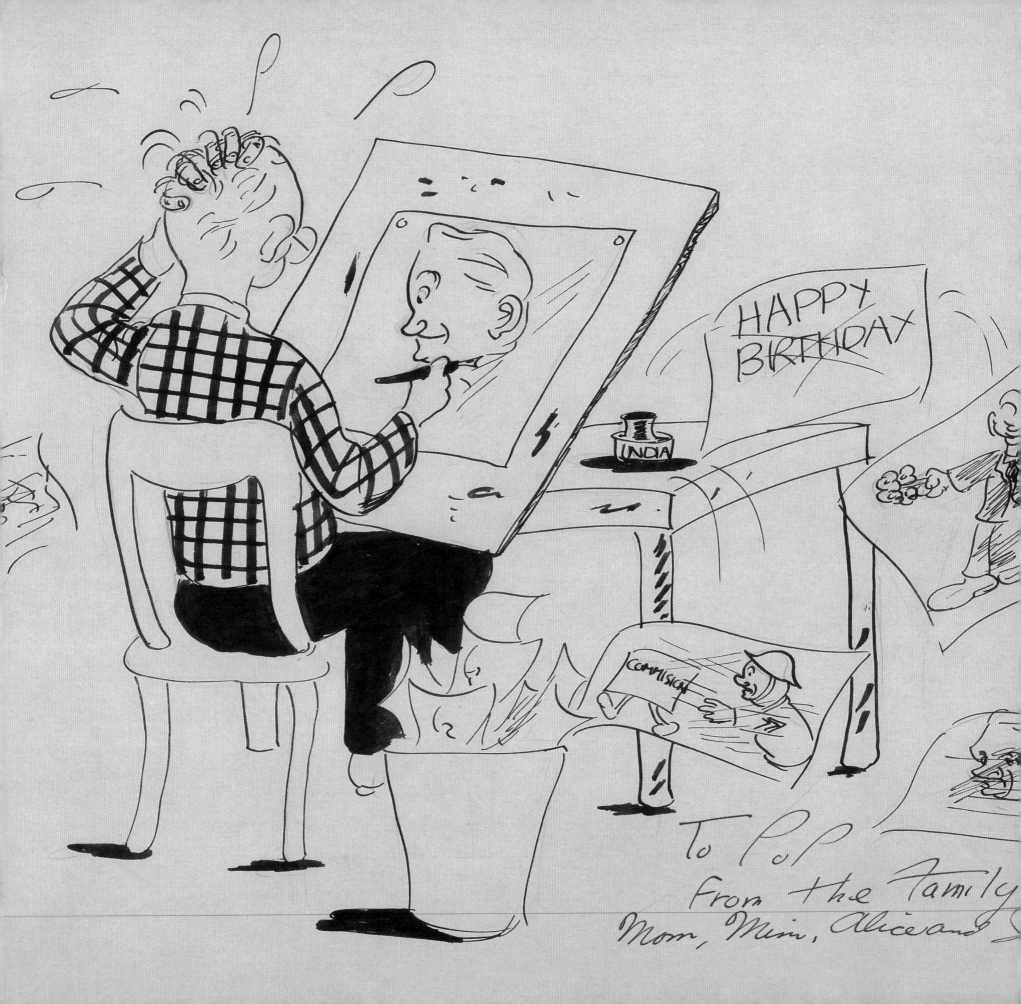

Beginnings . . .

My habitual response to my ignorance in this matter and others is to make up an explanation—that is, if I don't know the truth, I script it, then revise it, until I have a story line, a motive for things I don't know or don't understand, and then in the course of very little time I come to accept my story line as fact.

JULES FEIFFER, *Backing into Forward*

Jules Feiffer was born in the Bronx on the eve of the Great Depression, twin misfortunes of location and timing, in Feiffer's judgment, except for the fact that the late 1920s and early 1930s were also the Golden Age of Comics.

Little Orphan Annie and *Wash Tubbs* were not quite five when Feiffer emerged on January 26, 1929—the same month as *Tarzan of the Apes*, *Buck Rogers in the 25th Century*, and *Popeye the Sailor*. *Mickey Mouse* debuted as a syndicated strip in 1930, *Dick Tracy* in 1931, *Terry and the Pirates* and *Li'l Abner* in 1934, *Superman* in 1938, and Will Eisner's *The Spirit* in 1940. Collectively, the funny papers and their siblings, comic books, would serve as Feiffer's creative muse, his private tutor, his one reliable ally from childhood through adolescence. Comics provided him emotional and intellectual succor in the short term. In the long run, Feiffer was counting on them to provide him a way out.

In dozens of interviews over the years and in his memoir, *Backing into Forward*, Feiffer describes himself, in essence, as a "changeling"—a child assigned by mischievous fate to the wrong parents, the wrong borough, the wrong life—a captive innocent whose intended destiny would have to be heroically earned. Growing up in an atmosphere of "economic gloom," weighed down by "a pervasive feeling of powerlessness," equally beset by anxiety and resentment, the change-ling sensed the possibility of rescue in the arts. "All the pleasure in my life came from movies, radio, cartoon strips, and the comics." So did much of his education. What books borrowed from enlightened neighbors did for young Abe Lincoln in the Kentucky wilderness, Depression-era

Feiffer stars in a birthday card drawn for his father, David Feiffer, c. 1943.

JULES

Mickey Mouse
doing a
War Dance
by
JULES

movies, radio, and the comics did for young Jules Feiffer. The formative influences of his childhood were filtered through double features at the Ward Theater on Westchester Avenue, across from the El, three blocks from home: gangster films starring James Cagney and Humphrey Bogart; musicals, where he fell in love with Fred Astaire and Ginger Rogers, Mickey Rooney, and Judy Garland, Donald O'Connor, and Busby Berkeley; and screwball comedies such as *My Man Godfrey*. At home, Feiffer listened to radio around the clock: *The Adventures of Superman*, *I Love a Mystery*, *Fibber McGee and Molly*, Fred Allen, Jack Benny, *Don Winslow of the Navy*, and Edgar Bergen and Charlie McCarthy.

Feiffer taught himself to read crouched over the Sunday papers, spread out on the floor of his bedroom. "It was like looking at dancing wallpaper," he says. "A page full of Cagneys, fighting, strutting, stamping, gesticulating. The colors were vibrant; the settings exotic, menacing, or absurd; the language at once formulaic and transporting.

"I was trying to draw myself out of the world I was living in, into the one I *wanted* to live in. It was not a career choice. It was a survival choice."

The universe Feiffer inhabited in real life was a crowded four-room apartment in

the East Bronx neighborhood of Soundview, a stubby peninsula defined by the Bronx River on the west and Long Island Sound to the south and east. Eight decades later, Soundview is still more readily defined by the highways that whisk people through and beyond it— the Bronx River Parkway and the Bruckner Expressway—than by scenic Soundview Park to the south, which had not yet been created from marshland when Feiffer was growing up. Not that a park to play ball in would have made a difference. Feiffer would no more have found a home on Soundview Park's generous playing fields than he did in the streets around Stratford Avenue. Other boys his age played baseball and stickball, ricocheting hits off stoops, brick walls, and fire hydrants. Feiffer hid out in his room with sheets of drawing paper, copying Popeye's triple-wallop punch and Dick Tracy's Mount Rushmore profile over and over, trying to perfect the style of his artist heroes.

"What I loved most," he wrote in a special issue on comics he edited for *Civilization* magazine in 1998, "what meant more to me than home and family and life itself—were the adventure strips. Soldiers of fortune, danger in exotic lands, death on the high seas . . . these were the dreams that boys were made of. I was transported out of my Bronx bedroom to desert islands, where a young man with his wits about him might well find buried treasure."

OPPOSITE A precocious early self-portrait and two early Mickeys, c. 1934–35.

TOP Jules at age three, c. 1932.

ABOVE Age six, c. 1935.

BOYS SHOP tom an' Huck

327

The Sky Climbers
OF AMERICA
OFFICIAL HEADQUARTERS

feb. 12-1930-

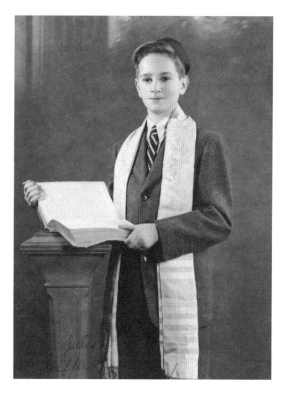

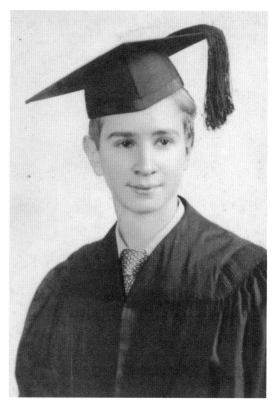

OPPOSITE Group shot of David Feiffer and employees at his short-lived Tom-an'-Huck Boys' Shop at 927 Bergenline Avenue in Union City, New Jersey, taken February 12, 1930. Feiffer, last row center, and hatless, came from a family of successful shopkeepers but did not have the knack himself. He "was the only member of his family who couldn't keep a business going," Jules recalls. "Every business my father opened, closed about fifteen minutes later."

THIS PAGE, CLOCKWISE FROM TOP LEFT Jules's sister Alice, May 1953; Jules at eight, 1937, in a staged shot with "the Lone Ranger" at Gimbels department store; age thirteen, at his bar mitzvah in 1942; in cap and gown for his high school graduation, 1947; Jules's sisters, Alice (left) and Mimi (right), c. 1952. Alice was living with Mimi and her husband, Bill, while attending classes at New York University. Mimi was a skilled seamstress, and the sisters often went shopping together for fabric.

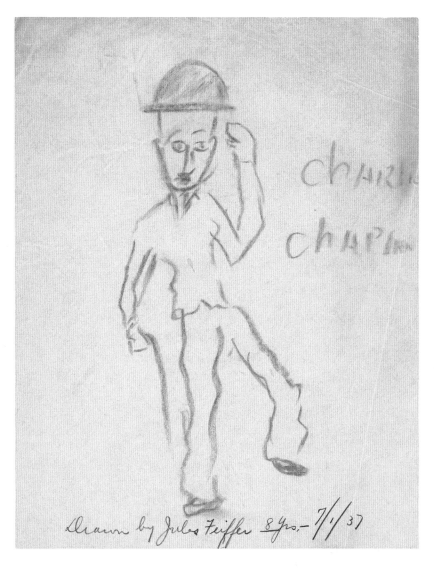

ABOVE Feiffer escaped the Bronx and Stratford Avenue by way of newspapers and the movies: a sketch of Charlie Chaplin done at age eight (left), and a horse and rider from the same period, c. 1937 (right).

OPPOSITE, CLOCKWISE FROM TOP LEFT Action sketches of heroes who could fend for themselves physically: prizefighters Max Baer and Jack Dempsey; cowboy Tom Mix; an unidentified quarterback, charging; and lion tamer and animal trainer Clyde Beatty. "A lot of this stuff came from being taken to the movies by my family," says Feiffer. "I liked action. I liked to draw . . . I just couldn't participate."

Max
Bell

Jack
Dency

Tom Mix

Clyde
Beatty

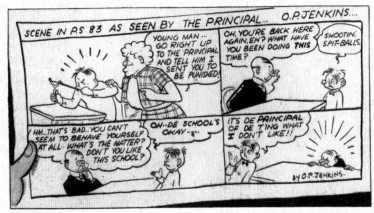

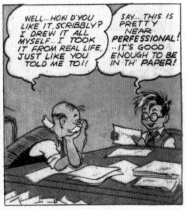

THIS PAGE Among Feiffer's favorite early strips were Sheldon Mayer's *Scribbly*, 1939 (top); Percy Crosby's *Skippy*, December 29, 1935 (above); and E. C. Segar's *Popeye*, May 15, 1936 (left).

OPPOSITE From the time Feiffer could hold a pencil, he never stopped trying to improve his line. Over the years, his devotion to Popeye was unmatched—he socked Popeye and had Popeye socking Bluto every which way a lug can be slugged, as these childhood drawings attest. His dedication to the Sailor Man came full circle when he was asked to write the script for Robert Altman's movie version in 1980. And in April 2012, a Feiffer Popeye ran as a variant collector's edition cover for the first issue of a new comic book series published by IDW.

Getting his hands on the best of these strips spurred Feiffer's ingenuity. "The tragic irony of my boyhood," Feiffer wrote in *Civilization*, "was that these particular comics—without which I couldn't have survived a life on the ropes in the fifth grade—appeared in newspapers that were not allowed in my house—or in any good, liberal, Jewish household. The truly great strips were carried in the worst papers—the Hearst press or the New York *Daily News*—which were Republican, antiliberal, and not overly fond of Jews, either." With the resourcefulness of an addict, Feiffer scavenged for his fix late at night, prowling through stacks of discarded newspapers in the dark alleyways of the Bronx and outside the doors of neighborhood supers—none of whom were Jewish.

At seven, Feiffer was smitten with a feature in an early comic book by Sheldon Mayer called *Scribbly*—"an underrated, often brilliantly wild cartoon about a boy cartoonist, with whom, needless to say, I identified like mad." (As did David Levine, a contemporary of Feiffer's who would later become a noted artist for the *New York Review of Books* and a lifelong friend, who was reading it with equal attention in Brooklyn.) At eleven, Feiffer fell under the spell of Milton Caniff's *Terry and the Pirates*, launched in 1934 at the suggestion of Joseph Patterson, the founder of the *Daily News*. In contrast to Roy Crane's manic style,

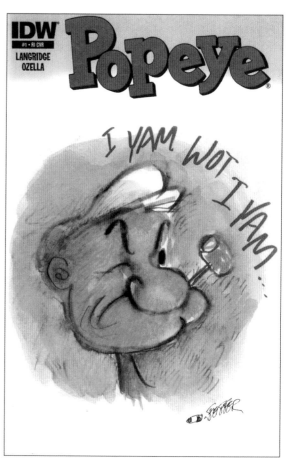

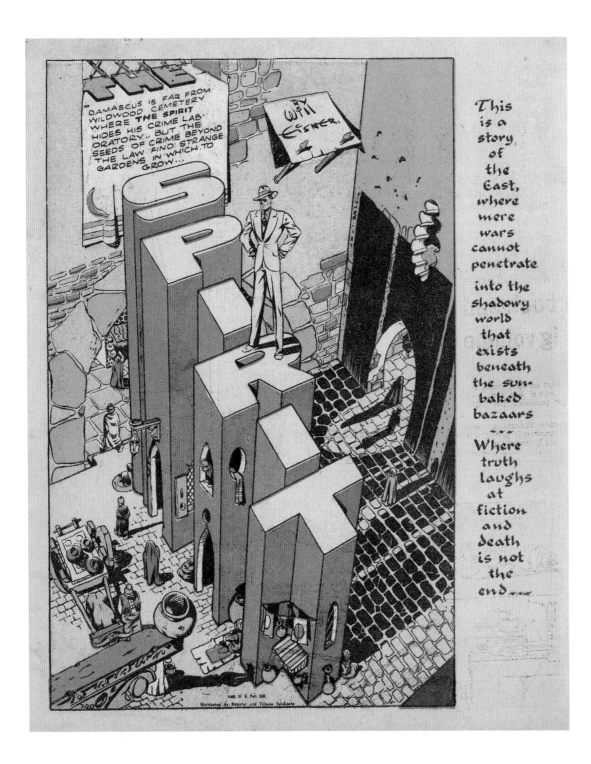

Another big influence was Will Eisner, creator of the black-and-white strips *Muss 'Em Up*, about a rule-breaking detective, and *Hawks of the Seas*, which he signed "Willis Rensie" ("Eisner" spelled backward). Eisner's breakthrough strip, *The Spirit*, began appearing as an eight-page lead feature in a comic book insert in the Sunday comics on June 2, 1940, when Feiffer was eleven. Eisner was "an early master of the German expressionist approach in comic books—the Fritz Lang school. *Muss 'Em Up* was full of dark shadows, creepy angle shots, graphic close-ups of violence and terror. Eisner's world seemed much more real than the world of other comic book men because it looked that much more like a movie."

In Eisner, another Bronx boy (although he was born in Brooklyn), Feiffer recognized his first plausible role model. The movies might have set him to fantasizing about hobnobbing with Hollywood royalty, sipping "martinis at the 21 Club with William Powell, Myrna Loy, Moss Hart, and Gertrude Lawrence, but who was I kidding? I came from Eisner's streets, which were clotted with puddles and swill, where garbage floated in the river. I couldn't make it in the Copa or El Morocco, or with one-liners. I belonged on a street corner with John Garfield, our eyes squinting into the glare of the class system. Eisner spoke my language. This wasn't surprising, since he was also from the Bronx."

which the young connoisseur also admired, Caniff's style was "suave. His densely detailed camera eye gave us movielike storyboards of gentlemen adventurers and gun-toting, pirate dominatrices."

Feiffer's earliest drawings were in "a very primitive style—imitated comic book stuff: running, jumping, car crashes, fistfights, guns. I was playing out in fantasy form all the non-playing I did on the streets because I didn't have the skills. All the dexterity that was not displayed on the street was on the paper."

Periodically forced out of the house by his mother, Feiffer resorted to sketching his heroes in chalk on the sidewalk to distract bullies, and it worked. He created a persona that made his shortcomings irrelevant. He discovered an audience. And soon they were paying.

"I have a vivid memory of him sitting at a table drawing with his tongue out and humming, which he does even now," recalls Alice Korman, his younger sister, emphasizing the uncanny lifelong intensity of Feiffer's concentration. "Then he would send me out into the street to sell his comic books for seven cents. I was probably six or seven. They were four or six pages, folded together."

By age eleven, Feiffer was turning out sixty-four-page issues of *Comic Caravan* each week, using a variety of pseudonyms to convey the impression that a fleet of artists was at work. Shifting from style to style in imitation of the cartoonists he most admired, Feiffer created his own universe of super heroes. Among the seemingly endless cast of characters that

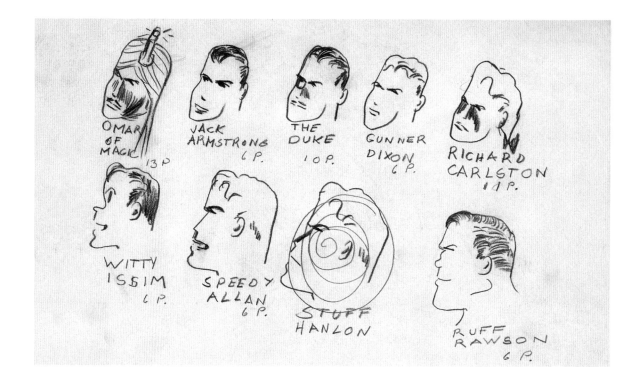

appear in these childhood comic books are Foreign Correspondent, in the style of *Terry and the Pirates* creator Milton Caniff; American Man, which took its cue from *Green Lantern* and artist Martin Nodell; Fishman, in a nod to Bill Everett's *Sub-Mariner*; and Ultraman, Feiffer's take on *Superman* and the teamwork of creators Jerry Siegel and Joe Shuster. Another of Feiffer's inventions was Hoiman—Brooklynese for "Herman"—a character with a broken nose who was strongly influenced by Slats of *Abbie an' Slats* (a strip Feiffer had been devoted to ever since its first appearance in 1937). "In my head I graduated, in my early teens, from comic books to comic strips," Feiffer explains. "And I made up different artists' names for each character I created, just like I made up different identities for myself."

OPPOSITE Splash page from *The Spirit* no. 60, July 20, 1941. Will Eisner, creator of Feiffer boyhood favorites *Muss 'Em Up, Hawks of the Seas,* and the incomparable *The Spirit*—which launched in 1940 and initiated a generation of American boys into the noir tradition—was Feiffer's idol, mentor, and boss.

ABOVE A pantheon of early Feiffer creations modeled on his favorite comic book heroes, recycled into the Bronx weekly known as *Comic Caravan*.

LEFT Sketch sheet à la Leonardo da Vinci, starring President Franklin D. Roosevelt, Adolf Hitler, Emperor Hirohito, and an American soldier from the early 1940s.

OPPOSITE Milton Caniff's *Terry and the Pirates*, September 7, 1937 (panel, left), served as Feiffer's model for the artful decking of a Nazi by the Foreign Correspondent hero of *Comic Caravan* no. 15. Feiffer was a master of the swipe from an early age. His mother saved almost all of his work from this period, "but when I told her I was taking them out to the street to sell, she just blew a gasket." Putting a higher value on her son's work than he did, she thought his street price of seven cents was too low.

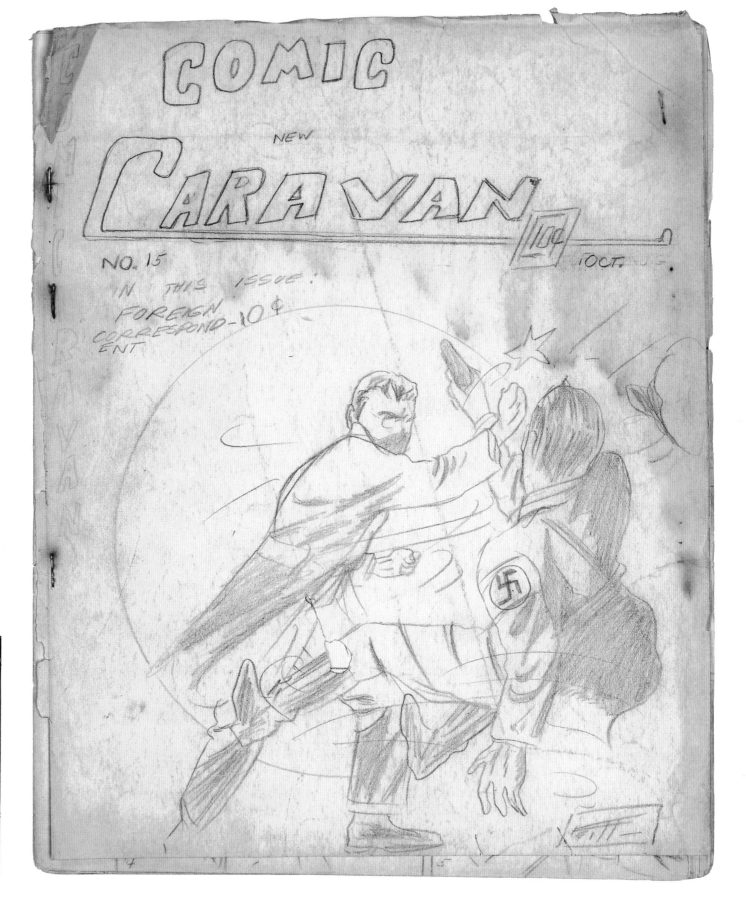

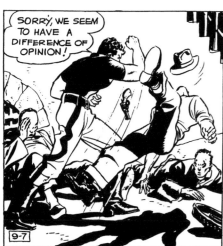

The Golden Age of creative swipes:

Timely, later known as Marvel Comics, launched Bill Everett's Sub-Mariner—both hero and antihero—in 1939; Feiffer floated the virtuous Fishman to battle evil forces a few years later. Panel from Sub-Mariner origin story (right), "Here Is Sub-Mariner!," *Marvel Comics* no. 1, October 1939.

The Hawkman was an early DC Comics character, created by writer Gardner Fox and artist Dennis Neville, later illustrated by Sheldon Moldoff. It debuted in January 1940. Feiffer recast him as Vulture, the Flying Knight. "This is terrific," Feiffer says. "It shows me at my stealing best." Detail from Hawkman origin story splash page (far right), *Flash Comics* no. 1, January 1940.

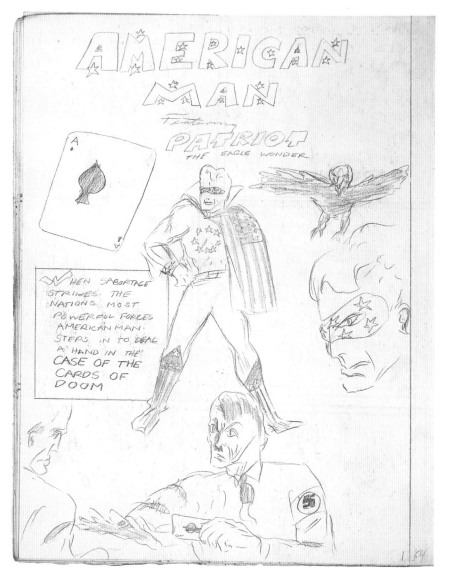

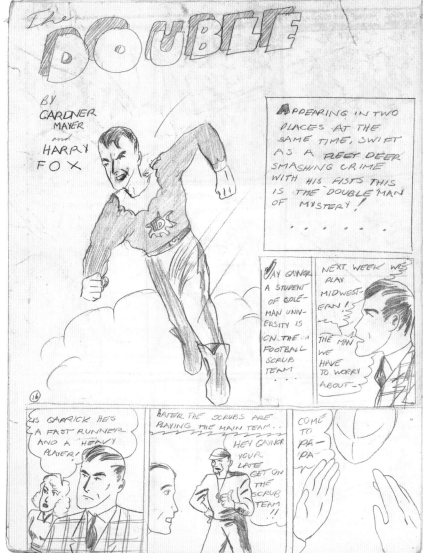

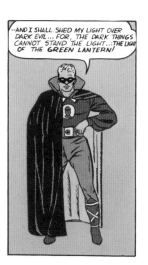

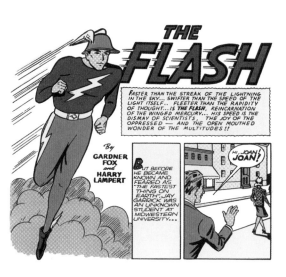

Green Lantern hit the stands in 1940. It was a collaboration between artist Martin Nodell and writer Bill Finger, published by All-American Publications—one of several companies that would later coalesce into DC Comics. The patriotic American Man was Jules's homage/knockoff. Panel from Green Lantern origin story splash page (far left), *All-American Comics* no. 16, July 1940.

The Flash, another Gardner Fox creation, illustrated by Harry Lampert, launched in 1940 by DC Comics and was the inspiration for Feiffer's the Double. Feiffer borrowed and mashed up their names in the credits for his own opus: Gardner Mayer and Harry Fox. "Even the names I swiped," he says of these early efforts. "I was original in some things—and not in others." Detail from the Flash origin story splash page (left), *Flash Comics* no. 1, January 1940.

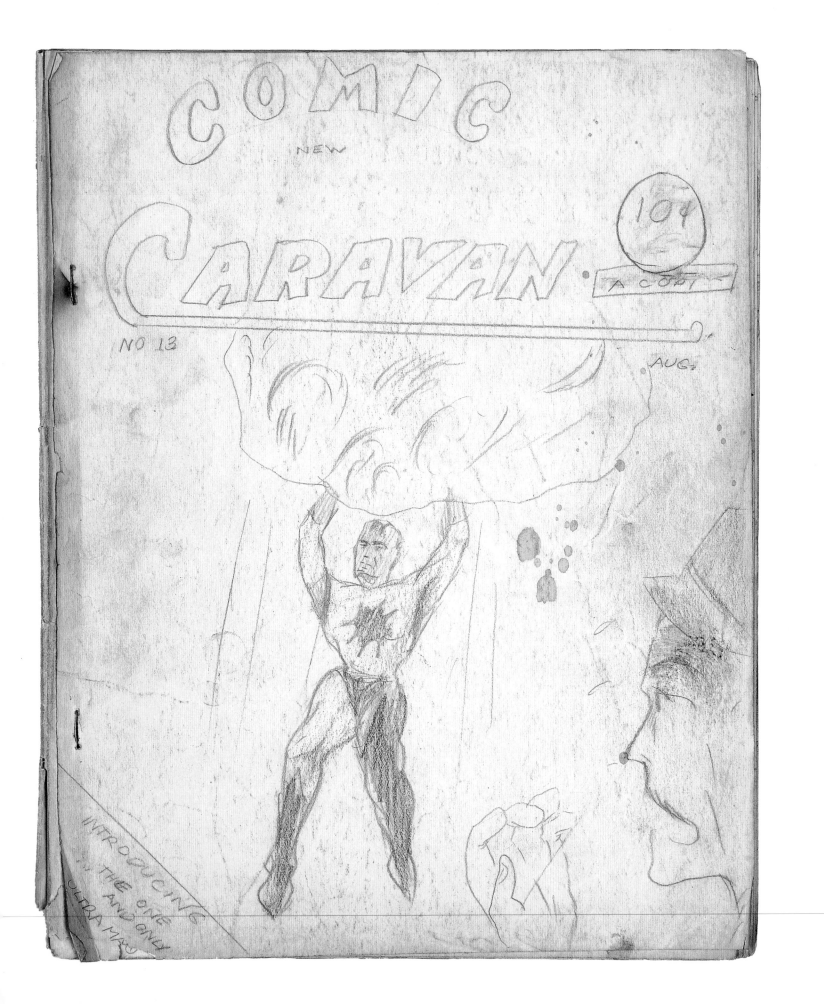

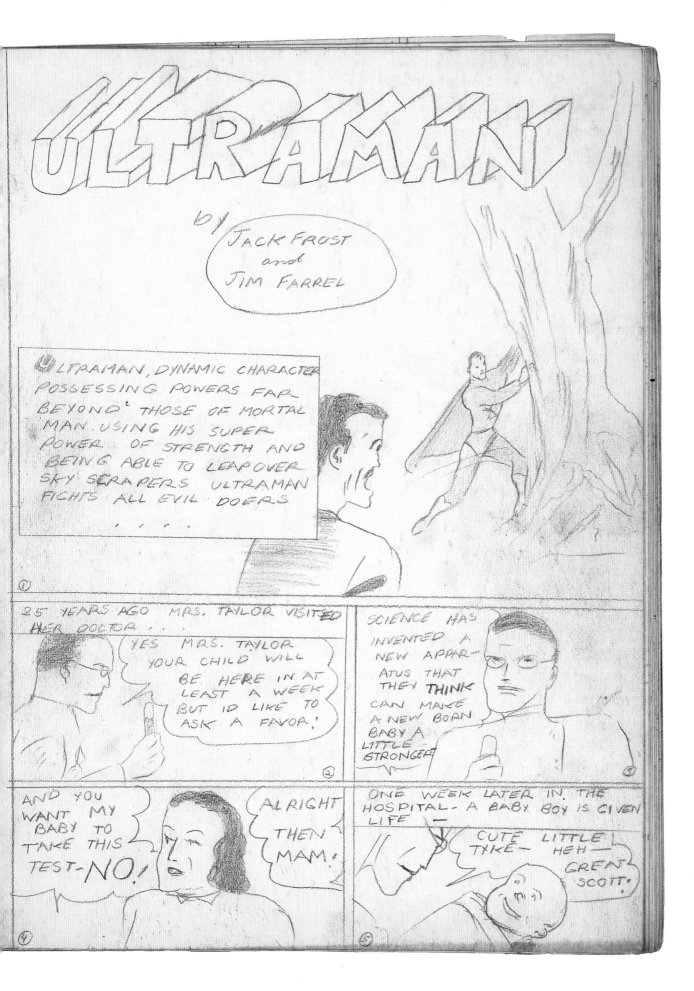

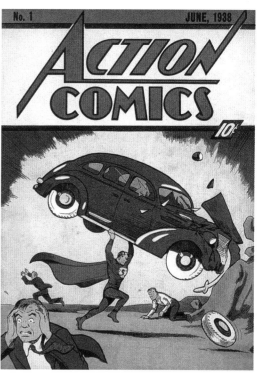

When Feiffer created Ultraman, his answer to Superman, he made sure his fans would get the message, via a cover that echoed artist Joe Shuster's and writer Jerry Siegel's *Action Comics* no. 1, published by DC Comics in June 1938, when Jules was nine. Feiffer's invented author and artist, "Jack Frost" and "Jim Farrell," echoed the symmetry of Siegel and Shuster's "JS & JS"—but keyed to the not-yet-famous JF, who gave them life.

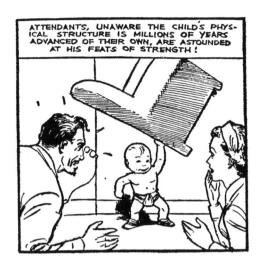

Feiffer's inspiration for a superstrong baby (panel fourteen, opposite) came from "The Superman Is Here!" Above, panel from the twelfth installment of the Superman newspaper strip, January 28, 1939. Text by Jerry Siegel, art by Joe Shuster, published by DC Comics.

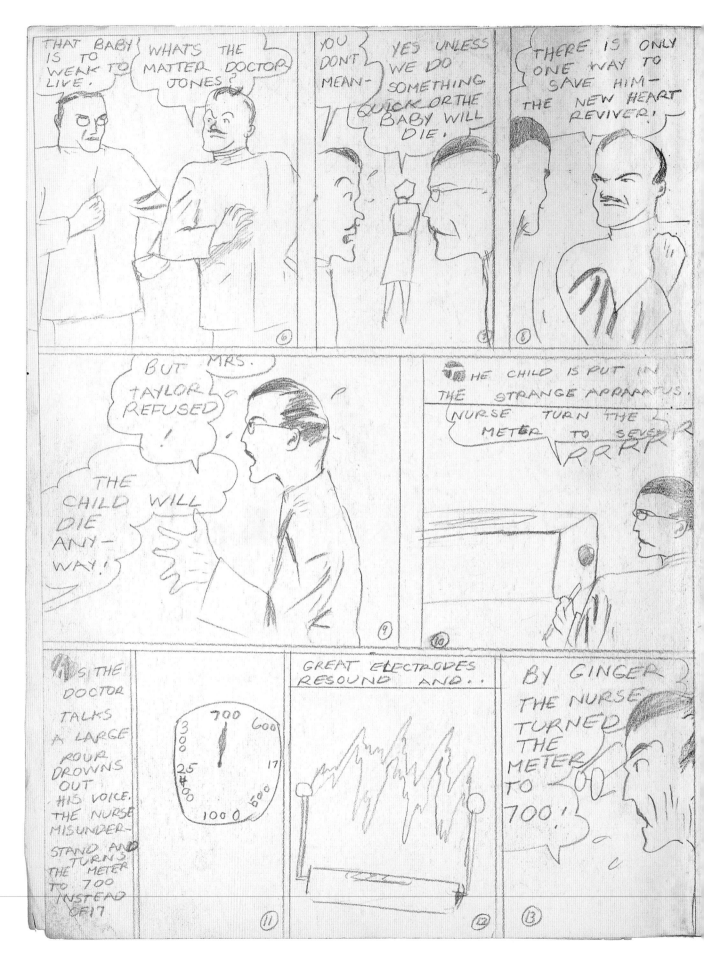

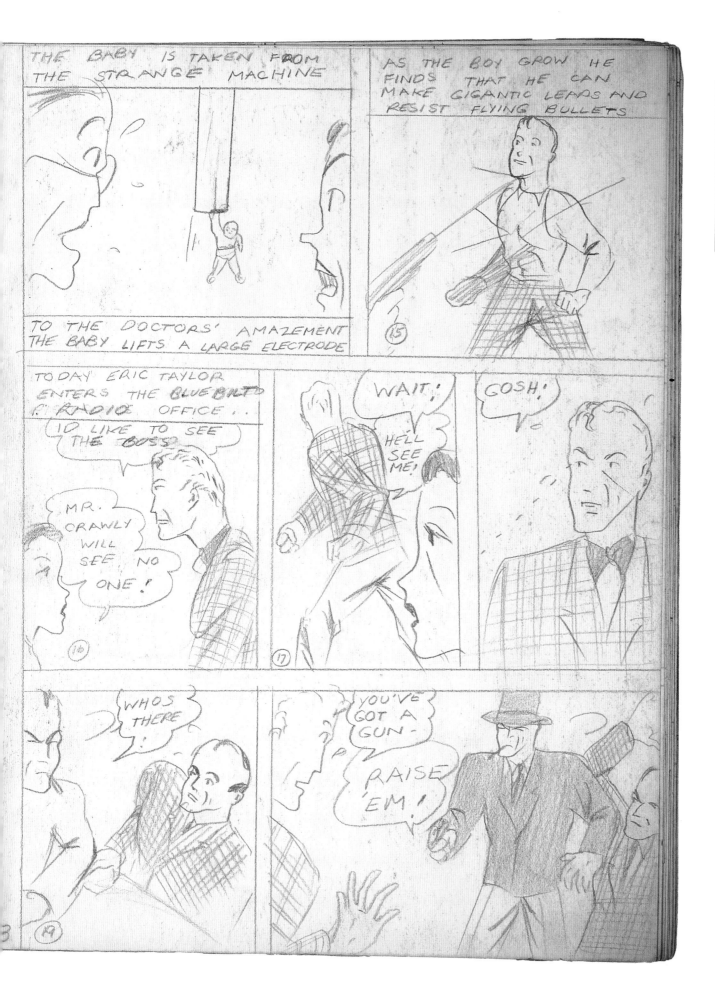

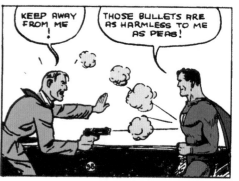

Bullets bounce off the chest of Feiffer's Eric Taylor (panel fifteen, left), no doubt inspired by this popular Superman trope. Above, panel from *Action Comics* no. 7, December 1938. Text by Jerry Siegel, art by Joe Shuster, published by DC Comics.

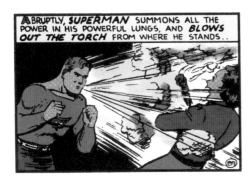

Another trope of the Superman comics served as inspiration for Eric Taylor's super-breath in the first panel on page four (right). Above, panel from *Action Comics* no. 20, January 1940. Text by Jerry Siegel, art by Joe Shuster, published by DC Comics.

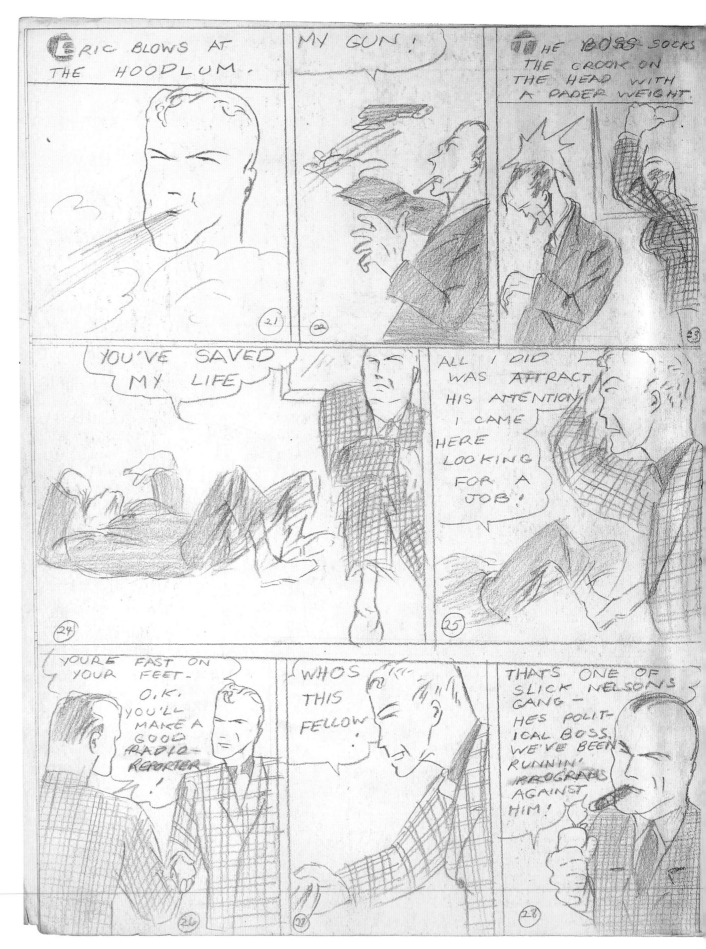

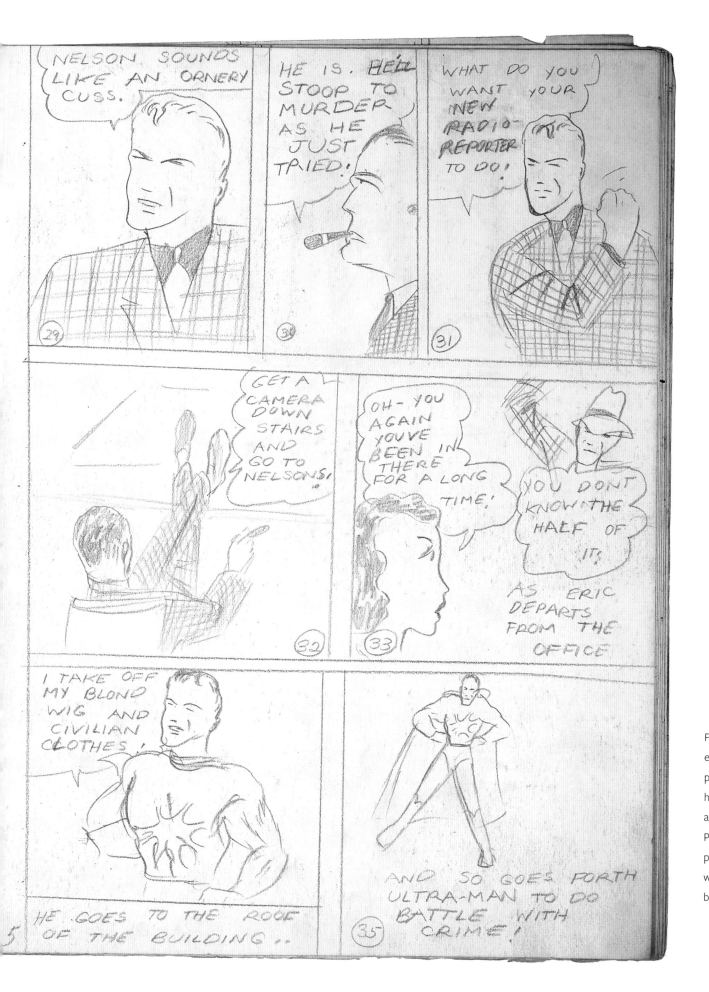

Feiffer followed the Superman storyline closely, ensuring that doctors would counsel worried parents and that bullets would ricochet off his hero's chest, even as he cleverly substituted an accident with a medical gizmo for Superman's Planet Krypton origin tale. That Ultraman owed his powers to human error and a powerful machine was a canny, futuristic touch on the eve of the bomb. The blond wig is pure invention by Feiffer.

37

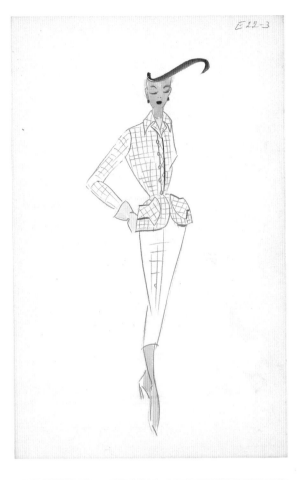 E22-3

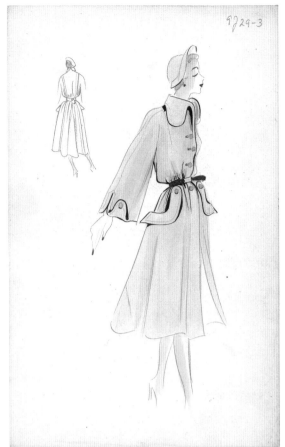 9729-3

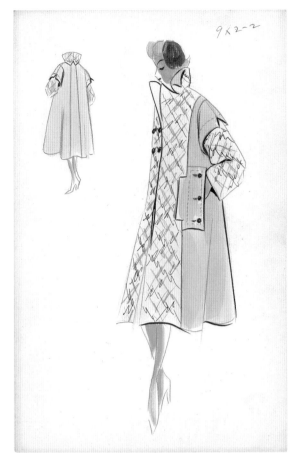 9K2-2

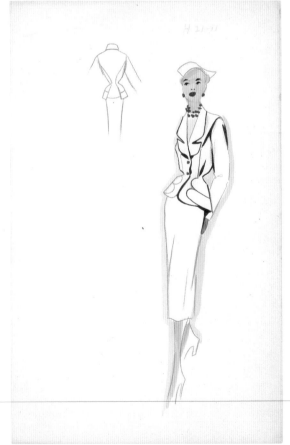 H21-11

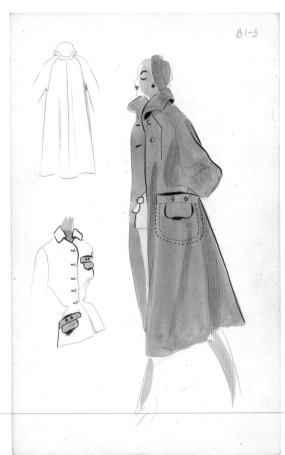 B1-3

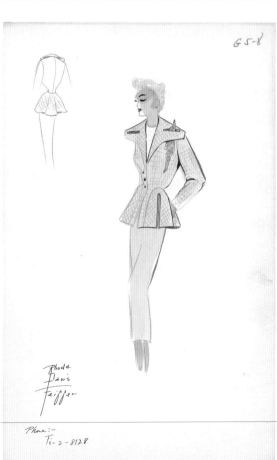 G5-8

Rhoda
Davis
Feiffer

Phone:-
T2-2-8128

Drawing—and piecework—ran in the
family. Feiffer's mother, Rhoda, the daughter
of a Polish Jewish tailor, was also an artist, a
fashion designer who prepared pencil and
watercolor sketches at a table in a corner of
the living room on Stratford Avenue and sold
them to manufacturers on Seventh Avenue in
Manhattan for three dollars apiece. Born in
a small village outside Lodz, Poland, Rhoda
Davis had come to the United States as a
young child. The family settled in Richmond,
Virginia, where she worked at overcoming
any lingering trace of her Eastern European
accent, which she replaced with perfectly
inflected English, something that set her
apart from the other mothers in the largely
immigrant Soundview neighborhood. It was a
voice, says Feiffer, "that resonated class" and
sounded "superior to even her own children."
(It was not sufficient armor to protect her
from the reflexive anti-Semitism of the day.
When Rhoda became an intern at *Vogue* in
her early twenties, Edna Woolman Chase, the
magazine's editor in chief from 1914 to 1952,
referred to her as the "little Jewess.")

Rhoda was five feet tall, with a "round,
lively, pretty face reminiscent of Giulietta
Masina," Feiffer recalls. She dressed stylishly
and well, creating an effect that was more
"Upper East Side lady" than "Bronx house-
wife." She was cultured. She listened to the

Metropolitan Opera broadcasts on Saturday
afternoons. She loved the theater, but although
there were always theater magazines lying
around the house, she never went herself, and
she never took her children. "The theater was
dirt cheap back then," says Feiffer, "so it wasn't
the money. My theory is that it was shame,"
the consequence of his mother's perceived fall
from grace. "She experienced the Depression
not as the national economic disaster it was,
but in terms of her own family's failure. My
father's failure. She had had quite a success-
ful young woman's existence, hung around
with a lot of young, ambitious artists, a sort of
bohemian crowd, all of which ended with her

OPPOSITE Feiffer's mother, Rhoda Davis Feiffer,
was a gifted designer and the main breadwinner in the
family. She freelanced in New York's garment district
throughout Feiffer's childhood, peddling her designs
to a variety of potential clients, as her son would later
do with his cartoons. These six sketches date to the
late 1940s, when an end to wartime shortages made
longer, fuller hemlines possible and Christian Dior's
elegant "New Look" swept the fashion industry.

ABOVE Unpublished art and sketch from the late
1990s by Feiffer suggest it's best not to argue with
genes: "*Vanity Fair* commissioned me to go to a fash-
ion show and do some commentary.... I could not
believe these long-leggedy young women, who didn't
look quite human, who walked down the runway and
their bodies came in different sections. The head and
neck had nothing to do with the shoulders. So I tried
to get that across in these drawings."

marriage and with the Depression. My mother was embarrassed that she had married someone who could not make a living. It was humiliation that she felt—the shame that she couldn't keep up her wardrobe, keep up appearances. It was demoralizing that the job had fallen to her to make a living for her family, which most women in that day were not expected to do. During those Depression years, she stopped seeing her friends, all of whom were doing better than the Feiffers. We saw no one socially who was not a relative."

But in an age when few mothers in aspiring middle-class families worked, Rhoda Feiffer had a career. Not—as she made clear to her children—the one she might have had if she had not been pressured into marrying David Feiffer in her early thirties, but a career nonetheless.

"My mother was a very good designer," remembers Alice. "She understood how clothes were constructed; she could draw how a coat should hang."

Jules recalls his mother sketching at the table in the living room and the "unwilling excursions" he made with her to the Garment District as a boy. Alice, four years younger, remembers those trips with pleasure, in particular visits to an office directly across from the old Metropolitan Opera, which their mother either rented for a time or was entitled to use while working for one of the many manufacturers for which she freelanced as a designer. Among them were Mainbocher and Mangone Models; the latter specialized in women's coats and suits and was one of the more sophisticated houses in the District. (Mangone is the only place Jules can recall her working steadily, for a period of two or three years.)

"I went with her often," Alice remembers of the Seventh Avenue office across the street from the Met. "In the summer, they'd have the windows open—there was no AC—and you could hear the artists vocalizing across the street."

If Rhoda Feiffer was the family's breadwinner and its representative in the larger world, then her husband, sweet and gentle Dave Feiffer, was its casualty. By Jules's account, his father was as inept a businessman as his aunt and uncles were successful in menswear, real estate, and jewelry. Feiffer senior had come to the United States from Poland as a young man and enlisted in the army, becoming a master sergeant. Unlike his wife, he spoke with a slight accent—"not heavy," says Alice, "just enough so you'd know English wasn't his first language." The seminal family story about Dave Feiffer was that he had borrowed, then squandered, five thousand dollars of Rhoda's hard-earned money. Rhoda would never say just what he

blew it on—women, cards, alcohol?—but even in the Depression, his failure as a provider was conspicuous. His longest stretch of uninterrupted employment, Jules recalls, was during World War II, as a civilian working for the navy in Port Newark, New Jersey. (Alice believes he was a longshoreman. Jules remembers that he was a quartermaster on the docks, handling supplies.) Dave made two attempts to complete dental school, once after World War I, and again, twenty-five years later, after World War II, when he returned on the GI Bill. It was a profession he enjoyed and for which he seemed to have a genuine gift. Academically, Jules remembers, his father was at the head of his class, but he had a severe reaction to the chemicals used in dentistry and both times was forced to quit. And at some point after that, a few more failed ventures and short-lived jobs along, Dave Feiffer seems to have given up. He spent much of Jules's childhood reading his way through the morning and evening newspapers and a bookcase stocked with classics and bestsellers that shared space in the living room with an unused piano and his wife's much-used drawing board.

In a family where she understood from childhood that she came last, Alice felt lucky that "my father loved me dearly," and her older, outwardly confident sister, Mimi, was close to him as well. When Mimi and Alice saw Jules's

play *Grown Ups* in 1981, based in large part on the family, they told him they recognized the mother in the play as their own, but not the father, who was nothing like the man they remembered and loved. "They knew a more connected and supportive person than I did. I was *her* son, my mother's property, so he kept his hands off," says Jules. Bob Laurie, a high school friend of Jules's, recalls Dave Feiffer as a silent, "nearly invisible presence, especially in contrast to his wife and his older daughter, Mimi—the 'firebrand.'"

Four years older than Jules, Mimi could have been the model for Katie Morosky, Barbra Streisand's character in the 1973 film *The Way We Were*. Mimi was smart, political, popular, and sure of herself, a party-line Marxist at a time when Marxism was the default creed in New York City public high schools, and she became a member of the American Communist Party after enrolling in Brooklyn College. "Kids," as Jules put it in his memoir, "if they were not Red, were hottish pink. Teachers were Reds, and if they were not Reds, they were fellow travelers."

"A lot of my political formation came from arguing with [Mimi]," he told Gary Groth in an August 1988 *Comics Journal* interview shortly after she died, "because I was not a communist. I wasn't a socialist. I was a weak-kneed liberal. We fought a lot. I always lost."

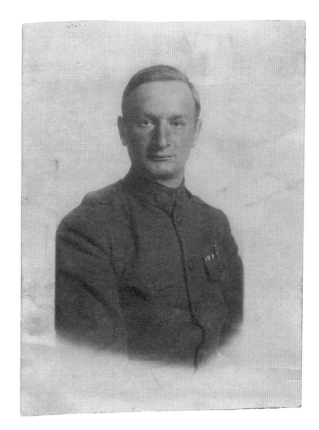

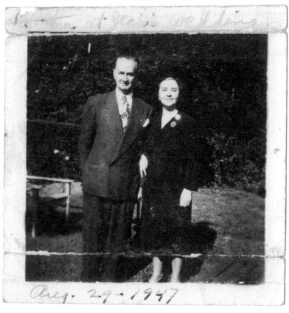

TOP David Feiffer, 1919. Jules's father enlisted in the U.S. Army and served as a master sergeant in the 307th Infantry. During World War II, he had a civilian job at a navy base in New Jersey, one of his longest-running jobs.

ABOVE David and Rhoda Feiffer, August 29, 1947.

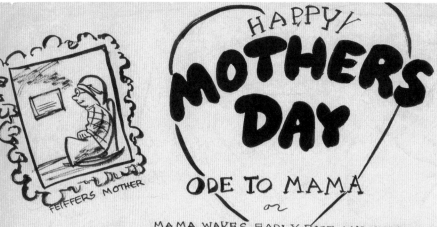

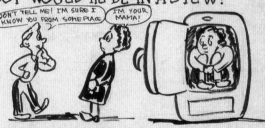

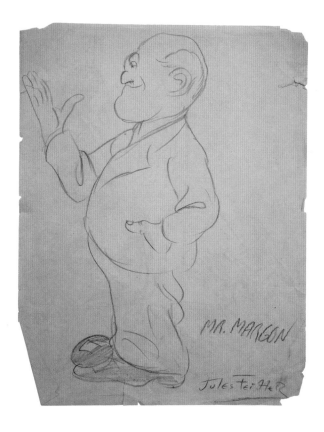

At James Monroe High School in the Bronx, a couple of blocks from the Feiffers' apartment, Mimi was a star, eventually becoming the first female editor in chief of the school newspaper, the *Monroe Mirror*. Jules was dazzled by Mimi's intellectual friends, most of them boys who were as verbal, confident, and left-wing as she was and far more willing to pay attention to him. Hanging out in the afternoons, they voluntarily read Jules's homemade comic books and with their non-stop companionable banter taught him how to wisecrack and bullshit his way through adolescence, an essential counterweight to the left-wing novels and copies of the *Daily Worker* that Mimi supplied.

Jules entered Monroe the September after Mimi and her friends graduated. Four months shy of fourteen, he fully expected to be tapped as the *Mirror*'s cartoonist and was shocked to be told by Mimi's successor—a boy he knew, who had been to their apartment—that he was not quite ready.

As far as Jules was concerned, becoming the paper's cartoonist was the only thing he *was* ready for. Apart from art class, where he had one great teacher, Max Wilkes, nothing else that went on in high school was of any interest to him. He professes to have spent most of his time in class in a "narcoleptic" fog, even as he managed to make enough sense of what was going on to earn passing grades. His goal was simply to graduate, for only then would the world let him do what mattered most to him. Unwilling to be rebuffed a second time by the school paper, Jules kept his sulky distance for the next two and a half years, until a friend, Myron Moscowitz, who had made a mark in the school theater and liked Jules's cartoons told him he couldn't hang around with him anymore—not until Jules became a big shot, too. Go back to the newspaper, Myron said.

Jules was not in the habit of taking anyone's advice, but he understood the prize, swallowed his pride, and found his way back to the *Mirror*'s office. By then, his work had improved enough to win him the job, and his cartoon panel on school life appeared weekly for the next two years, until he graduated. The panel was prominent enough, and topically funny enough, to make him a "minor-league celebrity" at Monroe—it was his first small taste of fame.

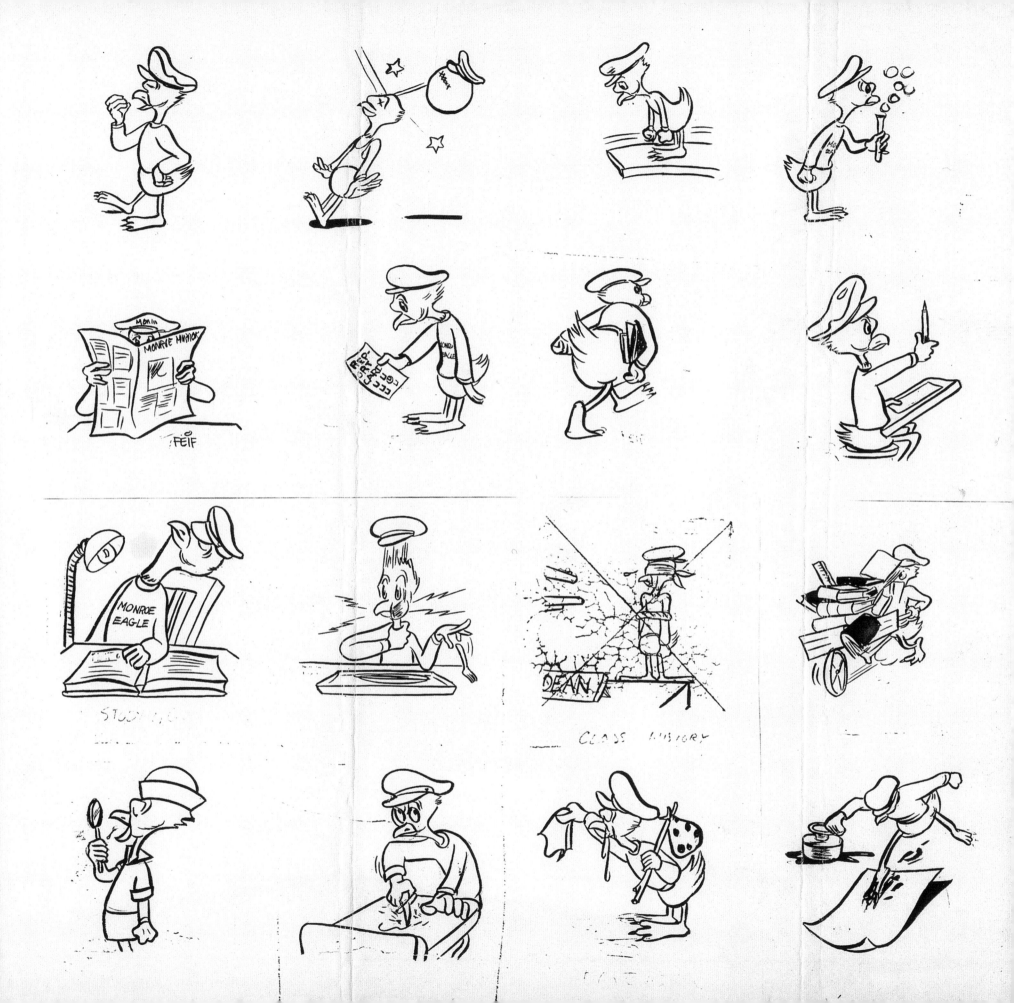

CLICK
CLACK
CLICK

ZZZZ

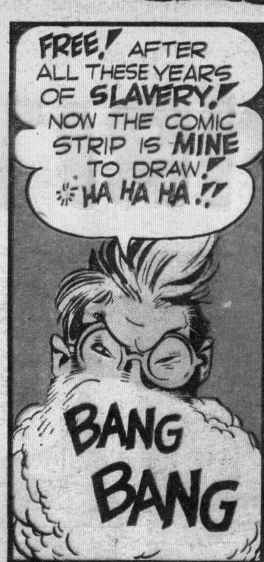
FREE! AFTER ALL THESE YEARS OF SLAVERY! NOW THE COMIC STRIP IS MINE TO DRAW! HA HA HA!

BANG BANG

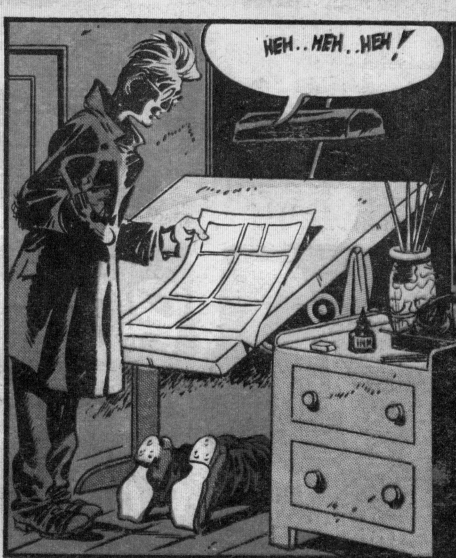
HEH..HEH..HEH!

BANG BANG

HEY, EISNER, WHERE'S NEW YEAR'S SPIRIT? IT'S WAY PAST THE DEADLINE! GET IT HERE IMMEDIATELY
CLICK

Apprenticeship

I had no idea how one got to be an assistant to a daily strip cartoonist. . . . That seemed to be way outside the realm. Comic books were more accessible because they were more raffish, they weren't drawn as well, generally. . . . It looked like it might be a field to enter before I did what I wanted to do, which was to have a syndicated adventure strip.

JULES FEIFFER, *Comics Journal*, 1988

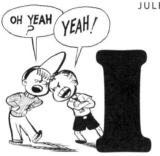

It is tempting to speculate on what might have become of Jules Feiffer as an artist had he been accepted by either of the colleges he applied to in his final year of high school—Cooper Union, the working-class MIT; or New York University's Washington Square School of the Arts. The story with NYU, Feiffer recalls at a distance of more than half a century, was that, having to find room for an influx of GI Bill students, the university cut the credit for high school art courses, which were Feiffer's strength, from one down to a half credit, "making me a half credit, and only a half credit, shy of admission, which meant I would have had to go back to school for summer classes to make it up. A mother who was able to argue on her children's behalf might possibly have been able to change the outcome, but my mother, strong in so many ways, could never stand up to authority, so NYU was out.

"At Cooper Union it was a different story. I simply made a mess of the entrance exam, having at that time, as well as now, no ability to deal with test questions that far more simpleminded people than I have no trouble handling. Call it IQ dyslexia, but even at this age I would not be able to qualify as a student for the college course I teach.

"The whole idea of going back to high school in order to get into NYU was anathema to me," he says, and in retrospect, "it was probably the best accident that ever happened to me. An accident that was one of the smartest things I've ever done." Instead of spending the next few years in a classroom, Feiffer gathered up some drawing samples, headed into the city, and introduced himself to Will Eisner.

Eisner, twelve years older than Feiffer and the successful proprietor of a four-man "shop" that turned out the weekly sixteen-page *Spirit* Sunday supplement (Eisner farmed out additional pages, the strips *Lady Luck* and *Mr. Mystic*, to other artists), appears to have been an easy touch, although not at first. Looking up from his drawing board one morning in the summer of 1946, Eisner saw a scrawny seventeen-year-old standing just inside the doorway, a portfolio tucked under his arm. Feiffer had looked up the address of Eisner's studio—a cluttered office on Wall Street, a couple of blocks east of the Stock Exchange—and taken the subway down from the Bronx. Eisner invited him in and took a cursory look at the pages Feiffer had brought as a sample. It was a comic book written by the editor of the *Monroe Mirror* that Feiffer, despite his distaste for illustrating anyone else's words, had agreed to draw in the hope that the work would make it into print. (His collaborator's mother claimed to know the publisher of a local paper, who, she was sure, would be eager to publish the eight-page comic *Adam's Atom*.)

Eisner turned over the sample pages and told Feiffer they "stank." Without missing a beat, Feiffer changed the subject from his lousy sample pages to Eisner. Feiffer was a scholar of Eisner's work. He could recite his hero's triumphs chapter and verse, from *Muss 'Em Up* to *Hawks of the Seas* (a swashbuckler), from *Espionage* (a spy thriller) to, of course, *The Spirit*, Eisner's ongoing magnum opus. Feiffer knew that Eisner—like himself in his *Comic Caravan* days—played with pseudonyms, now and then signing work as "Will Erwin" and other variants of his name. "What could [Eisner] do?" Feiffer recalls. "I had such a complete dossier on his life's work that he had no choice but to hire me as a groupie."

Eisner's recollection of their first meeting, in an interview with the *Comics Journal* in May 1979, is understandably more streamlined. "Feiffer walked in and asked me for a job and said he'd work at any price, which immediately attracted me. He began working as just a studio man—he would do erasing, cleanup. Gradually it became very clear that he could write better than he could draw, and preferred it, indeed, so he wound up doing balloons [dialogue]. First he was doing balloons based on stories that I'd create. I would start a story off and say, 'Now here I want the Spirit to do the following things—you do the balloons, Jules.' Gradually, he would take over and do stories entirely on his own, generally based on ideas we'd talked about. I'd come in with the first page, then he would pick it up and carry it from there."

With a morning's work, Feiffer had secured for himself what artisans in past ages

called an apprenticeship and what twenty-first-century college graduates would recognize as an unpaid internship. Paid or unpaid, it was a spectacular coup.

"When Jules got a job with Eisner," recalls his high school friend Bob Laurie (another aspiring artist at James Monroe, with whom Feiffer chased girls and went on American Youth for Democracy outings to Bear Mountain), "I was jealous, because of the ride he was on." But not surprised. "Jules always says he was insecure as a kid, but I didn't see it. I still don't believe it. He was so outgoing. I think most people took him for gregarious.

"And he was funny. His work at the time didn't resemble what he does now. He just never stopped cartooning. I had a job at an ad agency as a messenger, and one of the agency clients needed a cartoonist. I got Jules to do cartoons for the guy, who paid twenty-five dollars. I kept five and gave Jules twenty. That was the only time we ever worked together."

Feiffer's own assessment of his drawing skills at sixteen or seventeen remains unforgiving. "I couldn't draw a convincing chair or table or desk. I was hopeless at vehicles of any kind. I drew guns as if they were made of melting butter." Although he had taken a painting class at James Monroe, painting never really interested him. Neither did printing, graphics,

ABOVE Sketch from Feiffer's anatomy drawing class at the Art Students League, c. 1945.

OPPOSITE Practice sketches, c. 1947. Working for Eisner, Feiffer was constantly sketching, trying to improve his line. He felt his figures were "passable," thanks to his training at the Art Students League, but judged his brush line—crucial for a cartoonist— "splotchy and ham-handed."

or lithography, all of which he studied in school. "It was always words *and* pictures. If I didn't tell a story, doodles were of no interest to me." A year or two before Feiffer turned up at Eisner's studio, while he was still in high school, he had taken a drawing class at the Art Students League in Manhattan, at his mother's suggestion. "I was maybe the youngest person there. I took an anatomy class in one of those big dirty rooms. The place still looks today the way it probably did at the turn of the twentieth century. There were people there from their twenties through their sixties and seventies. No one my age."

His teacher was the elegant Robert Beverly Hale, a bohemian Brahmin from Boston with a "Harvard drawl," who a few years later would become curator of the Metropolitan Museum's contemporary American art department (and who continued to teach at the League until 1982). "He was a wonderfully gifted natural teacher, a gut teacher," Feiffer recalls, "who taught me lessons I use to this day. And whose critical but supportive approach I adopted, with the addition of laughs, in my own teaching."

Roaming the room in a three-piece suit, Hale would occasionally stop at a student's table to comment or correct a mistaken line. Feiffer remembers Hale "gently taking the charcoal out of my fingers to correct the drawing of a nude I was making a mess of."

Sometimes he was less than gentle, "savaging" a drawing, but never the student, and always to a purpose. "He would pick it apart but also take you through it. He had a work-focused way of going at it. A total absence of ego; it was all about the work. You were grateful and in total awe of what he was able to convey." Feiffer took encouragement from Hale's close attention. "If he spent so much time with me," he figured, "I must show promise," and when Feiffer emerged from Hale's class, he felt he knew his anatomy—"more or less."

Working for Eisner, Feiffer quickly came up short. Yes, he could sketch the human figure— "shakily but passably"—but only in pencil or charcoal, not in the thick and thin calligraphic brushstrokes that defined comics artwork, a skill it was assumed any aspiring cartoonist would already have mastered. "My brush line didn't shine, it clunked. It wasn't thick or thin, it was splotchy and ham-handed." Surrounded by the older, more experienced artists who worked for Eisner, Feiffer was knocked sideways by his limitations. For some reason, Eisner didn't throw his newest assistant out. Instead, he simply rotated him through the various tasks in the shop, which operated somewhat like a graphic assembly line—one man penciled figures, another did backgrounds, a third did lettering, each an essential element in the production of a weekly comics supplement.

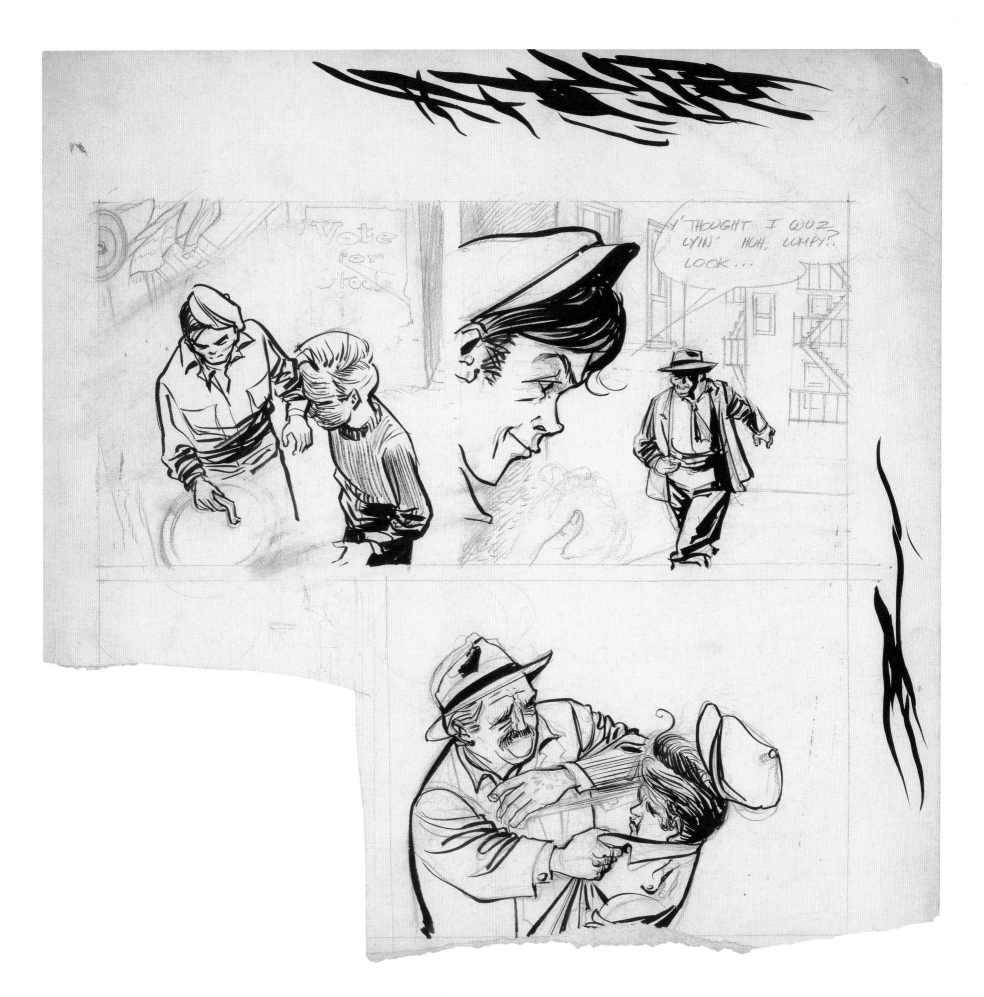

As Feiffer recalls, when he bombed out on inking, Eisner tried him on backgrounds. But for all Feiffer's childhood exposure and practice, it turned out that he couldn't draw a convincing taxi, tenement, or dark alley either. He eventually found his level with a series of simpler tasks Eisner gave him, drawing dialogue balloons and, with the help of a ruler, the borders around panels. Feiffer filled in patches marked with an X to indicate black ink, erased or whited out other artists' mistakes, and did pasteups. Having had years of practice, he was especially good at signing Eisner's signature—better, in fact, than the boss was.

What Feiffer lacked in lettering and drafting skills, Eisner recalled in an interview with John Benson for the first issue of *Panels* (Summer 1979) three decades later, "he made up for . . . in his intensity. He was a great man to have in the shop because almost instantly we had a good strong interaction. I could talk stories out with him."

In 1947, after a year in Eisner's shop, Feiffer returned to art school, enrolling in Pratt Institute, a small, well-regarded design and architecture school in Brooklyn that offers both four-year degrees and classes by the semester, with a large percentage of its students attending part time or at night. Feiffer signed up for a two-semester course known as the "foundation year," the launch to a four-year degree program

for some, a one-shot academic exposure to the arts for others. Suspicious as ever of academic settings, Feiffer chafed at Pratt's emphasis on design and its sympathy with the advertising world. But he was bowled over by his fellow students. "The good part was that I was thrown in with all these GIs just back from the war. I was eighteen or nineteen; these guys were twenty-four or twenty-five, they had been to war, and they were men. They had such self-assurance. Most of them were married and had children, and they had a groundedness of a kind I had never seen, mixed with good humor and infinite patience with me. While I was shocked, as we began the semester, to see that I was infinitely ahead of them in drawing ability, in a few months they had caught up with me and then left me in the dust, because they were motivated and mature. It fascinated rather than angered me, because it made me aware, and quite in awe, of what happens with age, experience, and the ability to focus. It would have been different if they had condescended to me, but the only condescension came from the day-school teachers, who had total contempt for my dreams of becoming a cartoonist.

"The day-program professors emphasized design and advertising. They thought that advertising was a worthwhile profession, cartooning worthless. Later, after I was back with Eisner, I started going to the night school,

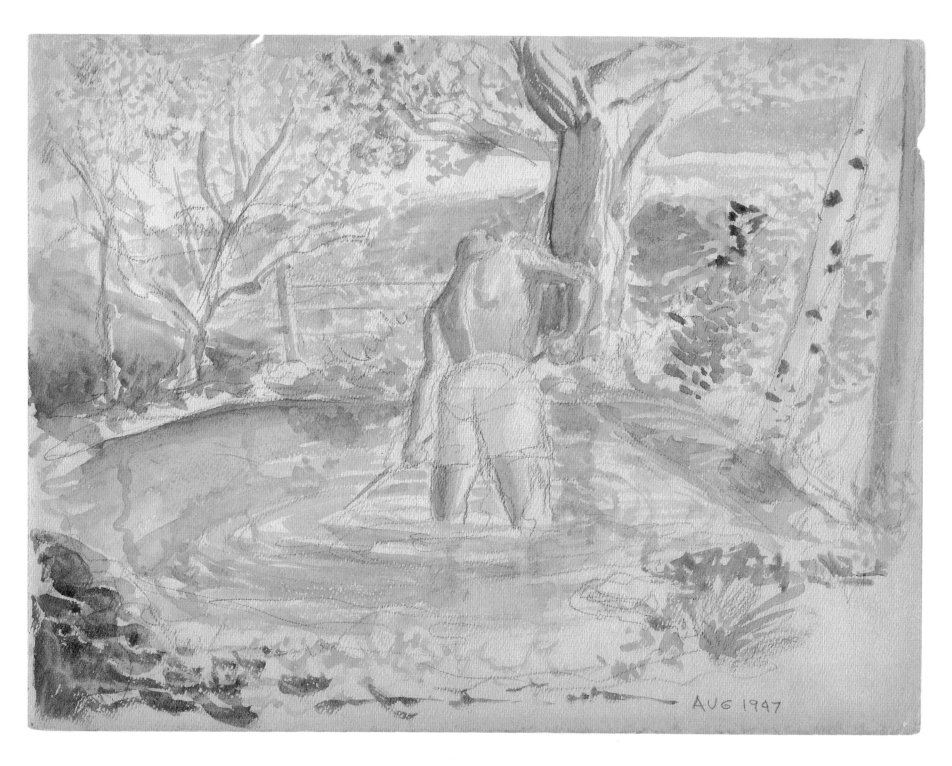

AUG 1947

where they had a part-time faculty drawn from various professions, and they were much friendlier and nicer and helpful. And though some of them were working in advertising, they weren't disdainful of my ambition at all."

By the summer of 1948, Feiffer was back in Eisner's shop. After a year of being exposed to how things were done, he began to catch on. Eisner rewarded Feiffer by letting him color photocopies (which were used as color guides

A pastoral watercolor, dated August 1947, when Feiffer was studying at Pratt.

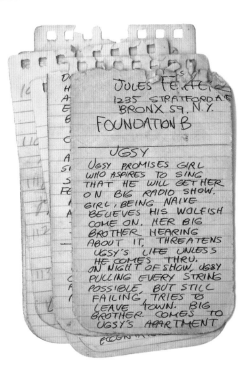

TOP Four panels for a strip called "Bronx Boy," created by Feiffer while working for Eisner, c. 1949. One of several strips that were never launched but proved how much of Eisner's style—and the styles of his many other heroes—Feiffer had mastered.

ABOVE Story notes from the late 1940s for another possible Eisner shop strip, "Ugsy," that never materialized.

at the printer) for the sixteen-page *Spirit* section, a thrilling promotion to Feiffer. "Every Sunday, readers of the *Parkchester Review* would open their papers and read the *Spirit* section, never dreaming that the display of color in the strip was the work of a boy two subway stops away and a year out of high school." By now, Eisner had begun to pay Feiffer ten dollars a week, a respectable sum for a twenty-year-old who still lived at home. At the same time, Feiffer had started to outgrow his worshipful view of things. Emboldened by his insider status, he began to challenge his boss on the quality of the writing. Eisner's art was as good as ever, Feiffer conceded, but the postwar stories—Eisner had spent 1942 to 1945 in the army, writing and illustrating Pentagon publications, including *Army Motors*—didn't have the "zing" of their prewar predecessors. As Feiffer recalls in the *Comics*

Journal, after one of these Oedipal sessions, Eisner—who had long relied on his chief letterer, Abe Kanegson, to tighten up the dialogue—had finally heard enough. "If you think you can do it better," Eisner said, "write me a story."

Preparing for his debut as the ghostwriter of one of America's most popular strips, Feiffer drew on his own adolescence, inventing "a young criminal off a Bronx-like street that could have been Stratford Avenue, robbing a candy store that could have been Pensky's [Feiffer's neighborhood hangout]." Following the Eisner formula he knew by heart, Feiffer added his own noir touches, which included a little girl bouncing a ball and reciting "A, my name is Alice" in the foreground while bloody bodies pile up behind her.

Eisner was pleased and told Feiffer to write some more. The collaboration continued, with

Feiffer inventing stories that conformed to "Eisner's playbook," then sketching layouts for Eisner to critique and revise. There was never any question in his mind about what he was doing—he was "channeling" the master. It was part homage, part tutorial—a graduate course in cartooning he could never have had at an institution of higher learning. Eisner's recollection in *Panels* is more generous. He saw Feiffer as a genuine collaborator, who quickly grew in the job. By the late forties and early 1950, just before Feiffer left for the army, "Jules was actually writing stories. . . . He would do some stories. Or we would do it together."

The actual art was done by a succession of Eisner's hired hands. One of them was a young artist named Wallace Wood. Wood's work left Feiffer cold, but he went on to have a rich and legendary career, working for a range of other cartoonists—Harvey Kurtzman, William Gaines, Joe Orlando, and Steve Ditko—and contributing to a variety of publications, including *MAD*, *Galaxy Science Fiction*, *House of Mystery*, *Creepy*, *Eerie*, *T.H.U.N.D.E.R. Agents*, and *Daredevil*.

After two years of ghostwriting *The Spirit*, Feiffer was making twenty-five dollars a week, and he told Eisner he thought he deserved thirty. Eisner disagreed, but when Feiffer threatened to quit, Eisner told him that

in lieu of a raise he could fill the last page of the *Spirit* section with his own strip.

A few months earlier, Feiffer had come up with an idea for a children's strip to run in a comic book called *Kewpies*. The new strip, *Clifford*, would be about a kid, drawn in a style Feiffer "hoped would look like Walt Kelly's *Pogo*." Feiffer wanted "to write and draw about the kind of kids I had grown up with, as they really were, and not as adults chose to see them," and the strip was written entirely from Clifford's point of view. In the early pages, he's an awkward, skinny kid who enters a bubble-blowing contest. Clifford has aspirations—there's a Yale pennant hanging in his bedroom—a Brillo pad topknot for hair, and a leftward sway to his hips that eerily anticipates the cantilevered posture of the adult Feiffer. The drawing is primitive but engaging: There are wonderful images of contestants blowing fantastic bubbles—question mark–shaped, people-shaped,

ABOVE LEFT Panel from a *Pogo* strip by Walt Kelly, January 9, 1955, whose style Feiffer had in mind when he dreamed up his own pint-size hero, Clifford.

ABOVE RIGHT Panel from Feiffer's third installment of *Clifford*, July 17, 1949.

RIGHT AND OPPOSITE *Clifford* was Feiffer's first published strip. It appeared for the first time in an Eisner comic called *Kewpies* (Spring 1949), a few months after Feiffer's twentieth birthday. *Kewpies* was retired after a single issue, but *Clifford*, which Eisner believed in, lived on as a bonus backup feature in *The Spirit*'s weekly newspaper supplement.

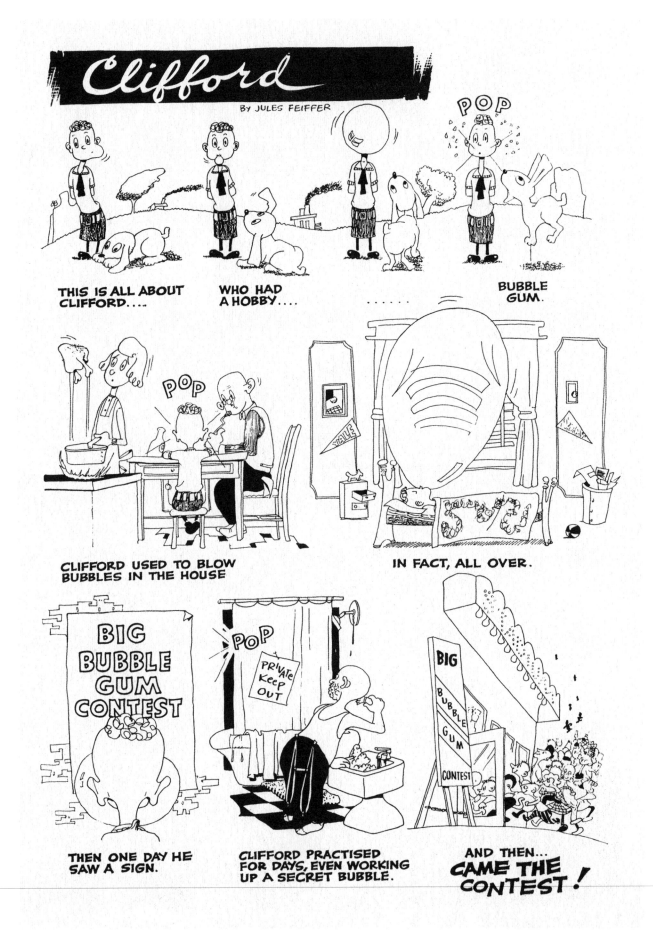

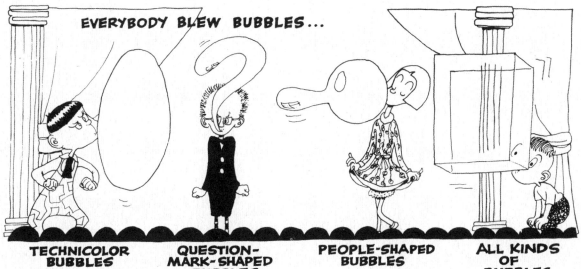

EVERYBODY BLEW BUBBLES...

TECHNICOLOR BUBBLES

QUESTION-MARK-SHAPED BUBBLES

PEOPLE-SHAPED BUBBLES

ALL KINDS OF BUBBLES

THEN CAME CLIFFORD'S CHANCE

HE BU-*LEW*...

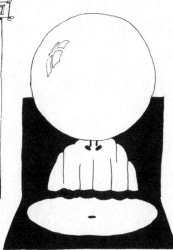

AND *BLEW*....

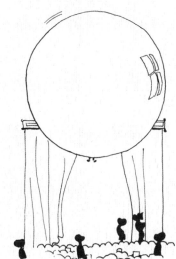

AND...

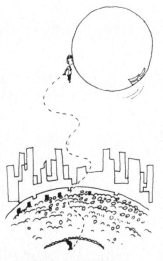

BLEW HIMSELF RIGHT OUT OF THE STADIUM.

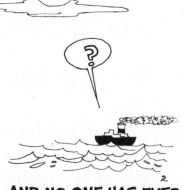

AND NO ONE HAS EVER SEEN CLIFFORD SINCE...IN FACT, HE *MIGHT* BE BLOWING STILL....

square-shaped—and a surreal ending, as Clifford blows a moon-size bubble that floats him high into the sky. In the weekly incarnation of the strip, which began July 10, 1949, Clifford grows steadily less geekish and more conventionally appealing, until he looks like a sketch for one of the characters in Charles M. Schulz's *Peanuts*, which would debut a year later.

At twenty, Feiffer had the idiom of the cartoon kid down cold—the decent, long-suffering main character, occasionally clever but more often hapless, forever being oppressed by adults (on whom he takes regular, harmless revenge) and repeatedly snookered by his best friend/nemesis, in this case a smart aleck named Seymour. Though the strip displays none of the intellectual heft or satiric bite of his later *Village Voice* panels, Feiffer acknowledges that *Clifford*'s worldview was "an early version of the self-pity that made me famous" and was more broadly reflective of his long-standing affection for children as cartoon subjects, because they are so much less hidden than adults, who "don't betray as much with their body language."

In Eisner's judgment, *Clifford* was a great feature that "deserves to be recognized as the forerunner of *Peanuts*. Whether Charlie Schulz was influenced by Feiffer I don't know, but Feiffer was there with the *Peanuts* concept before *Peanuts* got there," he told John Benson in *Panels*. "I don't know whether he'd claim it, but *I* credit him with it."

Near the end of his three-and-a-half-year apprenticeship with Eisner, Feiffer's twin roles of faithful disciple and ambitious understudy came together in a hybrid Spirit/Clifford strip that sends up the relationship between master and apprentice. The strip, a tour de force titled "Happy New Year" (December 31, 1950), opens with a weary Eisner making a midnight visit to the office, where he falls asleep while trying to dream up his next story idea. The door opens and in slips the young Feiffer, who finds his boss slumped over his desk and sees his chance. The story was part wish fulfillment, part daring self-assertion. It was a sign that Feiffer was coming into his own, getting ready to move on and prove what he was capable of.

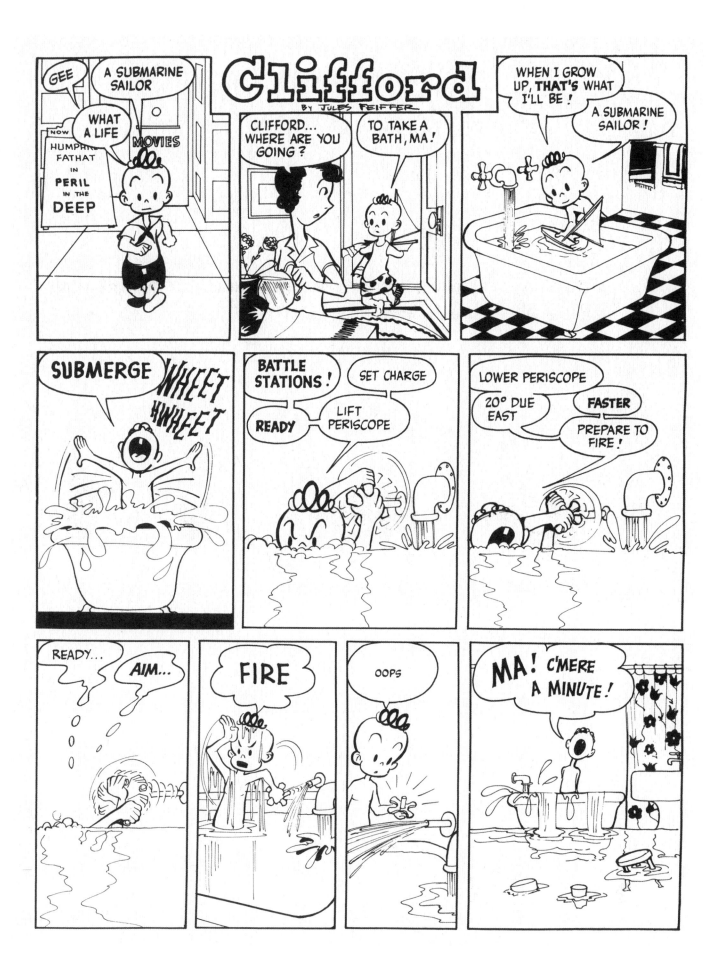

The reappearance of *Clifford*, July 10, 1949, breaking in as a back-page kid's strip in the weekly *Spirit* section.

Clifford
By Jules Feiffer

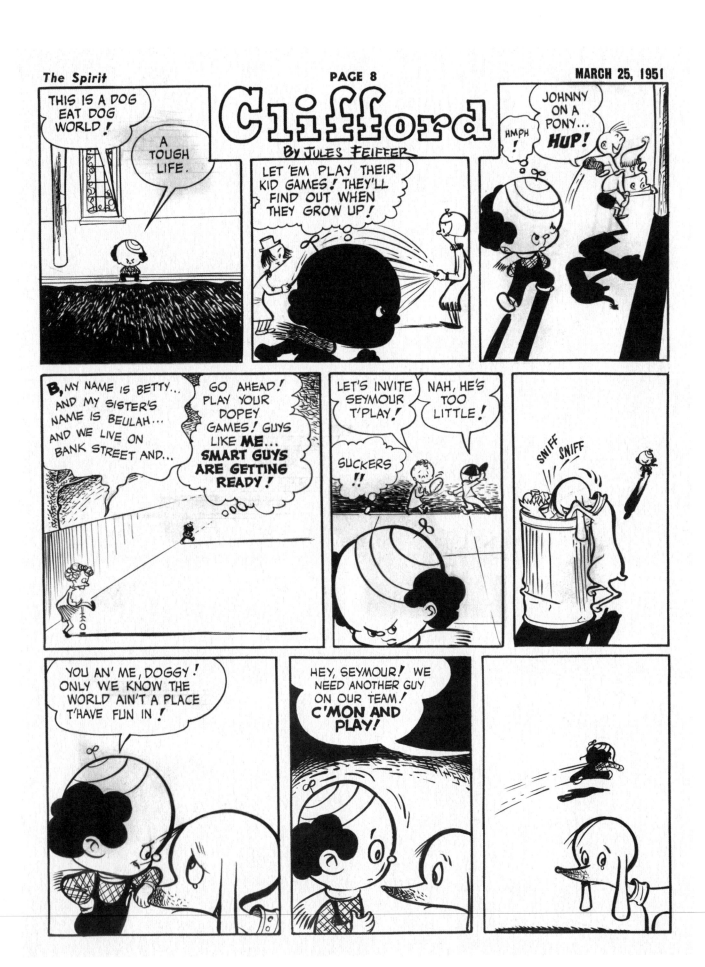

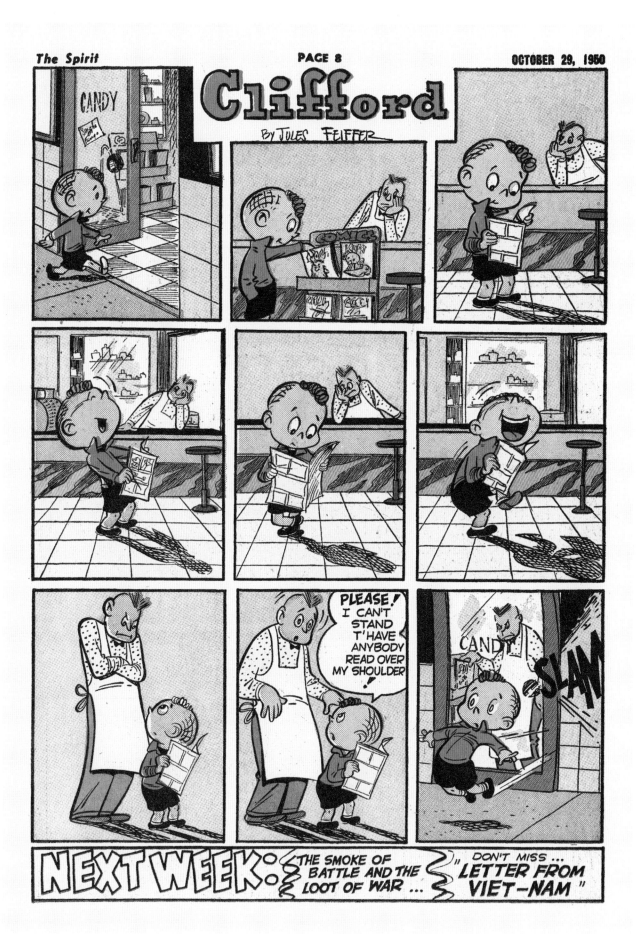

OPPOSITE Original art for *Clifford*, scheduled to run on March 25, 1951, but printed almost a year earlier, on February 26, 1950 (Eisner had his staff work months and months ahead, stockpiling art for when it would be needed). The publication date was moved up when Feiffer was drafted into the army, with the last *Clifford* strip running on March 4, 1951, after eighty-seven weekly installments.

RIGHT *Clifford*, October 29, 1950.

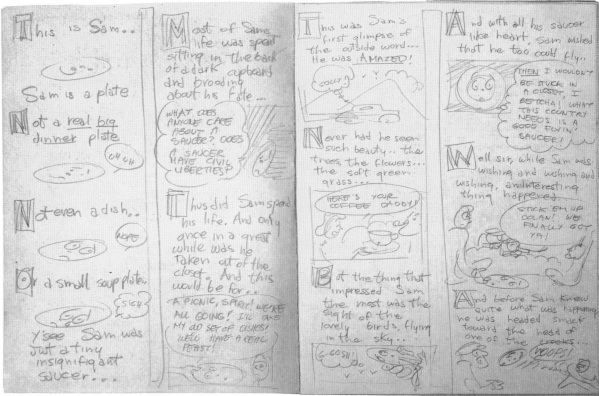

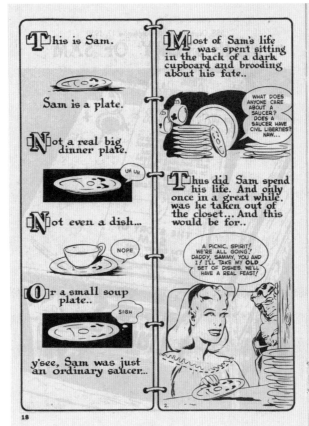

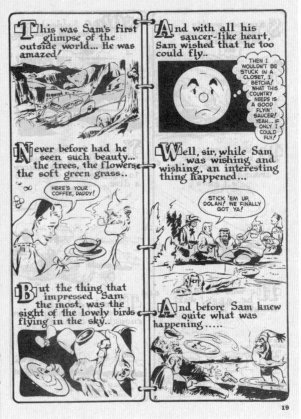

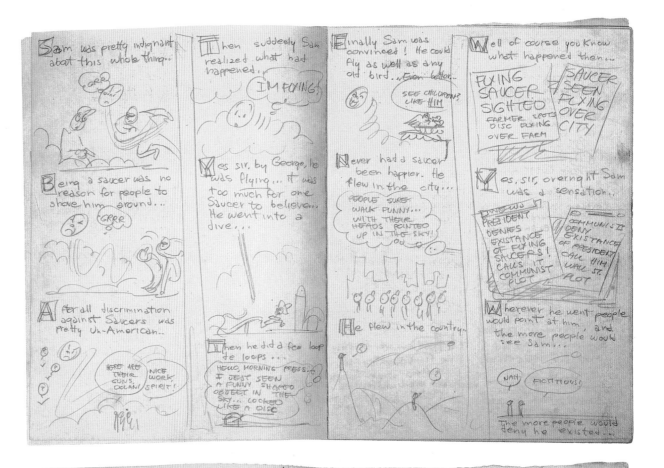

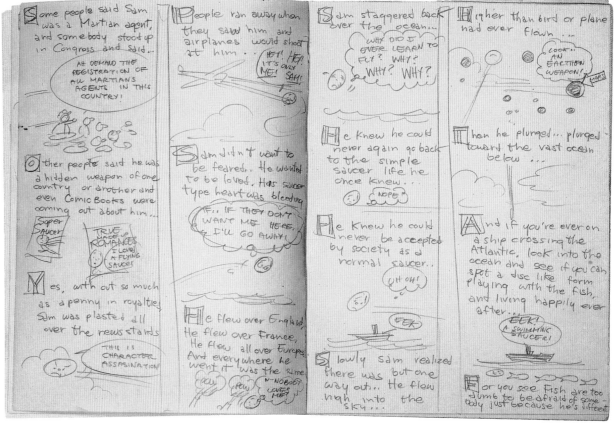

OPPOSITE, TOP, AND THIS PAGE At the same time that Feiffer was working on *Clifford*, he sketched out a different story line, this one for an Eisner feature titled *The Spirit's Reader*, "a primer for adults." "The Story of Sam…the Saucer That Wanted to Fly" appeared in *The Spirit* no. 538, on September 17, 1950, and shows a different corner of Feiffer's brain.

OPPOSITE, BOTTOM Will Eisner's final art for the first three pages of this seven-page story.

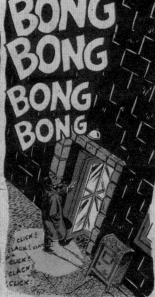
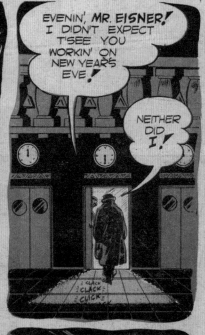
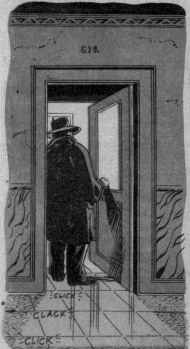

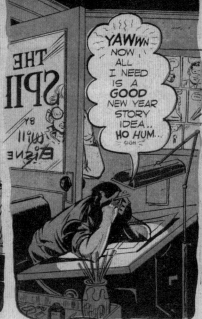

In three and a half years in Eisner's shop, Feiffer had risen from a bumbling no-account to a trusted writer, story runner, and official comic strip creator in his own right. *Clifford* was a hit with readers and his boss, and as the year 1950 drew to a close in this December 31 installment, Feiffer decided to celebrate his work on *The Spirit* by concocting a seven-page story (only four of which are reproduced here) entitled "Happy New Year" (also called "Deadline" in reprints), with the artist at the center.

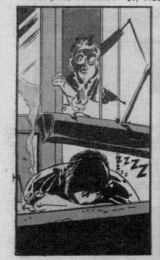

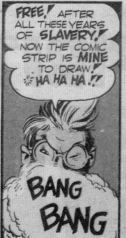

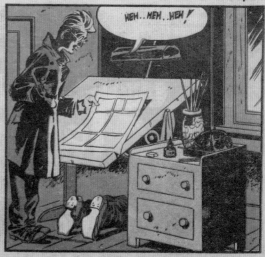

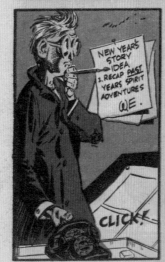

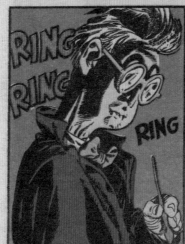

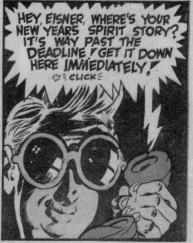

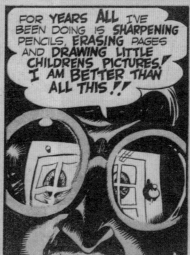

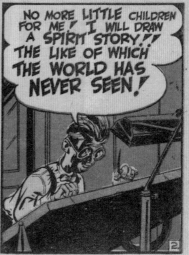

 THE **SPIRIT**

ACTION
Mystery
ADVENTURE

SUNDAY, DEC. 31, 1950

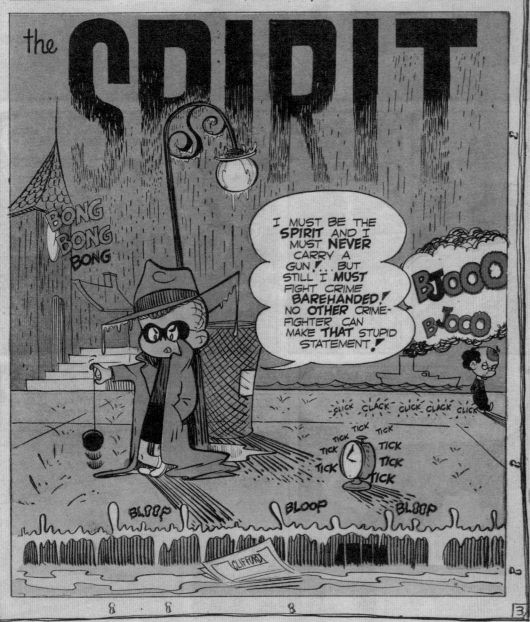

It was a dark and subversive tale that ran on
December 31, 1950. Naturally, Feiffer wanted to
close out the year with a...

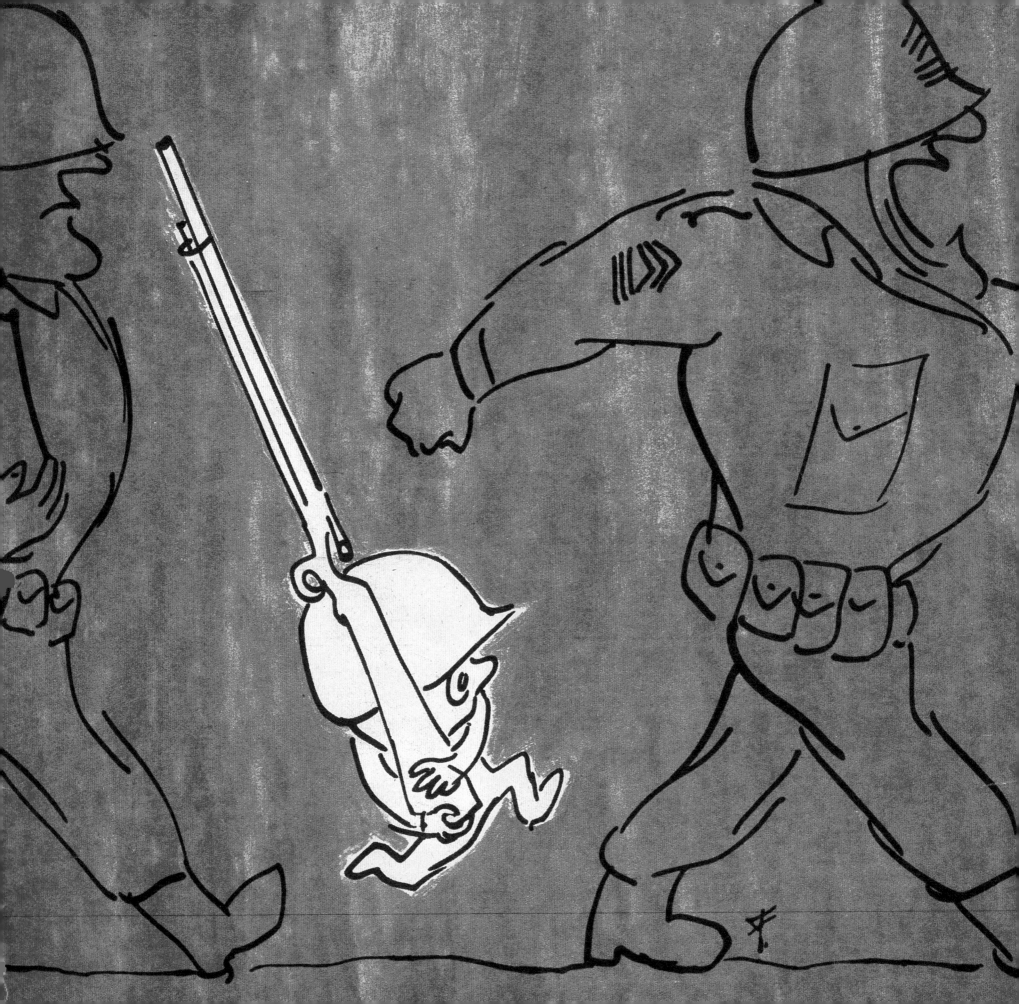

The Army

It is the official policy of the army not to draft men of four. Ergo, you cannot be four. Ergo, you only think you are four.

JULES FEIFFER, *Munro*

In 1950, after three years in Eisner's shop, Feiffer came up with another idea for a kids' strip; this time he pitched it to the syndicates. Like Clifford, the hero of *Kermit* was a child, a musical prodigy with a full-blown career as a composer and conductor, who wanted nothing more than to be allowed to live like a normal kid. Kermit was roughly the same age and stature as Clifford, but where Clifford's nose pointed up, Kermit's sat sideways, like a flattened egg; Clifford had curls, Kermit an unruly, four-pronged tuft, similar to his creator's. Most important, throughout his two-year run, Clifford, in classic kid-strip fashion, had remained very much under the control of the adult world. Though still working within the familiar kids' trope, Kermit's creator tweaked the standard frame just enough to conjure the Huck Finn fantasy of pulling off an escape from adult custody. By the third strip, Kermit has slipped away from his captors—Madam Gleep, his controlling guardian, who keeps Kermit on a short leash while exploiting his talent, and her jockey-size confederate, Humbolt Scathingway, who does Gleep's dirty work, both suitable stand-ins for parents—only to be captured and held prisoner again. In twenty-four drama-packed strips, Kermit manages to turn the tables on his tormentors and is ready to set off on his next adventure.

Feiffer had just begun peddling *Kermit* to the syndicates when he received the letter he had been dreading—from his local draft board.

Detail from the cover of the
Herald Tribune, June 28, 1959.

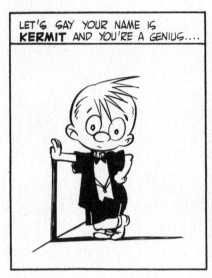
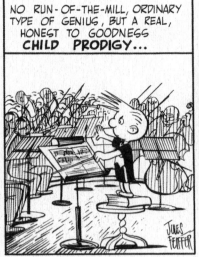
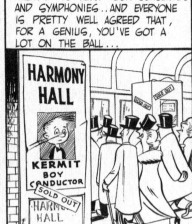
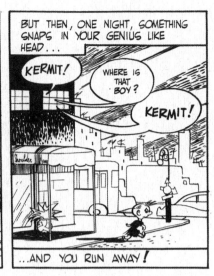
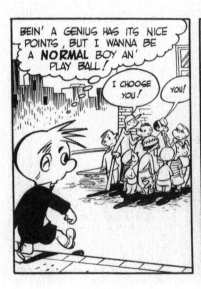
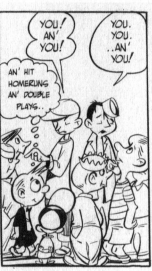

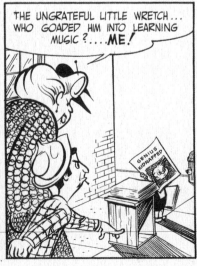
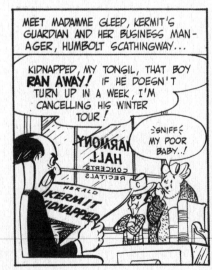
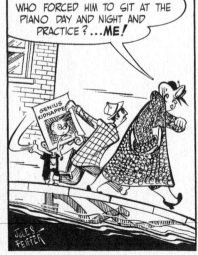
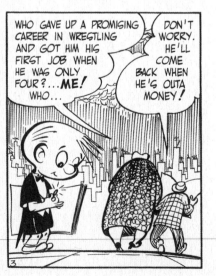

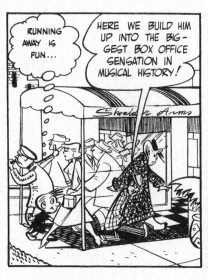
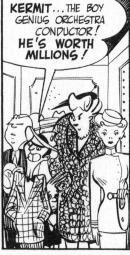

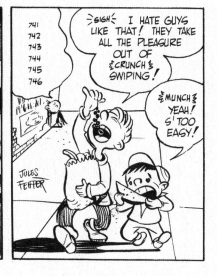

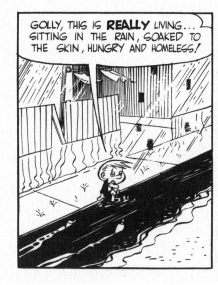
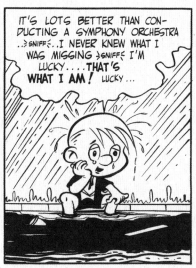
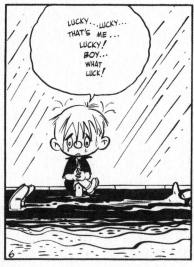
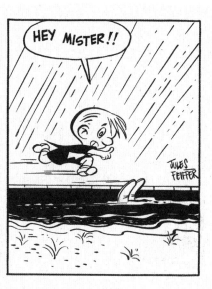

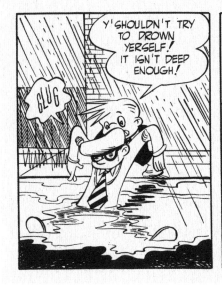

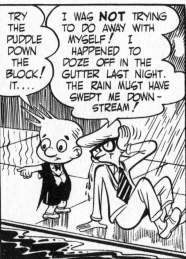

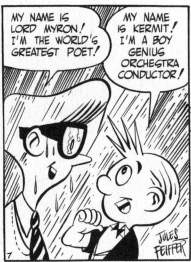

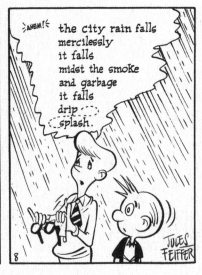

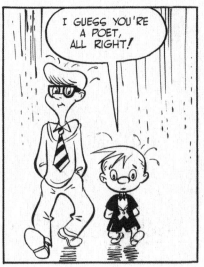

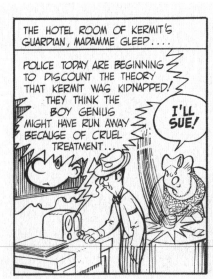

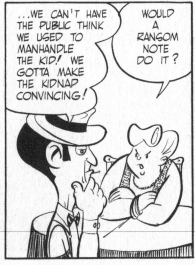

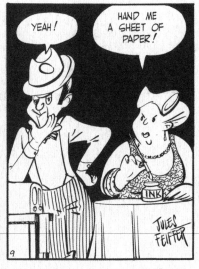

THE SUBWAY TRAVELED DAILY BY MILLIONS OF COMMUTERS ON THEIR WAY TO WORK...NORMAL, DECENT, HOME-LOVING PEOPLE....

STAND BACK!
STAND BACK!

BUT, AS THE MORNING TRAIN ROARS INTO THE STATION, A SUBTLE CHANGE PASSES OVER THE CROWD...

STAND BACK! LET THEM OUT FIRST! STAND BACK!

THE BREATHING IS HEAVIER...THERE IS A RAW, HUNGRY LOOK IN THE EYES...AND SUDDENLY—

STAND BACK! STAND BACK! STAND...

HOWEVER, ONCE SAFELY IN THE CAR, THE COMMUTERS RESUME THEIR NORMAL, DECENT WAY OF LIVING...

STAND BACK STAND BACK STAND BACK

HOW'D WE GET OVER HERE?

I DUNNO!

NOW THAT WE'RE BACK ON THE SUBWAY, HOW DOES ONE APPLY FOR A SEAT?

TECHNIQUE, KERMIT! TECHNIQUE! Y'GOTTA SPOT WHO'S GETTING OFF AT THE NEXT STOP!

SEE HOW SETTLED THIS GUY IS? HE'S STAYIN' ON...BUT THAT LADY OVER THERE...SHE'S PUTTING ON HER GLOVES AND FIDGETING WITH HER HANDBAG... I'M STANDING IN FRONT OF HER!

Y'ALSO GOTTA BE FAST!

THE SUBWAY HAS SOME VERY EDUCATIONAL READING MATTER!

RANSOM NOTE RECEIVED

HMM...SO "POW" BUBBLEGUM IS THE ONLY BUBBLEGUM THAT EFFECTIVELY FIGHTS THE COMMON COLD...NEVER KNEW THAT!

WELL, WHADDA YA KNOW...SLAM POWDER, THE BALL PLAYER RECOMMENDS "CHEWY" AS THE ONLY WHITE BREAD NOT HARMFUL TO BIG LEAGUERS...HMM...OBVIOUSLY, HE'S DONE RESEARCH ON THE SUBJECT!

WE GET OFF HERE!

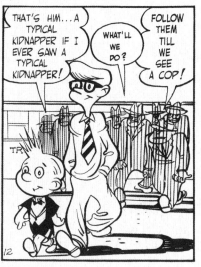

THAT'S HIM...A TYPICAL KIDNAPPER IF I EVER SAW A TYPICAL KIDNAPPER!

WHAT'LL WE DO?

FOLLOW THEM TILL WE SEE A COP!

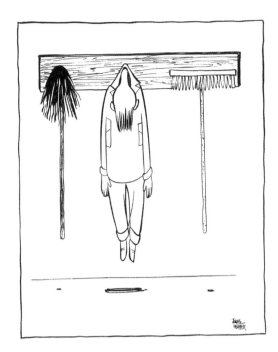

A draft notice is nothing personal, but Feiffer took his very personally. Between December 1950, when Harry Truman declared a state of emergency and ordered American troops into Korea, and 1953, the army called up more than a million and a half young men. A Gallup poll taken in February 1953 reported that 70 percent of the country—including 64 percent of men aged twenty-one to twenty-nine, the target group for the draft—believed it to be fair. Not Feiffer. He felt as thoroughly hijacked as Kermit.

Nothing in life had prepared Feiffer for the U.S. Army. He was officially inducted on January 19, 1951, a week before he turned twenty-two, and reported for duty a few days later at Fort Dix, New Jersey—a two-hour train ride from the Bronx. On the strength of his portfolio, which he had submitted in the hope of being spared combat, he was almost immediately assigned to the Signal Corps Photo Center and shipped to Long Island City—just in time to celebrate his twenty-second birthday on Stratford Avenue, an hour's subway ride away. Yet so completely did he feel the army's assault on his selfhood that he claims to have lost the power of "New York speech" within the week.

"The army revealed in me so much anger, so much rage—the storm that I had been sitting on [before being drafted], that I had repressed for years because the people I was resenting and hostile toward all had the cover story that they were *doing it for my own good*—whether it was family or teachers—and part of that I accepted. I accepted their cover story, and I was confused by their cover story. But even though I knew they were harming me, I didn't think they were bad people.

"The army, I knew, was not doing anything for my own good. The army was out to disembowel me, was beginning to disembody me. They first started by removing my identity and giving me a uniform. And then, as a reaction to that, they removed my ability to speak. I could not speak for two years. I stuttered and stammered, I couldn't put words together. I could only be coherent when I was drinking—after a couple of drinks, my power of speech would return. But I was so essentially flustered, and on the defensive, so scared, that it affected my speech. I'd have a thought in my head, I'd start to say something, but the words wouldn't follow the thought in my head. The language that came out had nothing to do with what I thought I was about to say.

"They were stealing my soul. They were turning me into a puddle—not a soldier, by any means. I was never going to be a soldier. But their determination to turn me into a soldier meant I was also losing my self.

"My only salvation was to work my way out of it by doing cartoons about it. That was my only hold on sanity, because I considered myself nuts for those two years. Nearly certifiable nuts."

Feiffer's day-to-day adventures in the army, recounted at length in his memoir, suggest that he was at least as resilient a victim of military madness as the average highly sensitive private, and more resourceful than most. Though it is hard for anyone who has ever met Feiffer to conceive of him ever having actually cleaned an M1 rifle, crawled under barbed wire, or performed jumping jacks in an open field, it is not at all hard to picture him fishing out the Eisner *Spirit* supplement from the Newark *Star-Ledgers* scattered around Fort Dix's dayrooms and giving them more prominent display. When it came to trumpeting his civilian accomplishments, Feiffer came to life, and he was a regular Beetle Bailey when it came to finding ways to avoid physical exertion. Early in basic training, he went into business with another artistically talented schemer, Harry Hamburg, designing personalized helmet liners for noncommissioned officers. The enterprise, which suggests a script for *Sgt. Bilko*, secured them repeated exemptions from field duty—a major triumph in the ongoing battle against authority.

Feiffer's second posting was to a film unit in Astoria, Queens, forty minutes from Stratford Avenue by subway and a sort of safe house for the young relatives of important Hollywood types. His third stop was Augusta, Georgia, where he learned he was about to be trained in the art of laying down communications cables in enemy territory. At once understanding that the army might actually be planning to ship him to Korea, Feiffer talked his way into a safer assignment back with the Signal Corps, this time in Fort Monmouth, New Jersey. There, while standing in company formation, he got the idea for a strip called *Munro* and found his voice as a satirist.

Though a Lefty by birthright and a semi-pliant fellow traveler in his sister Mimi's Marxist wake, Feiffer had stubbornly resisted the party line all through high school. The closest one can come to labeling Feiffer politically, then or now, would be to call him an instinctive refusenik, suspicious of all claims of certainty and all isms, capable of optimism only for brief periods while waiting for the other shoe to drop—which he knows it ultimately will. Until he made the acquaintance of the army, this instinct had no distinct outlet beyond the world of grown-ups. Writing *Munro*, an allegory laced with an anarchist's sting, gave shape to his instincts and established a satirical style that would serve him for the rest of his career.

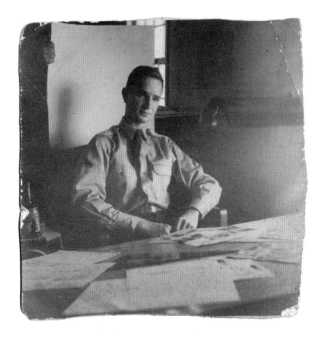

Private Feiffer, September 1952.

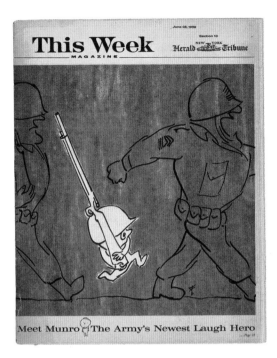

ABOVE Though it was the defining work of Feiffer's early career, *Munro* (his first long-form satirical work) did not see print until after the *Village Voice* strip had made him famous and his second book, *Passionella and Other Stories,* had been published. The *Herald Tribune* celebrated Feiffer and the book with a splashy cover story in its weekend magazine on June 28, 1959.

OPPOSITE AND FOLLOWING TWO PAGES Feiffer didn't know where he was going with *Munro* until he'd finished it in 1953 and discovered that the insane world he'd created was the perfect reflection of his worldview—the army's parting gift to him. "It was the first work of this kind that I toyed with, and I didn't understand exactly what I was doing, and I didn't know what the rules were," Feiffer told Robert Boyd in the preface to *Feiffer: The Collected Works Volume 2* in 1989. The U.S. Army, according to Feiffer, "displayed every rule of illogic and contempt for the individual."

Once again, Feiffer chose a child for a hero, one younger and smaller than his predecessors. Munro is four when he receives a letter from his draft board. An older friend has to read it to him, but Munro gets the point. Though he's brilliant at playing the boy emperor at home, in the face of this official summons, he turns docile. He shows up for his draft board physical as required. He is weighed, measured, and interviewed alongside candidates three times his size and five times his age, and is passed through the system without a hitch. "It was the first work of this kind that I toyed with, and I didn't understand exactly what I was doing." What he did know was that "*Munro* was going to be a subversive book. It was going to attack the mind-set of the military in a time of war . . . not as a polemic or a scathing satire but as a funny and entertaining story. A children's story." Thanks to an indulgent boss, Feiffer managed to write most of *Munro* at his desk. And though he would not find the ending to his story until 1953, after he had completed his tour, Feiffer had found his voice and his gift.

The writing is spare, the send-up of military illogic brilliant, and the drawing, totally in service of the subject, suggests a huge leap in confidence and in clarity of style. It is an early version of Feiffer, but it is unmistakably Feiffer—a monumentally pissed-off artist, whose every line finds its target. Like one of his super heroes, Feiffer turned out to have a superhuman trait—a built-in bullshit detector of extra sensitivity, fitted with laser goggles capable of penetrating the thickest smoke screen.

Though he would not comprehend the source or depth of the anger his army experience unleashed until he entered therapy years later, finding an outlet for it in *Munro* made Feiffer see that "it was no longer possible for me to think of myself as a conventional cartoonist. Previously, I had wanted to break with convention by doing something in line with Al Capp and *Li'l Abner*—those were the departures I wanted to take, all within the recognizable and familiar form of the daily comic strip. Once I did *Munro*, I realized that I was going off in a different direction. I was going to write these cartoon narratives, and they were going to be political *and* social *and* cultural."

Even after Feiffer found his ending for *Munro*, it would take another six years for the story to make it into print—on the wildly flapping coattails of his *Village Voice* strip. Two years after that, the animated short of *Munro* would win an Academy Award. It was a nice payoff, but peanuts compared to what writing it in the first place did for Feiffer's career.

He had one of his big friends read it to him.

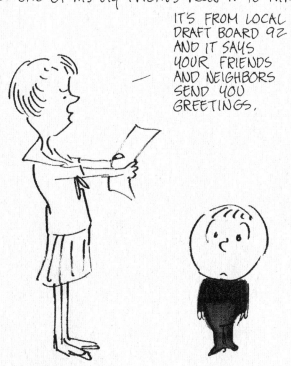

IT'S FROM LOCAL
DRAFT BOARD 92
AND IT SAYS
YOUR FRIENDS
AND NEIGHBORS
SEND YOU
GREETINGS.

So while other children jumped rope and hula hooped and chased each other around the block, and did exactly what it was normal for them to do, Munro came to the shocking realization that at the age of four, **he** had been drafted.

After awhile he grew tired of playing. He lost all his zest for

mud

guns

food

But the sergeants

And the captains

And the colonels

And the generals –

always loved to play. They never seemed to get tired.

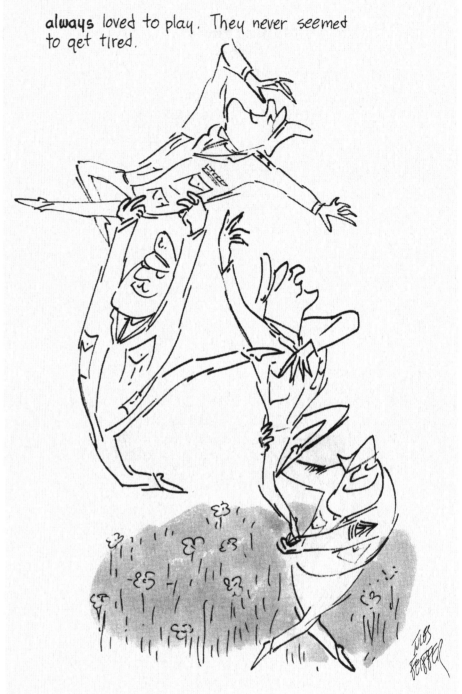

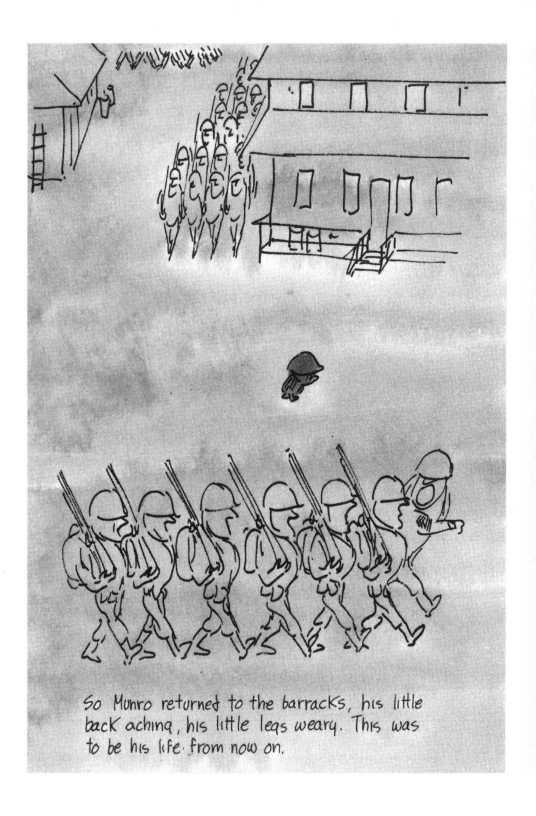

So Munro returned to the barracks, his little back aching, his little legs weary. This was to be his life from now on.

All the men looked

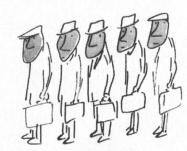

"WE'RE GOING TO SEPARATE THE MEN FROM THE BOYS!" said the sergeant.

And Munro began to cry.

Artist in Waiting

If it hadn't been for books, we'd have been completely at the mercy of sex.

ANATOLE BROYARD, *Kafka Was the Rage: A Greenwich Village Memoir*

A month after Jules Feiffer was discharged from the army, he traded his childhood home in the Bronx for a second-floor walk-up on East Fifth Street, on Manhattan's Lower East Side, now the gilded East Village. He paid twenty-five dollars a month for a room and a half, and began collecting his military discharge benefit of thirty dollars a month, which would last six months.

As an alumnus of Eisner's shop with a substantial portfolio, it was not hard for Feiffer to find work. He cycled through several commercial studios, doing journeyman hackwork like most of his peers, including Edward Sorel and David Levine (whom Feiffer had gotten to know through an army friend, Harvey Dinnerstein; like Levine, Dinnerstein was from Brooklyn, and he introduced Feiffer to a whole circle of artists there). Artists' work was expected to blend in, not stand out. A distinctive style was not welcome. "Decorative leisure moments for the eye," as Feiffer called them, were the norm. The rules were clear, which made it child's play for Feiffer to break them. Given the limited hours he managed to work and still get paid, it was not a bad exchange. Working just long enough to qualify for unemployment and then getting yourself fired was even better. Six months doing hackwork, six months on the dole. Being free to work on his own material was the goal, and Feiffer pulled it off for almost three years.

Pencil sketches, early 1950s.

Two of Feiffer's influences: William Steig, "Mother Loved Me But She Died," *The Lonely Ones*, 1942 (top); and Robert Osborn, "Silence, dissenters!," 1954 (above).

Feiffer continued to experiment with

different styles—imitating the lines of artists he admired—with greater skill but with much the same fervor as when he was a kid. William Steig—the later, experimental William Steig of *The Agony in the Kindergarten* and *The Lonely Ones*, as opposed to the Steig who did *Small Fry* cartoons for the *New Yorker*— was a particular favorite, as was Robert Osborn, whose satirical edge and line Feiffer responded to with equal admiration. Feiffer had been swiping from Steig for years, most recently in a two-page tour de force of a quartet of blissful military officers executing joyous pas de deux in *Munro*.

Meanwhile, with a caution he hadn't

felt the need to exercise in the army, Feiffer began to dip his toes into the postwar New York scene. The epicenter for aspiring artists and writers and cultural hangers-on in the mid-1950s was Greenwich Village, but the Village intimidated him. "The idea of living there depressed me," he says. "It scared me off because I felt less able to compete with all those name-dropping, fast-talking guys, all infinitely better with women than I was."

Fortunately, Feiffer knew one of those fast-talking guys, a gregarious friend from his army days, Jim Ellison, to whose weekend parties an unending stream of brilliant and luscious

college girls seemed to miraculously find their way—not a one of whom Feiffer could summon the nerve to kiss, date, or "lay" unless he was drunk *and* they had just been dumped by one of his pals. A washout as a stud, Feiffer was an opportunistic and gifted second banana, he recalls in his memoir, "a parody of Cyrano, laying down the witty, arty, quasi-literary, semicultured soundtrack that put one Roxane after another in the mood to get laid by Mike or Terry. After the third or fourth tryst, when one or the other dumped the girl, it was I, their hanger-on, whom she sought out for counsel. *What happened?* she needed to know. *What could be done about it?* What we did about it was go to bed."

This prolonged romantic education eventually paid off, not just in flesh-and-blood women to have sex with, but in anthropological field notes. Feiffer claims to rarely notice his physical surroundings—he can't tell you what color shirt he's got on without checking a sleeve—but when it came to the distortions of love, lust, and friendship between the sexes in postwar America, he seems to have missed no signal and wasted no encounter, committing to memory all the vanity, self-delusion, and self-doubt of the male species and the self-abnegation, misplaced trust, and false hopes of the female. He would mine this repository for years.

Feiffer was simultaneously absorbing the paranoia and political doublespeak of the Cold War, the labored cool of middle-class hipsters, the pompous self-satisfaction of the powerful, and the formulations of Freud that percolated into psychobabble for the masses. And when Feiffer wasn't hanging out or looking for sex, he was reading, a pleasure he came to late and hungry. He tore through works by his contemporaries (Norman Mailer, J. D. Salinger, Saul Bellow, Bernard Malamud), gobbled up history (he recalls reading Matthew Josephson's *The Robber Barons*, which had been published when he was five), and dipped into Erich Fromm, whose titles—*Man for Himself* and *The Sane Society*—could easily be mistaken for punch lines in future Feiffer panels.

"What was interesting about the fifties," Feiffer says, "is that while we thought of it as a repressive time, and a suffocating time, we failed to acknowledge, even though we were in the middle of it, that it was also a time when these terribly exciting things were going on. Basically we were redefining and rewriting the American sensibility. Not only from its pre–World War II days, but basically from the early years of the twentieth century. The whole culture was in transition. Elvis was part of that, and rock and roll was part of that."

As it happened, Feiffer was never an Elvis fan—though he would make wonderful use

of the King's singular contortions in the *Village Voice* strip—but he was wild for television from the start and displays the same total recall of shows he saw sixty years ago, and their sequence in the weekly lineup, as he does of comics. Dave and Rhoda Feiffer had bought an early television while Jules was still living at home, which is where he first saw, and fell in love with, Sid Caesar on *Your Show of Shows*, which debuted in February 1950. Feiffer bought his first TV soon after he moved out on his own, in order to watch the Army-McCarthy hearings, which were broadcast live between April and June 1954.

TOP Sketches "from the desk of Jules Feiffer," early 1950s.

ABOVE Spot illustration used to solicit work from potential commercial clients, c. 1953.

ABOVE Sketch, early 1950s.

OPPOSITE The first two strips and the sixth from "Dopple," a proposed daily comic from 1953 Feiffer peddled to syndicates without success while doing short stints in commercial studios, 1953. Six strips were finished and another eighteen were penciled. According to Robert Boyd in his preface to *Feiffer: The Collected Works Volume 2*, "the Dopples are an Irish-American couple whom Feiffer created as a cross between Sean O'Casey's *Juno and the Paycock* and Mr. and Mrs. Micawber in *David Copperfield*. This eccentric pair set off to prove that the world is flat and succeeded. 'Dopple' was too unconventional for the comics page, and only Publishers Syndicate expressed any interest. Feiffer relates that they told him 'Dopple' was 'very promising, if only I would change it entirely and make it like everything else.'"

"At that time, there were still these live, hour-long anthology shows on Sunday and Monday nights. *Studio One* on Monday was where they originally ran Reginald Rose's play *Twelve Angry Men*, with Robert Cummings playing the Henry Fonda part. He was brilliant, as was Edward Arnold.

"These were powerful, powerful shows at the time—not that they were great writing, but because the climate was so oppressive that it was like being in the Soviet Union and seeing anything that went against the government diktat. That's what these were like.

"Rose wrote political allegories. He couldn't say anything about race, so he did something that was about race but wasn't, called *Thunder on Sycamore Street*." As originally written, the story was about a white family driving out a black family that had moved onto the block, but *Studio One* vetoed it for fear of losing Southern audiences and changed the targeted family to an ex-convict's. "It was at the height of McCarthyism, the blacklist was rampant, and to turn the TV on Monday night and see where this program was going was so breathtakingly exciting, I called everybody I knew to tell them to watch it."

It was a fresh lesson in coded politics, which Feiffer would never view as limited to the fifties. The fifties just happened to be when

he tuned in to it as an adult. His reading of the period in retrospect is that both politically and culturally the fifties were the incubator of the explosions to come.

"There was all this stuff just bubbling beneath the surface that hadn't exploded yet— abstract expressionism, poetry, music. When we came to the sixties, it just dominated. The same thing with Hollywood movies. In the fifties there were bland and boring post-blacklist movies. But all that set the stage for *Bonnie and Clyde* and *The Graduate* and all the things that later exploded."

There was little hint of these elevated preoccupations in the two commercial strips Feiffer came up with soon after his discharge. "Dopple," centered on a scattered character with a "world is flat" obsession, was judged too unconventional for a daily or weekly comics page by most of the syndicates that he shopped it to. In a preview of the kind of perverse reactions his work would continue to spark long after he had made it big, one syndicate, Feiffer remembers, called "Dopple" "very promising"— "if only I would change it entirely and make it like everything else."

On the rebound, Feiffer sketched out a strip of the kind he figured syndicates were interested in. The double whammy of Fredric Wertham's *Seduction of the Innocent* and the 1954 hearings of the Senate Subcommittee on

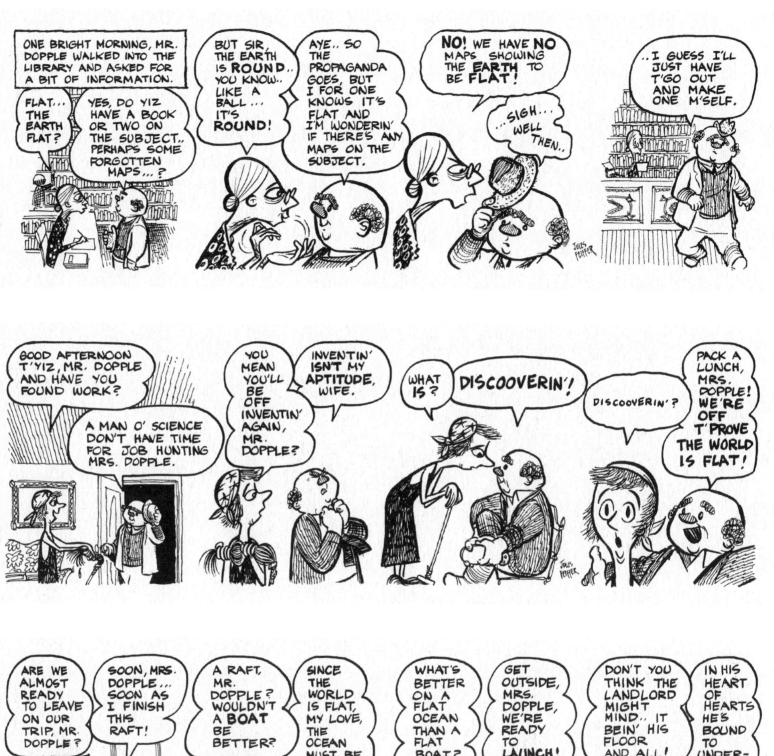

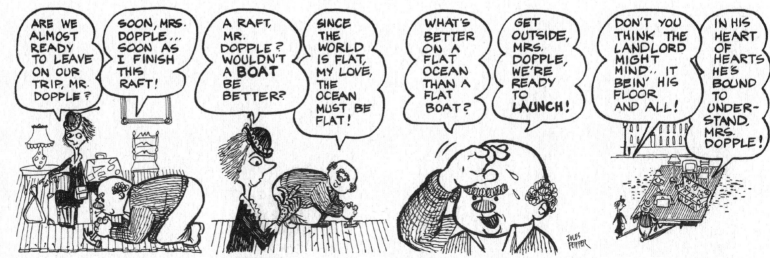

Then, one day, y'realize...
WHAT HAVE YOU DONE
IN LIFE? Almost
five years old, and
WHERE ARE YOU?

The antepenultimate panel from "Natalie," a daily comic strip Feiffer started and dropped after he roughed out six panels in pencil, 1954. Robert Boyd describes "Natalie" as "Feiffer's attempt to make the strip that Publishers Syndicate wanted. Gone is the fantasy, the ethnicity, the innovative panel design, and the continuity of 'Dopple.' Gone too was his desire to do the strip."

Juvenile Delinquency had lowered the boom on comics as effectively as Joe McCarthy had scattered the Left, and syndicates were scrambling for wholesome material to suit the Comics Code they had voluntarily imposed on themselves. Feiffer's candidate was a strip about a ten-year-old girl named Natalie, but his heart and his imagination were not in it, and he threw in the towel after two pages. The one trace of bona fide Feiffer in the strip suggests what was on his mind, though. "Ever notice how YOUTH slowly crumbles away?" asks Natalie's little brother, head in hands. "One time y'get a kick out of playin' in the mud, swallowin' dirt, cuttin' up worms . . . Then, one day, y'realize . . . WHAT HAVE YOU DONE IN LIFE? Almost five years old, and WHERE ARE YOU?"

After four years of listening to art directors' second, third, and tenth guesses about the jut of a line or the curl of an "e" in sketches that he didn't care about, and bombing out with the work he did care about, Feiffer was starting to feel desperate. He was twenty-seven. He was supposed to be famous by now. Instead, he was peddling his wares just as his mother did, "a door-to-door salesman hoping somebody would fall for my work, and fall for my line. By this time I was so used to rejection, I didn't expect very much."

Still, he continued to make the rounds of publishers with *Munro* and two other cartoon narratives he had worked up. One, about conformity, was called *Sick Sick Sick*; the other, "Boom," was about the bomb. Feiffer managed to get in the door at some of the best publishing houses in New York—Simon & Schuster, Random House, Harper's, Henry Holt, Crown—only to hear the same line from all of them: There is no market for comic books for grownups by somebody no one's ever heard of. Come back when you're famous.

"The thing that drove me crazy was that editors welcomed me. They were friendly. They took me to lunch. They were fans of mine. They just weren't going to publish me."

One of the first to show an interest in Feiffer's work was Paul Jensen, "a sweet guy at Simon & Schuster. This was when S&S was publishing books of cartoons. Bill Cole, a freelance editor and poet who knew just about everyone in publishing and was very interested in the cartoon scene, became a fan, loved *Munro*, and brought it to Paul Jensen. Paul called me up and asked me to come in, and we met. His job was to find people like me. He courted me. We had wonderful conversations. He just wasn't going to publish me."

What Jensen did do was send him along to a young editor at Harper's, Ursula Nordstrom, who would later become a legendary children's book editor. Nordstrom couldn't figure out how to publish Feiffer either, but she introduced

Once...

Boom

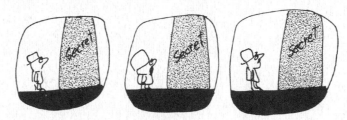

the surface of the earth looked like this... and in some places like this and it was, of course, all due to the Bomb tests.

Almost every country had its own Bomb.

If you've got a Bomb you're supposed to test it.

Like to see if it works.

"Boom," Feiffer's nuclear satire, took almost as long as *Munro* to find a publisher. It originally ran as a four-page feature in the *Village Voice* as part of their third-anniversary celebration on October 29, 1958, and appeared between hard covers in 1959 in the collection *Passionella and Other Stories*. Shown here are the first five panels (right) and the last panel (following page).

In his introduction to *Feiffer: The Collected Works Volume* 3 in 1992, Robert Boyd calls "Boom" "the most savagely political" of Feiffer's longer pieces. "The *Voice* was willing to publish [his] most politically barbed (and thus risky) cartoons. Feiffer said of "Boom" that 'the Atomic Energy Commission was putting out constant communiques to the public saying there was no harm done to the atmosphere' by atomic bomb tests. 'People like I. F. Stone in his *Weekly* and Paul Jacobs in the *Reporter* were telling me just the opposite, and I chose to believe them and I was right.'"

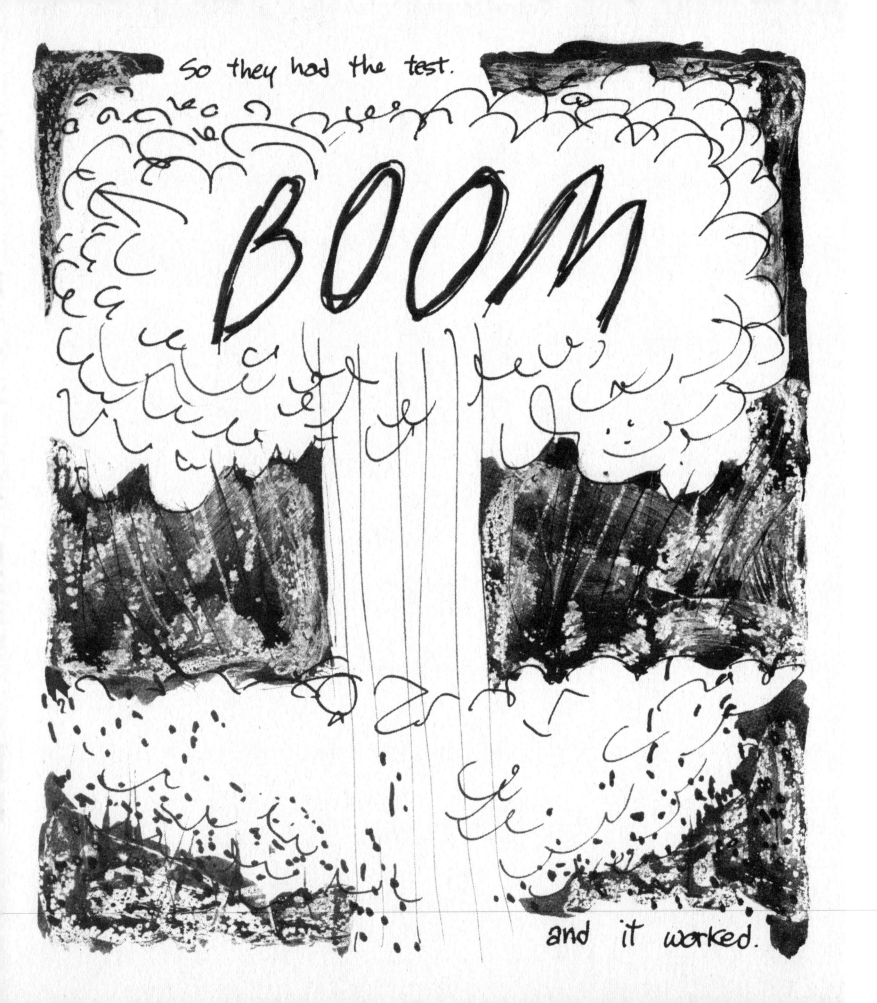

RIGHT In the early 1950s, while unsuccessfully peddling his wares to New York publishers, Feiffer became friends with author Ruth Krauss (*A Hole Is to Dig*) and her husband, Crockett Johnson, whose newspaper strip, *Barnaby*, Jules admired. Prior to Johnson releasing his now-classic children's book *Harold and the Purple Crayon* in 1955, the two men collaborated on an untitled comic written by Johnson, for which Feiffer did these six strips of art. The comic never saw the light of day, but Feiffer recalls, "Johnson was floundering about at the time we worked together, looking for a new project to interest him. Neither he nor I felt our collaboration held much promise. I think we were both relieved to put it behind us."

ABOVE Feiffer, in his early to mid-twenties, poised at his drafting table.

OPPOSITE During the 1950s, Feiffer regularly tried on different styles in search of his line. This one shows the influence of *New Yorker* regulars Carl Rose and Sam Cobean. "I believe this was submitted to the *New Yorker*, who rejected it," Feiffer recalls. "They were rejecting me for years, before I became enough of an institution to reject them. We were never right for each other."

him to Maurice Sendak because "she thought I should get to know somebody who was doing similar work. Maurice had just done a lot of things with Ruth Krauss, including the classic *A Hole Is to Dig*. So then I became friendly with Ruth and her husband, Crockett Johnson, who did the brilliant, sophisticated comic strip *Barnaby*, and later on, the famous picture book classic *Harold and the Purple Crayon*"—part of the daisy chain of connections that would continue to widen his circle of artist friends—but still no sale.

"I never considered the politics of it at the time, but it might well have been the atmosphere of repression because of McCarthyism. *Munro* was clearly antiauthority and antimilitary, at a time when the word 'peace' was considered a Communist term.

"I think what happened is that these editors, whose job it was to play the game, were very smart and had very different views than the people they worked for. And when they found someone they thought was original and new, while they couldn't publish him because the publishers wouldn't allow it, they would do everything else they could to get him around and encourage him. And so I became a kind of favorite underground boy who was shipped from editor to editor."

It is characteristic of Feiffer's lifelong certainty about eventually making his mark that he took away from two straight years of rejection an even deeper conviction that he would prevail. "All of these people had some positions of power," he says. "If they could have published me, they would have. And they made it clear that I *was* going to be published. That it was not my inflated ego alone that made me think I was on my way. All the signs—outside of the official rejection that came from the powers that be—every other sign was *whoopee*, you're going to meet new people who will love you. You're on to something."

In fact, his time watching editors turn over his sample pages on cluttered desks was not wasted. In office after office, Feiffer noticed copies of a weekly newspaper he'd seen nowhere else, called the *Village Voice*, which had been launched on October 26, 1955, by a somewhat unlikely trio of youngish New Yorkers with no prior newspaper experience: Edwin Fancher, Daniel Wolf, and Norman Mailer. After reading a few issues, Feiffer sized it up as the place most likely to be interested in running the work of a brilliant unknown. He understood the *Voice* didn't pay its contributors, but working for nothing was one of his specialties.

So I said to him, "now you listen to me. Just what kind of a girl do you think I am. If you're the kind of boy who thinks I'm that kind of girl who does that kind of thing." So he says, "HAPPY GRADUATION." So I say, "Get your hand away from there. I don't know where you get your nerve. You certainly think a lot of yourself. Well I can tell you now that I'm not the kind of girl you're used to taking out. I don't even know you and you're already ... You heard me, get your hand " So he says, "HAPPY GRADUATION." So I say, "Say what kind of a girl do you think I am anyway? So he says, "HAPPY GRADUATION." So I say, "You don't mean HAPPY GRADUATION. You just say that, but what you mean is something else and that something else certainly is not HAPPY GRADUATION. I know your kind. Yesterday you were telling some girl HAPPY BIRTHDAY and the day before you were telling another girl MERRY St. SWITHINS EVE and now you say to me HAPPY GRADUATION. Sure you talk an awful lot but do you mean HAPPY GRADUATION when you say HAPPY GRADUATION? Do you want me for my mind. Fat chance. I know what you want me for and if you think I'm ... Did you hear what I said about your hand ..." So he says, "You're different than all the others, HAPPY GRADUATION." So I say HAPPY GRADUATION yourself. So he says, "HAPPY GRADUATION right back at you." So I say "One more HAPPY GRADU what are you doing with those lights? ATION and I'll choke. So he says "HAPPY GRADUATION." So I say "Well you can stay in here in the dark if you want to but I'm going out in the for the last time get your hands off my" So he says "HAPPY GRADUATION, HAPPY GRADUATION, HAPPY GRADUATION, HAPPY GRADUATION" So here I am.

OPPOSITE Feiffer's elaborate family greeting cards continued long after he left home. A two-sided birthday offering to his younger sister, Alice, from the late 1950s, is styled like an Osborn cartoon with a touch of Steig.

RIGHT This unpublished, undated cartoon pairs UPA artwork with *Voice*-style patter.

1

Paulie's Mirror

for a difficult to find Campbell Caley
Tom Feeney

Ruth Shoulder

Paulie had a very marvelous mirror

2

In it he could see all kinds of things. He could see half people...

... or whole people. Standing up or leaning people...

3

People with funny faces...

4

He could see murder mysteries like in the movies where first you only see a hand...

5

... and finally the head of a horrible ghoulish werewolfeah monster who yelled "Whooee-goo - I got cha!"

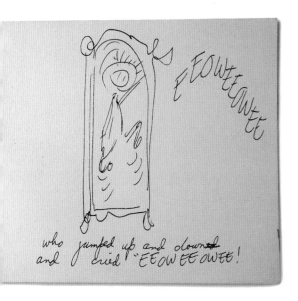

who jumped up and down
and cried "EE OW EE OWEE!"

And sometimes he'd see
just a little dot that
he could hide with his
hand..

But when he walked closer the
dot got bigger and became a
boy and soon it grew very
big indeed.

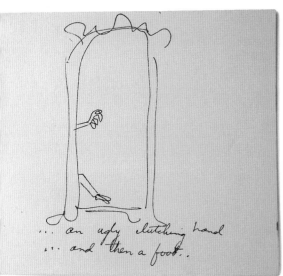

... an ugly clutching hand
... and then a foot..

And Paulie would see himself and
he'd say "Hello me"
But suddenly it wouldn't be him.
Instead it was a mean and
ferocious prize fighter

Paulie would swing his fists
and yell "How do you like that
one, you bully" and then he'd go
"Smash smash" and that would be the
fist sound and then he'd go "Uhhh
OOh, Aigh and that would be the bully
being beaten

Sometimes Paulie would look in
his mirror and only see the
top of a head—

He'd raise his hand in triumph
and bow modestly to the crowd
(filled with movie stars and
sports personalities)

Roughs for "Paulie's Mirror,"
an unpublished children's book,
mid-1950s.

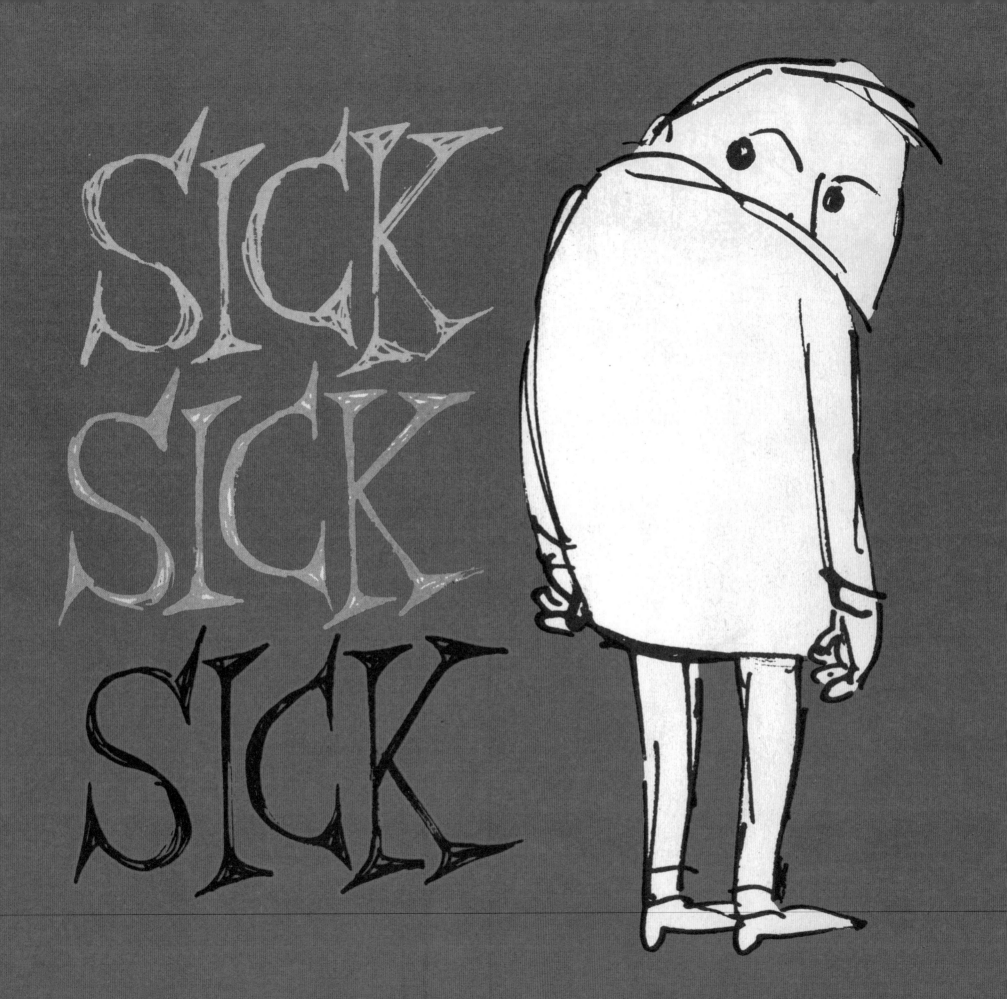

Sick Sick Sick

It was a comic strip for grown-ups . . . a vehicle for trenchant soliloquies, and dialogues about life, power, hypocrisy, violence, and despair.

HARRY KATZ, *former head curator in the Prints and Photographs Division at the Library of Congress*

One day I looked up from my desk," recalls Jerry Tallmer, one of the *Village Voice*'s first editors, "and there was a weedy young man there, sort of silent. He had a big portfolio under his arm. He may have opened it, or I may have said, 'What have you got there?' I took one look at three or four of his ideas and said, 'Let me show this to Dan Wolf.' Dan went crazy. He said, 'We gotta have him right away.' We knew this was something quite different."

"The paper was about a year old when Jules turned up," says Edwin Fancher, the *Voice*'s original publisher. "He said, 'Look—I've done these, I've tried to peddle them all over town, but nobody seems to be interested. I'd be happy to have you publish them.' My recollection is, his condition was to publish every week. So we said fine. We liked them very much, we took them, and they ran every week."

It was really that simple—so simple, in fact, that at first Feiffer couldn't take it in. As if he were back on Eisner's doorstep, he asked them what *they* wanted him to do, and got the answer he'd been waiting to hear for years. "They said I could do what I wanted."

Reflecting the concerns of its left-leaning, culturally alert readership, the *Voice* was at once parochial and wide-ranging in its interests. In his introduction to *The Village Voice Reader*, published in 1962 by Doubleday & Company, Daniel Wolf wrote that the *Voice* came into existence "at a time when the vulgarities of McCarthyism had withered the possibilities of true dialogue

Detail from the cover of *Sick, Sick, Sick,* 1958.

between people. The best minds in America—radical and conservative—were repeating themselves. Practically no one was testing reality, and General Eisenhower was our leader. . . . It was a philosophical position. We wanted to jam the gears of creeping automatism."

The *Voice* did a great job of being contrary from the start, but it was never a radical paper. "Ideology bored us," says Edwin Fancher. "Not simply the Communist line but the anti-Communist line, too." Nor, despite the best efforts of the paper's "silent" cofounder, Norman Mailer, who wrote a column called "The Hip and the Square" for four months in 1956, did it ever achieve the apotheosis of "hip" that Mailer envisioned. It wasn't an anarchist paper either, though one might have suspected as much from the way it was run. The paper was meant to make money, and eventually it did, but what it did most surefootedly, for all the chaos and unpaid bills, was find new voices and give them a forum. In exchange for the chance to be published, their copy by and large left untouched, writers were willing to go unpaid for years—and were.

There were essentially two editors. Daniel Wolf, forty when the *Voice* was launched, was a native New Yorker (Upper West Side) and World War II veteran who never completed his degree in psychology and had a sufficiently slender professional track record—he

had written articles on philosophy for the *Columbia Encyclopedia* and briefly worked for the Turkish information office—to prove the merit of the *Voice*'s founding mission: "to demolish the notion that one needs to be a professional to accomplish something in a field as purportedly technical as journalism." The *Voice*'s junior editor, who almost single-handedly propelled the paper into print each week, was Jerry Tallmer, a former editor of the Dartmouth College paper who doubled as the *Voice*'s theater critic. (He would launch the Obie Awards for off-Broadway and off-off-Broadway plays with Edwin Fancher in the paper's second year.)

No money changed hands, and none

would for another eight years, but Feiffer's official debut in the paper was announced with a flourish in a small box on the front page of the October 24, 1956, issue:

> The best birthday present we've had for our first anniversary is the new cartoon series *Sick Sick Sick*, which starts today on this page. Its creator, Jules Feiffer, is twenty-seven and a graduate of Pratt, and has been an ad-layout man and book illustrator since leaving the army.

The cartoon panel appeared on the front page as well, running across four columns. In fact, the *Voice* had already published three or

four Feiffer cartoons without fanfare in the weeks leading up to his official debut. "They were single-panel cartoons, like a *New Yorker* panel," Feiffer says. "They were political mostly. And they were more abstract—more Steigish, like *The Agony in the Kindergarten* or *The Lonely Ones*. People with three-sided heads and political captions. But not very successful."

The unannounced warm-ups were Feiffer's idea, meant to secure his place while he figured out what he really wanted to do. "The *Voice*, having seen the work I'd been trying to sell to publishers, said they'd print anything I did. I was the one who basically started to censor myself. Here I was offered all of this freedom, and the last thing I seemed to be willing to do was take advantage of it. Though that is what I had been yearning for. An interesting ambivalence. When publishers were saying no, I could be out-front and defiant. 'I'll show you.' And when they said yes, my response was 'Oh, who, me? Little me? Oh, no, you don't really want me to do that.'

"But after three weeks or so, I was so dissatisfied and pissed off at my refusal to use this opportunity that I began to do what I had meant to do from the beginning, which was to break down *Sick Sick Sick*, the franchise story about conformity, into six- and eight-panel strips, with the idea that it would become a

continuity strip week after week. And having done a bit of that, I thought, no, this is going to be too weird and too far-out for the reader, so I did some introductory strips to show where I was going with it, and the first one was the guy who's going to the bus stop and talks about having a stomachache.

"That turned out to be so successful that the 'introductory' strips never ended, and I never got to serializing *Munro* either, which probably would have been a very bad idea anyway. So I just lucked into the right approach, but with a great deal of timidity at the very beginning."

Doing the strip seldom took Feiffer more than a day. "I'd try to write it the night before, so I could look at the script the next day and see whether it was any good or not. Sometimes I was able to do that, sometimes not. The drawing never took more than two or three hours, laying it out first in pencil, then inking it. That was the most difficult part: finding a presentable style when I didn't think I had one."

No one casually leafing through the *Voice* that fall would have reason to think that the paper had lined up a regular cartoonist, so little did a given week's art resemble the art that came before it. The ink line went from thick to thin and back to thick again. Sometimes it was scratchy. Sometimes it wobbled. One week there were six panels to a strip, the next week eight, then nine, then seven, then

OPPOSITE Original magazine art, early 1960s.

ABOVE Movie poster for a British comedy titled *Brothers in Law*, starring Richard Attenborough, released in the United States by Continental Distributing Inc. in August 1957. A journeyman job for Feiffer, who had been at the *Voice* for nearly a year.

In Feiffer's first comic strip for the *Village Voice,* on October 24, 1956, he sent up the world of suits he'd been stranded in since leaving the army. The drawing style was intentionally primitive; the complaint, twentieth-century primal.

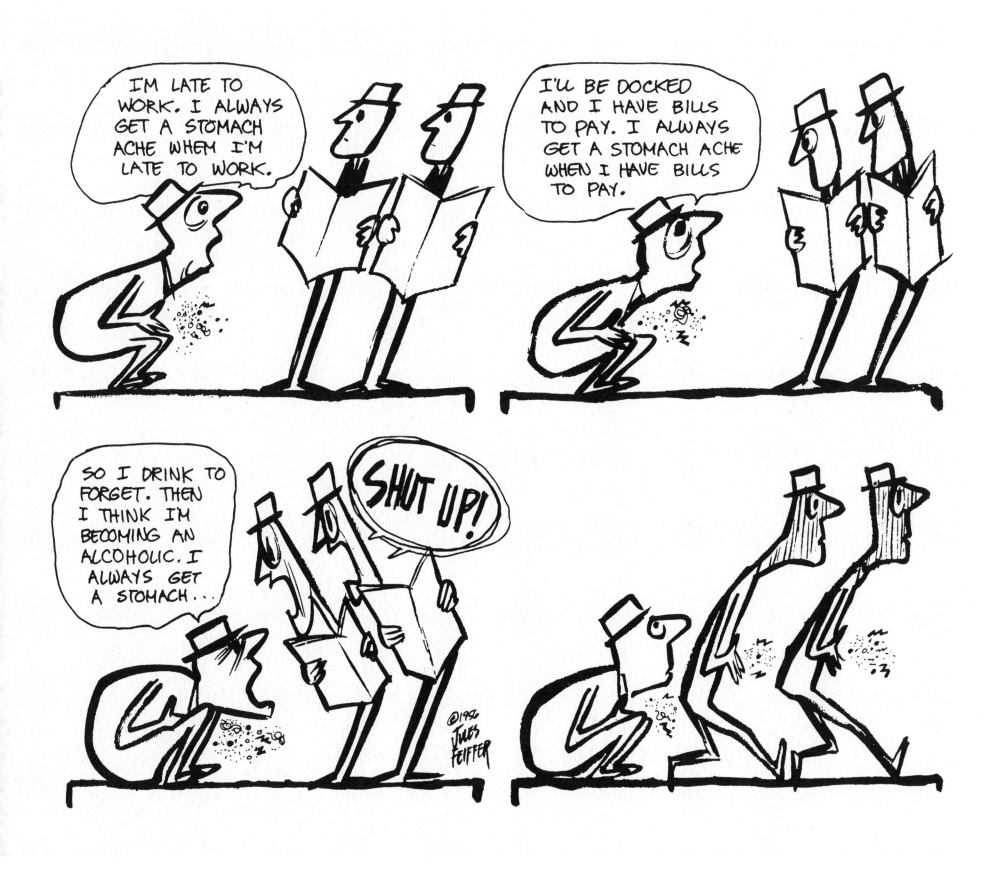

eight again, then six. The first week, the panels were defined by thick lines drawn beneath the characters' feet, as if they were standing on a loading dock; the next week they were set off with air space, the next by fine storyboard lines. The week after *that*, Feiffer tried something completely different. In subsequent weeks the words were sometimes set inside balloons, sometimes not. No characters repeat; no visual hooks register except that all the women have long necks and the men have none. The variety of styles suggests that an entire team of artists was being auditioned for the job in succession. Some seem to be under the influence of William Steig; others appear to be admirers of the French artist André François.

The author's voice, however, is singular. Anxiety, self-doubt, self-pity, self-delusion, disillusion, shame, one-upmanship, neediness, deception, false love, hollow sex, political sham—the touchstones and sore spots of the next forty years of Feiffer panels—tap dance across the stage like chorus girls. Years' worth of stored-up observations were now being funneled into a strict format.

"The strips were essentially monologues or duologues," Feiffer says, "because the format of the *Voice* being what it was, a third of a page, where I could at best get ten or twelve panels in, you have to figure out what works best in those panels, and the narrative was not going to do it—not enough for me, anyway. So I figured out these dialogues of one kind or another, which was something I'd never done before."

"Every really great comics artist has totally reinvented the medium," says Art Spiegelman. "It's a hybrid and a mutt to begin with, which is part of what makes it so difficult and challenging and so exciting to work in—because you can't be equally good at everything. You have to weave together your own strengths and weaknesses to make whatever you want to express be expressed well.

"Jules totally reinvented comics. There's almost no context for what he was doing in his day, starting out with absolute respect and love for the wonderful, dopey comics of his childhood. He was aspiring to that tradition, and fortunately for him and for everybody who's been lucky enough to have access to Jules's work, he wasn't that *good* at it. He just couldn't do that beautiful feathering, or get that Alex Raymond elegance and grace. He had to find his own way.

"That's what made Jules so significant and a real role model. He had to reinvent comics to take advantage of his subjectivity, his—I hesitate to use the word 'intellectual,' because that takes you into the zone of the stuffy—but his intellectual side."

However much Feiffer felt he had yet to hit his stride, the *Voice* printed everything he turned in. Earlier in the year, he had fled his apartment on Norfolk Street in the East Village, which he found irredeemably grim, and moved out to Brooklyn Heights, where a number of artists he knew were living, including David Levine, who was not just Brooklyn born and bred but, as Levine put it, "a separatist. I'm for cutting the ties of the bridge. It's got its special product, its language—all the traits that make up a country. Why not?"

"David was the only one of the group of painters I knew back then who had an ambition to be a cartoonist as well," says Feiffer. "He had a wide knowledge of comics. Long before the *New York Review of Books* existed [Levine did caricatures for the *Review* from shortly after it was founded in 1963 until 2008, the year before he died], he was doing fine pen-and-ink drawings, which evolved into the style he became famous for. When I met him, he was doing greeting-card illustrations. Within five years he was doing spots for *Esquire*."

Levine had also attended Pratt, though briefly, and he shared Feiffer's affection for Sheldon Mayer's boy cartoonist Scribbly, "which was high motivation for any of us who became comics artists."

Levine was also a big Eisner fan. "I thought Eisner was the most wonderful thing I'd ever seen," he said. "He saw the crease in the crunch of your clothing, and he kept it open, rather than being a dark spot. He had a way of drawing the shape of the face with cross-hatching, and he had a filmic approach, the opening page of his work was always a blockbuster page noire. A huge number of people were imitating him, people who weren't up to it."

Levine recalled liking Feiffer's work on *Clifford*. "I think it was better than *Peanuts*."

The Heights were a short subway ride from the *Voice*'s office in Greenwich Village, where Feiffer delivered his strip in person for years, taking the subway from Clark Street in Brooklyn to Christopher Street in the Village every Sunday and walking a couple of blocks east to the *Voice* office at 22 Greenwich Street.

"Our office was a ratty little place—hectic, full of old ratty typewriters," says Jerry Tallmer. "It was one flight up, across the street from the Women's House of Detention, next door to Sutter's Bakery. We had one fair-size room in front and a tiny little room behind—Ed and Dan's executive office. They had their desks there.

"I worked all day on Sundays. I'd be sitting there alone, copyreading one-inch classified ads, everything. Jules would show up in the empty office, hand me the thing, and go home. He never got paid a penny. I think he was really quite annoyed. He thought it was

One of the many artists Feiffer became close to when he moved to Brooklyn Heights was David Levine, a devoted native of the borough, a painter, and the only one of the group who shared Jules's ambition to become a cartoonist. His distinctive pen-and-ink caricatures of writers, politicians, artists, and scoundrels appeared regularly in the *New York Review of Books* from 1963 (shortly after the paper was founded) to 2007. His Feiffer as super hero from 1965 is inscribed to Jules "for helping to make it all livable." In a November 2008 profile for *Vanity Fair* a year before Levine's death, Feiffer called his friend "the greatest caricaturist of the last half of the twentieth century."

unfair, and it was unfair, but what the hell? What could we do? We paid nobody anything, including ourselves. That included the contributors. But people started flooding in."

Among the *Voice*'s early contributors were Gilbert Seldes, a onetime New York correspondent for T. S. Eliot's *Criterion*, writing on culture high and low; Nat Hentoff, who got paid to write about jazz for *DownBeat* magazine at the same time he was doing a column for the *Voice* for free; Seymour Krim, a Beat connoisseur and talented essayist; and the very young Millicent Brower, whose "Greenwich Village Girl" and "Those Village Men"—based on "girl-" and man-in-the-street interviews—came closest to capturing the spirit of the time and place that would be Feiffer's main subject.

Q What do you think of the Greenwich Village girl?

A Who knows? That's why they're so interesting.

Q Where would you say Greenwich Village men come from?

A From under a rock.

Q Do you associate Village girls with any particular kind of dress?

A Yes. Toreador pants, flat ballet slippers (if she isn't wearing Murray Space Shoes), a pony tail or a short man-styled hair cut.

Feiffer, in turn, managed to whack a fresh social kneecap every week, from self-absorption and insecurity to the symbiotic

relationship between bullies and the bullied, to Madison Avenue, nailing two of his favorite subjects, the bomb and advertising, with an eight-panel cartoon on November 28, 1956: "'Fallout is good for you' saturation campaign," and in his seventh at bat, on December 5, 1956, the secret shame of fifties intellectuals who had not yet been to Europe.

By then, the strip had been running for a month and a half, and no one involved had any idea whether it was catching on.

"Nobody talked about [Jules's work] much at first," says Edwin Fancher. "It took about a year before people started saying, 'This is a fantastic talent.' But we just loved it." In fact, the "haven't been to Europe" cartoon made a big splash, Feiffer recalls. "It was all over the place. Everybody loved it, and I got enormous feedback."

"He was making fun of himself and the phony-baloney culture of the fifties and early sixties," says Fancher, "tweaking the hypocrisy

Working for nothing at the *Voice*, Feiffer paid the rent by doing commercial work. Sometimes the sentiments expressed in art and commerce seemed interchangeable, as in a 1959 ad for Rose's Lime Juice (opposite). His seventh cartoon, from December 5, 1956 (above), hit a chord with the *Voice*'s readers, firmly landing him on their radar.

of his own milieu. Some of his humor was aimed at the *Village Voice* culture, which was fine with us."

Feiffer had found his place, and his people, at precisely the right moment, just as "one of the giant upward advances in brow in the history of comedy" was getting under way, according to Louis Menand in the *New Yorker* (January 5, 2009).

The style was deadpan, occasionally self-deprecatory, self-mocking, and other-people-mocking, and like mushrooms after a big rain, its practitioners, who had yet to learn of one another's existence, were popping up all over. The new comedy was not joke-based but situation-based, taking off from social mores and politics, playing off power and what was already being called the mass media. Mort Sahl, whose father had worked for the FBI, was appearing on nightclub stages in San Francisco armed with a stack of newspapers from which he riffed on everything from the army to Joe McCarthy's witch hunt, with lines like "The army is replacing the Eisenhower jacket with the McCarthy jacket, with a large flap that goes over the mouth" and "The left wing is made up of Communists, which *Time* magazine points out has a membership of four thousand, three thousand of whom are FBI agents."

In Chicago, Mike Nichols and Elaine May performed deadpan sketches that played off the mundane and the ridiculous, sending up controlling mothers, the funeral business, the power of phone operators to drive an innocent caller mad, and the existential pain of an IRS employee.

Feiffer's humor issued from the same current—a nascent welling up of literary, cultural, and political irreverence that triggered a shift in American sensibilities from buttoned-up to subversive. Feiffer did not invent it, only "lucked into it," he says, but his fierce send-ups of adults, assorted officials, and the received wisdom of the day hit home. He wasn't playing for laughs in his panels, but for squirm and eye-averting unease, and now and then for blood. "I wanted to put the essence of my reader on the page," he wrote in *Backing into Forward*, "to adapt the befuddled, feckless little man of humor as conceived by the great Robert Benchley, to move him out of his genteel, benign, suburban WASP landscape. I wanted to circumcise the sucker and transplant him from the Jazz Age from whence he came to the Age of Anxiety, from Babbittry and Dale Carnegie to Sigmund Freud and characters (like my readers) so busy explaining themselves that they never shut up. I wanted to put out-front the codified communication by which it seemed my entire generation lived our lives,

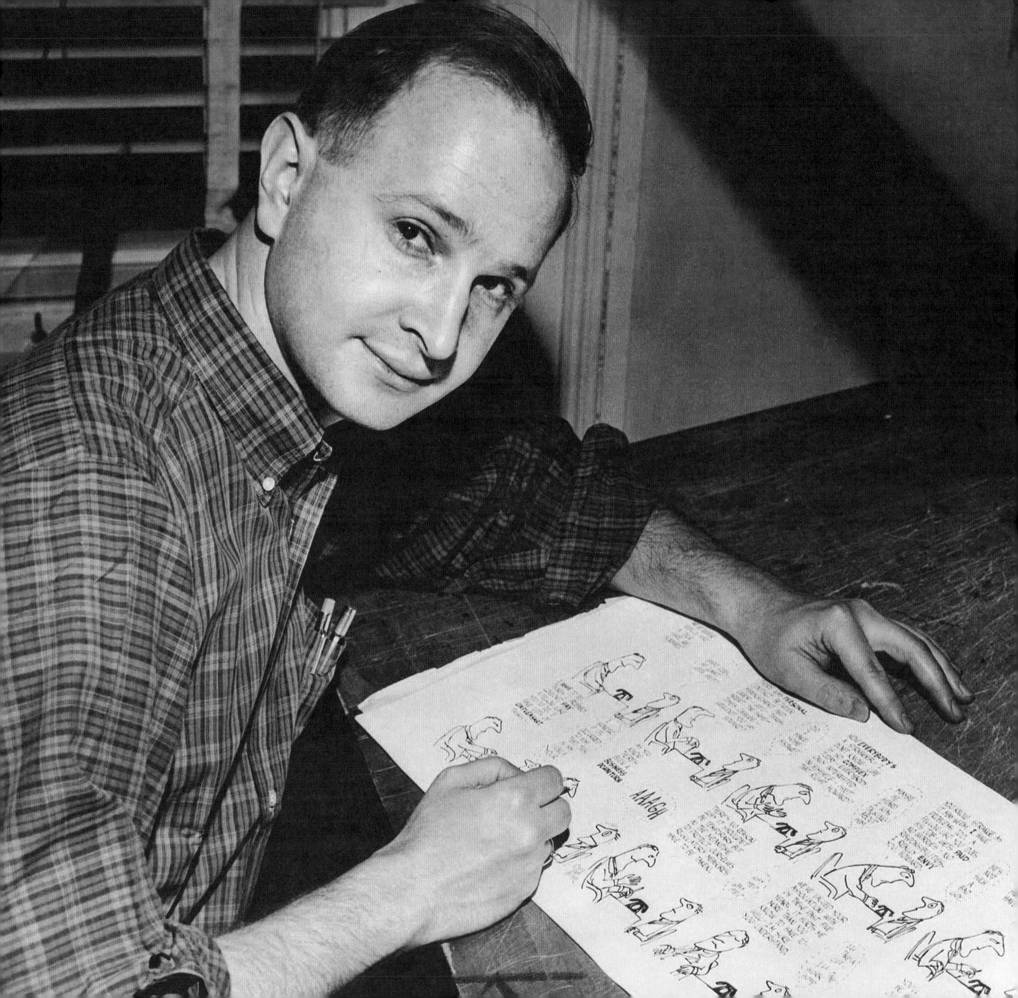

whether it was with family, friends, sex partners, colleagues in the workplace, or simply ourselves when no one was around to lie to."

Mike Nichols thought he first met Feiffer when he and Elaine May opened for Mort Sahl at the Village Vanguard in 1957, though Feiffer's recollection is that he first saw them late one night on the TV show *Omnibus* a year later. Whichever is the case, their reactions to discovering one another dovetailed.

"He was one of the earliest people we hadn't known but who were like us," Nichols said. "Coming upon Jules's work was just like my experience at the University of Chicago, where I looked around me my first day and realized everything was going to be OK. *This will be fine,* I thought. *There are other weirdos.* I'd found my people, which I never had up to then. It was the same when I saw Jules's work."

By early 1957, Feiffer had begun to hear from magazines that paid. Lois Cantor, an editor at *Pageant,* a popular general-interest magazine, commissioned a twenty-eight-page story that ran in the August 1957 issue. Feiffer hated the way it looked, especially his own drawing, but "Passionella," a modern fable about illusion and beauty, would turn out to have a relatively long shelf life. It appeared in book form two years later, published by McGraw-Hill, and was adapted in 1966 for a stage revue called *The*

Apple Tree, directed by Mike Nichols, which has been revived many times over the years.

When *Esquire,* the reigning men's magazine in the 1950s (and Hugh Hefner's former employer and stylistic template, minus the nudes), came calling, Feiffer turned out *The Deluge,* an updating of the biblical story in which Noah's task, to warn the world of the impending flood, required him to navigate modern bureaucracy.

Though magazines paid more than the *Voice*'s zero, the occasional assignment was not enough to pay the rent, even in Brooklyn. Feiffer continued doing short stints at various art outfits until his work at the *Voice* caught the attention of a UPA art director recently hired by CBS, Gene Deitch. Deitch had been brought in to jazz up CBS's recent acquisition, the low-budget animation studio Terrytoons, creators of Mighty Mouse, Heckle and Jeckle, and Dinky Duck, in New Rochelle, just north of the city. Feiffer was one of a handful of bright young talents Deitch brought in, and he actually liked the job, his colleagues, and even the reverse-commute from Brooklyn to Westchester. His first big assignment was to dream up a three-minute feature to run on CBS's *Captain Kangaroo* show, something the creator of *Clifford* should have been able to pull off without breaking a sweat. Feiffer did and he didn't. "Easy Winners" looked a lot like

OPPOSITE AND FOLLOWING TWO PAGES
One of Feiffer's earliest magazine assignments after he made his mark at the *Voice* was *The Deluge,* a three-page retelling of the story of Noah that ran in *Esquire* in October 1958. The tale is set in a 1950s present day, with atomic rainfall replacing the original precipitation, a large cast of bureaucrats, and a fleet of arks—one for every state. The art is pure Feiffer minimalist to match the hero. "Jules does only what he's got to do," says *New Yorker* cartoonist Ed Koren, a friend and a fan. "He's very spare. If he developed a character more—tonally cross-hatching, much more description—it would get in the way of the type. His draftsmanship is in the relationship of his text and his art."

the Deluge by Jules Feiffer

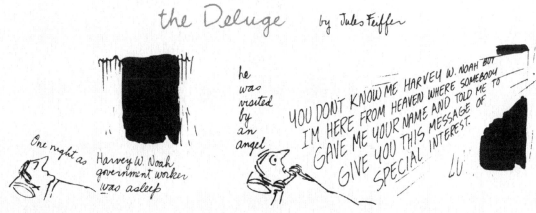

One night as Harvey W. Noah government worker was asleep

he was visited by an angel

YOU DON'T KNOW ME HARVEY W. NOAH BUT I'M HERE FROM HEAVEN WHERE SOMEBODY GAVE ME YOUR NAME AND TOLD ME TO GIVE YOU THIS MESSAGE OF SPECIAL INTEREST.

Whereupon the angel proceeded to explain that soon the Earth would be deluged with 40 days and 40 nights of atomic rainfall, at the end of which period there would be left no living creature on the land or in the sea and that Harvey W. Noah had been chosen to gather from over the world two of every kind of living thing and that he was to build an ark on which these creatures would live and that *they* would be the sole survivors of the deluge.

"What a screwy dream" thought Harvey W. Noah

and he went back to sleep

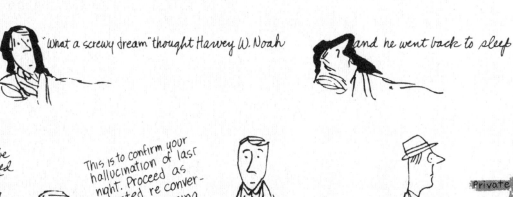

Only to be awakened the next morning by a telegram being slipped under the door.

This is to confirm your hallucination of last night. Proceed as directed re conversation pertaining to deluge etc.

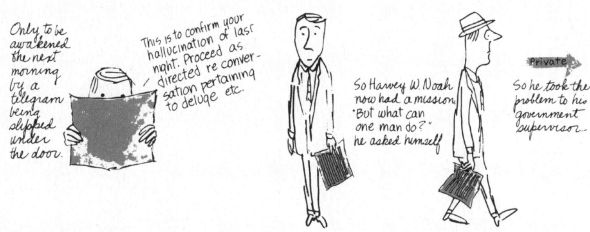

So Harvey W. Noah now had a mission. "But what can one man do?" he asked himself

Private →

So he took the problem to his government supervisor...

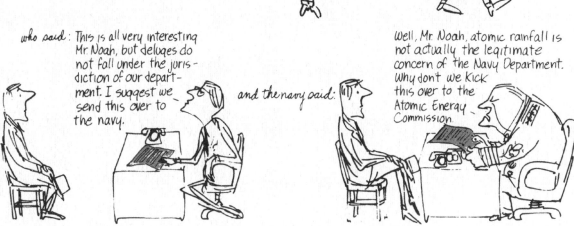

who said: This is all very interesting Mr. Noah, but deluges do not fall under the jurisdiction of our department. I suggest we send this over to the navy.

and the navy said:

Well, Mr. Noah, atomic rainfall is not actually the legitimate concern of the Navy Department. Why don't we kick this over to the Atomic Energy Commission.

And the Atomic Energy Commission said:

Well, frankly, we all think it's a bluff, but anyhow let's take it to the Secretary of State.

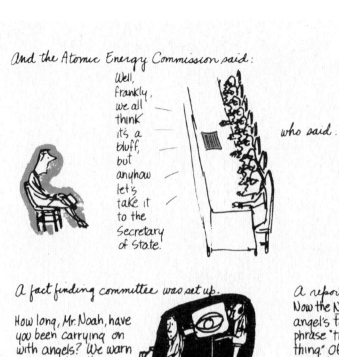

who said:

DOES THIS HEAVEN REALIZE IT'S DEALING WITH THE UNITED STATES GOVERNMENT?

A fact finding committee was set up.

How long, Mr. Noah, have you been carrying on with angels? We warn you, sir, it will go easier with you if you're honest.

A report was issued

Now the Noah version of the angel's telegram uses the phrase "two of every living thing." Of course it is clear from the loose wording that the term "living thing" is here symbolic for MAN, who is, after all, the highest form of living thing. Therefore the telegram should properly read: "two of every kind of man."

A special committee issued a report on the report:

Now two of every kind is obviously an unnecessary and wasteful duplication! We will not use the excuse of dire times to engage in pork barreling! The telegram should be amended to read: "One of each best kind."

A psychological testing group was brought in.

We have developed a test which will enable us to select those applicants most emotionally necessary to the healthful building of a stable society.

And so the selections began.

Now Ah see where the state of Vermont with 6% less population than mah state has two more delegates than the proud and dedicated people who it is mah honor to represent. Ah protest and decry this inequity etc.

The ark came up for discussion. The President gave his opinion —

The question remains is the building of such an ark a matter for the government or is it rather a matter for each sovereign state and in any case will not federal interference clearly rob from the states that old fashioned initiative which has made this country etc.

a *Clifford* spin-off, featuring a pint-size cast of Bronx wiseacres. Feiffer's studio peers loved everything about it. Then it came time to sell the short to the bosses at CBS, in a storyboard presentation for which he was called on to act out the story line, with sound effects. In his memoir, Feiffer recalls that a CBS executive in a pin-striped suit was his audience. The verdict was fatal: "It's closer to Dostoyevsky than it is to Peter Pan." Feiffer quit; Deitch was fired the next year. Their next collaboration would prove more successful.

When the London *Observer* picked up the *Voice* strip in the spring of 1957, Feiffer knew he had arrived. "It was one thing to be in the *Voice* in New York, which had a narrow coterie of bohemian types and literary intellectual types numbering in the thousands at most. The *Observer* was the star literary, journalistic, elitist intellectual newspaper in Britain. So the splash I made in the *Observer* when they picked me up was astonishing, and it turned me into a rock star over there."

The weekly feature, titled simply *Feiffer*, was eponymous proof that he had made it to the big time.

"The word on the strip," Feiffer recalls, "was that it was only going to be successful in the Village. Then only in college papers." He saw it differently. "My assumption always was that my subject matter, outside of local American politics, was about the anxiety of the middle class, and there was a rising middle class all

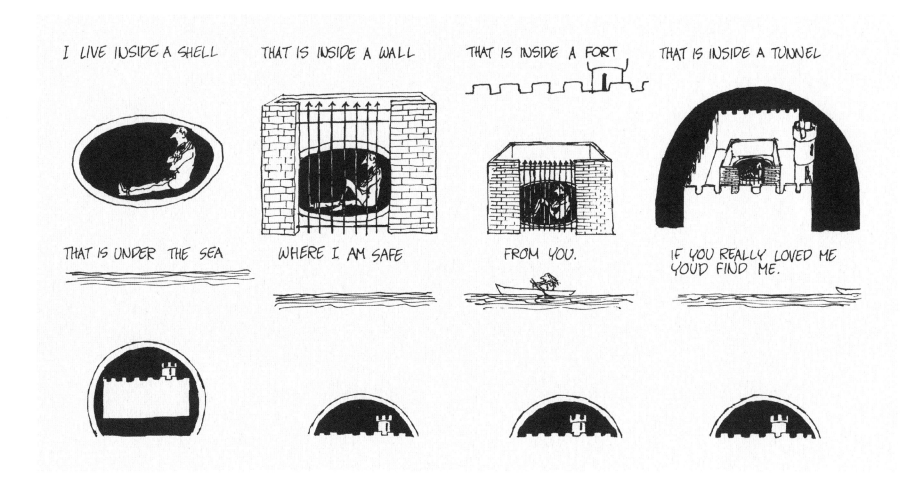

over the world, and essentially it was the same class, with the same anxieties, and I'm talking about this. So why shouldn't it go? Why shouldn't people in other cultures identify with it? They're suffering the same ambivalence, the same doubt, the same sense of repression. Their sex lives are beginning to change—all this stuff was happening everywhere at the same time."

In fact, the mid-1950s saw the first serious and prolonged engagement between European and American intellectuals and artists. Until then, with few exceptions, the United States had always been viewed as the beneficiary of

any transatlantic cultural exchanges. In the aftermath of World War II, Europeans looked to American culture for the first time with hungry eyes.

The 1950s also sounded the first peals of the modern civil rights movement. In May 1954, the Supreme Court declared segregation illegal in *Brown v. Board of Education*. Three years later, in September 1957, nine African American teenagers were barred from entering Little Rock Central High School on the opening day of school by the Arkansas National Guard, which had been ordered up by Governor Orval Faubus. In the lead-up

OPPOSITE *Village Voice,* July 16, 1958.

ABOVE *Village Voice,* reprinted in *Jules Feiffer's America: From Eisenhower to Reagan,* 1982.

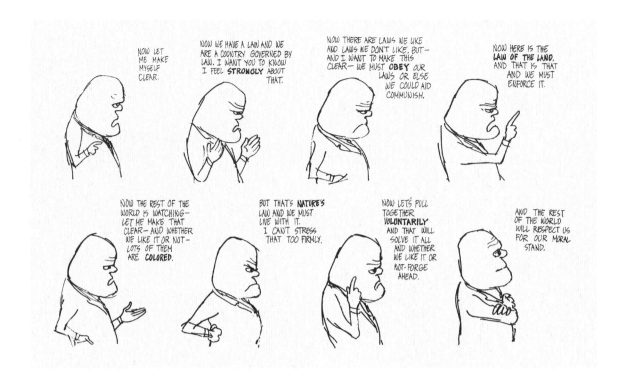

to this long-anticipated test case—the Little Rock Nine, as the students were called, had been handpicked by the local school board—President Dwight Eisenhower had made it clear that he would not use federal troops to enforce desegregation, and his dilatory, hands-off response to the crisis enraged Feiffer and prompted his first serious political cartoon (September 18, 1957).

He was especially offended by Eisenhower's expediency and his canny cover. "I may have been the only person who took the view that Eisenhower's way of speaking to the press was deliberate, that he liked to confuse them. Nobody could figure out what he was saying, or where he stood, on race policy, civil rights, or liberal issues—though on fiscal policy he always made himself perfectly clear.

"This guy was the most successful political general of his time. He knew how to talk to this guy and that guy and get this guy to play ball with that guy. He worked with George Patton, who was a maniac. He worked with Douglas MacArthur. And he got along with everybody. He learned how to deal with everybody by, for one thing, sounding and acting dumber than they were. Let them be brilliant or let them be forceful. He was always musing, and sounding like he hadn't made up his mind, when, in fact, he was slowly moving things around."

On the civil rights issue, Feiffer felt, Eisenhower "was not so much a segregationist because he was a racist; he was a segregationist because he wanted to leave the South alone. Whatever civil rights program there was, was

in the Democratic party, and the Republicans were hoping to pick up the South, which they eventually did."

Feiffer's reading of Eisenhower's folksy obfuscations was an early preview of the skepticism and psychological shrewdness that would characterize his political commentary for the next four decades. His view of politicians was of a piece with his view of corporate chiefs and parents: Whatever people in power tell you, assume they are shaving the truth, hedging it, or lying outright—read between the lines, check your wallet, look behind the curtains.

When it came to the civil rights movement, a subject he took on early, he aimed as many pokes at armchair liberals as he did at politicians. "Feiffer was one of the very first to understand that there were complexities—and even hypocrisies—in some of the attitudes of white liberalism," wrote Bayard Rustin, a crucial player in the civil rights battles of the fifties and sixties, in his foreword to the 1966 collection *Feiffer on Civil Rights*. He not only understood it, he feasted on it, in strip after strip, giving white liberals the same treatment he served up to generals, advertising executives, and smothering parents.

"The white liberals behaved toward blacks the way someone like Mitt Romney behaves toward people who don't have money," Feiffer says. "'They are not like me, but I want them

to believe I'm on their side'—and the white liberals believed they *were* on their side."

Feiffer was equally confident when it came to portraying blacks, who appear in his strips not as helpless victims but as savvy and rational operators, conscious of their power to scare the bejesus out of guilt-ridden whites with a well-timed word or gesture. Through Rustin, Feiffer had met and become friends with James Baldwin, whom he credits with having "rewritten" his "sensibility in terms of race." Feiffer threw himself into the ongoing debate over tactics among blacks as confidently as he had leaped into the first round of civil rights activism. His willingness to tweak civil rights leaders was rare on the left, but if he had played it any differently back then, he says, "I'd have been lying."

"About a year into the *Voice* strip, I began getting soundings from different publishers saying, 'I love what you're doing at the *Voice*. Can you do a collection for us that's something like that, but isn't that? We want something less controversial. You know, less this or that.'

"They were playing it very safe. They wanted the appearance of what I was doing; they just didn't want the content. It pissed me off, but I understood at the time that if I just outwait them, somebody will come along who wants to put these *Voice* cartoons between covers, and that's how I will first

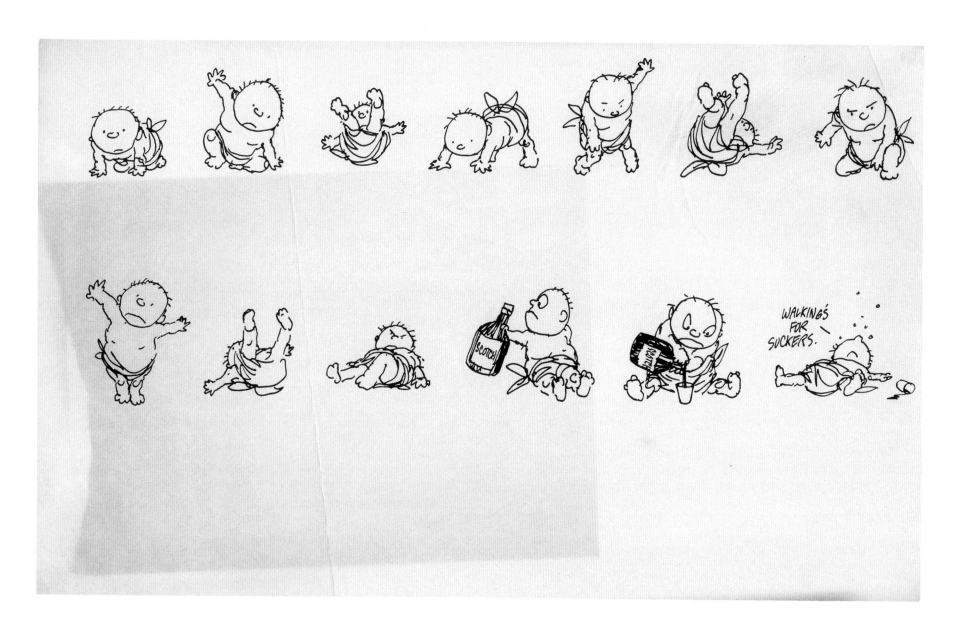

Feiffer's work was all over the lot yet all of a piece, like jazz, following no discernible pattern but finding a rhythm.

ABOVE Original art for the *Village Voice*, late 1960s.

OPPOSITE AND FOLLOWING PAGE Sketches for *Voice* strips, late 1950s. When working on a panel, Feiffer always began with the words, sketching out the dialogue or a soliloquy, and then finding his characters.

appear in print. Not in some adulterated form, because then what was the point of this whole exercise?

"Eventually, McGraw-Hill came along, and they could not have been nicer. They had just begun a trade book division, because they'd been strictly textbooks, and they were out to change their image. They said, 'We will publish what you want to publish.' They weren't

necessarily very savvy. In fact, they were pretty square as publishers. But the hip ones didn't want to publish me."

Sick, Sick, Sick, a selection drawn from the first year and a half of the strip, appeared between hard covers in April 1958, followed quickly by a softcover edition, sales of which took off at a pace that the *New York Times* would describe a few months later as a "gallop."

Who does your hair?
Maurice. Don't you love it?

I love it. I use Claude but he gives much too severe a cut.
Oh, I don't agree! It's very becoming! Mm, what smashing cologne!

It's Chiant by Count Manfred. Don't you love it?
I love it. May I sample?

Be my guest. I can't take my eyes off your miniskirt.
Don't you love it? I got it off the rack at Antoines. Want to try it on?

Well it's a little radical for me this season. Perhaps next season...

My dear
Radical! What ever do you mean?

I'm a fellow.

white shift

Groovy Groovy

1 { You know what it is?
{ A crisis of identity.

2 These kids today — they dont know
who they are.

3 They've been raised in an affluent society
& there are no more rules.

4 So when they're challenged by ~~problems~~ problems
they cant face up to it like our
generation.

5 <u>That's why they withdraw into drugs.</u>
6 <u>Don't you agree?</u>

Selfishness.
Me. Me. Me. Nobody thinks of the
other fellow.

It's old fashioned to respect your
parents. Oh Gramy, yes. That's square.

~~Scho~~ Education ~~is square.~~
~~Morning a living is square.~~
~~School is~~ ~~Morality is square.~~
Pat ~~riotism~~
~~flag is square~~

Did they ever know meat
rationing? No! All
they know is alienation.

They don't know who they are
today.
Oh shut up, you
fool, & <u>dance!</u>

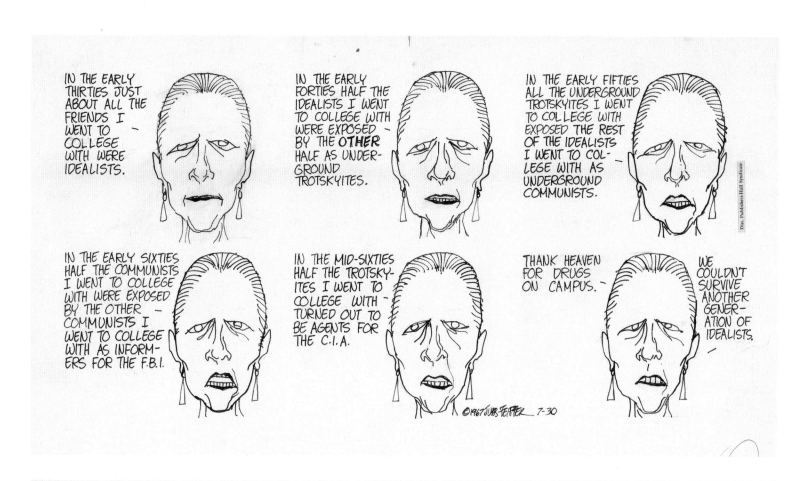

OPPOSITE, TOP

Village Voice,
November 19, 1964.

OPPOSITE, BOTTOM

May 6, 1965.

ABOVE RIGHT

February 18, 1965.

RIGHT

Village Voice, reprinted
in *Feiffer on Civil
Rights,* 1966.

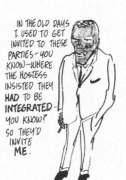

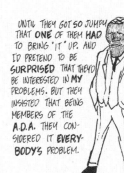

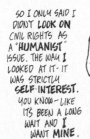

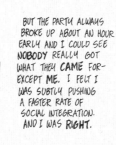

TODAY'S BOOK IS A RATHER BULKY BUT PROMISING FIRST ATTEMPT BY AUTHOR OR AUTHORS UNKNOWN.

IT'S CALLED THE BIBLE.

IT IS WRITTEN IN A NARRATIVE RATHER THAN INTROSPECTIVE STYLE WHICH MAY PERHAPS MAKE FOR QUICKER READING BUT LEAVES SOMETHING TO BE DESIRED ON THE LEVEL OF CHARACTER MOTIVATION.

IT PURPORTS TO BE A THEOLOGICAL AND HISTORICAL DOCUMENT, AND WHILE THIS REVIEWER DOES NOT QUESTION ITS SINCERITY, HE CAN ONLY REGRET THE PUBLISHER'S FAILURE TO INCLUDE A BIBLIOGRAPHY.

BUT THESE ARE MINOR CRITICISMS. ONE CANNOT DENY THE POWER AND SWEEPING RANGE OF THE SUBJECT MATTER— (ONE MIGHT EVEN CALL IT EPIC) —

— THE SUBTLE ALLEGORICAL NUANCES TOUCHED, AT TIMES, WITH WHAT SEEMS TO BE AN ALMOST METAPHYSICAL INSIGHT! IT WILL UNDOUBTEDLY CAUSE CONTROVERSY IN THE LITERARY FIELD.

BUT THE AUTHORS, WHILE WRITING IN A QUASI-JOURNALISTIC FORM SHOW OCCASIONAL FLOURISHES OF STYLISTIC DARING WHICH MAKES ONE IMPATIENT TO VIEW THEIR LATER EFFORTS.

I SHALL AWAIT THEIR SECOND BOOK WITH GREAT INTEREST.

LEFT, OPPOSITE, AND FOLLOWING TWO PAGES *Village Voice*, reprinted in *Jules Feiffer's America: From Eisenhower to Reagan*, 1982.

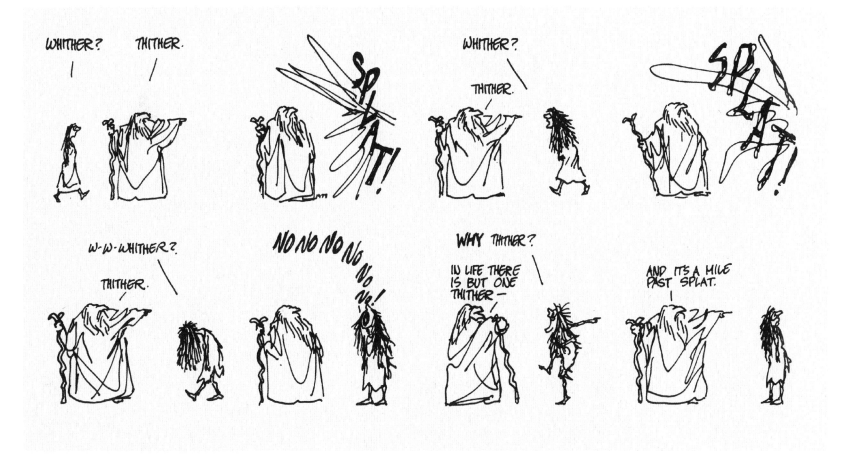

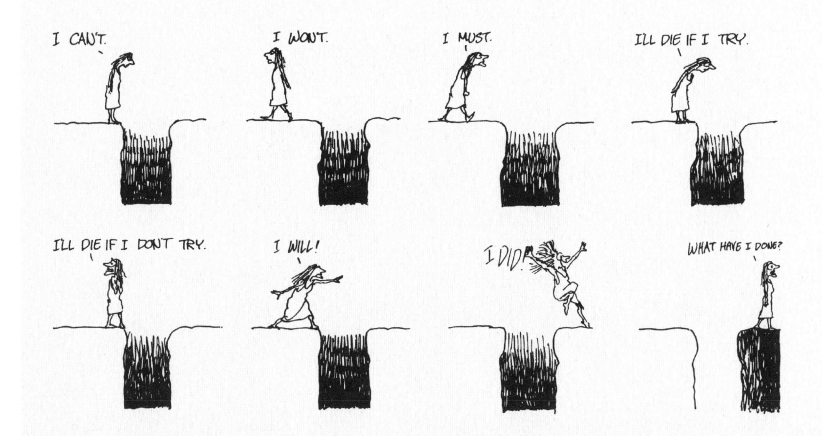

HOW DO YOU DO, MR. MERGEN-DEILER. I'M YOUR GROWN-UP. — YOU'RE MY WHAT?

SURELY YOU'VE ALWAYS WANTED A GROWN-UP? SOMEBODY WHO TAKES OVER THOSE PETTY DAY-TO-DAY AFFAIRS WHICH SO COMPLICATE ONE'S LIFE AND WHO HANDLES THEM CLEANLY AND EFFICIENTLY.

SOMEBODY WHO WILL NOT ALLOW YOUR INSURANCE TO LAPSE, YOUR RENT TO FALL OVERDUE, YOUR CAR TO BREAK DOWN. SOMEBODY WHO WILL NOT BE NERVOUS IN REGARD TO CALLING THE LANDLORD ABOUT REPAIRS, THE GIRL FRIEND ABOUT BREAKING A DATE, THE BOSS ABOUT A NEEDED RAISE.

IN OTHER WORDS SOMEBODY WHO IS TRAINED TO DO ALL THOSE ADULT THINGS TOO MANY OF US HAVE BEEN ASKED TO DO SINCE CHILDHOOD AND STILL CAN'T QUITE MANAGE. SOMEBODY WHO IS WILLING AND HAPPY TO STAND ON YOUR OWN TWO FEET FOR YOU, TO FIGHT ALL YOUR BATTLES, TO MAKE ALL YOUR DIFFICULT DECISIONS — i.e., YOUR GROWN-UP! — YOU MEAN I I WON'T EVER HAVE TO MAKE A DECISION AGAIN?

ONCE IN YOUR EMPLOY I, YOUR GROWN-UP, WILL MAKE THEM ALL! — IT'S UNBELIEVABLE! IT'S WHAT I'VE DREAMED OF ALL MY LIFE! WHAT DO YOU WANT ME TO PAY YOU?

GEE, I DON'T KNOW. WHAT DO YOU THINK I'M WORTH?

I'M CONSUMED BY NOSTALGIA.

NOT FOR MY CHILDHOOD BUT FOR ANDY HARDY'S CHILDHOOD.

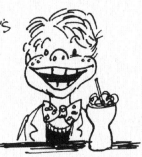

NOT FOR MY PARENTS BUT FOR LEWIS STONE AND FAY HOLDEN AS MY PARENTS.

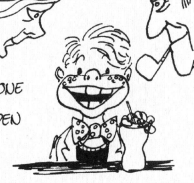

NOT FOR MY OLD GIRL FRIENDS BUT FOR JUDY GARLAND AND ANN RUTHERFORD AS MY GIRL FRIENDS.

NOT FOR THE BRONX BUT FOR #1, SHADY LANE, JUST OFF MAIN STREET, SMALLVILLE, U.S.A.

I DON'T PINE FOR MY REAL PAST. — I PINE FOR MY MGM PAST.

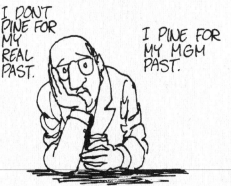

WHEN THEY DRAGGED ME TO SCHOOL AT 5, I REMEMBER SCREAMING:

BUT I'M NOT READY

WHEN THEY SENT ME TO CAMP AT 10, I REMEMBER SCREAMING:

BUT I'M NOT READY!

WHEN THEY DRAFTED ME AT 19, I REMEMBER SCREAMING:

BUT I'M NOT READY!

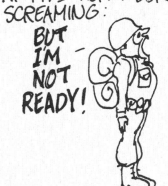

WHEN THEY MARRIED ME OFF AT 23, I REMEMBER SCREAMING:

BUT I'M NOT READY!

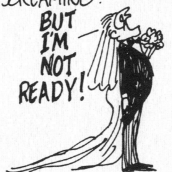

WHEN THEY MADE ME A FATHER AT 24, 25, 26 AND 27 I REMEMBER SCREAMING:

BUT I'M NOT READY — NOT READY NOT READY NOT READY!

FINALLY, AT 50, I RAN AWAY FROM MY WIFE, MY KIDS AND MY GRANDCHILDREN.

I'M NOT COMING OUT AGAIN TILL I'M READY.

DADDY! — GRANPA! — GEORGE!

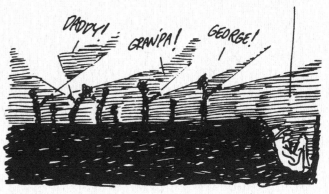

Pencil roughs for "A Biography" in fourteen panels and sixty years, rejected by *Playboy*, 1950s.

Feiffer Is Famous

One of the best cartoonists now writing, [Feiffer] is the best writer now cartooning.

Kansas City Star, June 28, 1959

The success of *Sick, Sick, Sick* as a book transformed Feiffer into a made man almost overnight. "I was now an authentic favored guy," Feiffer recalls, "at least on a cult level, in the environs of downtown New York and other parts of the country where people somehow managed to get the *Village Voice*."

A couple of weeks after publication, the new author heard from a fan in Chicago. Hugh Hefner was thirty-two to Feiffer's twenty-nine, and the "girlie" magazine he had founded five years earlier—the first issue, featuring a 1949 pinup shot of Marilyn Monroe on the cover, was edited in his Hyde Park apartment and published with a thousand-dollar loan from his mother (among other investors)—was fast approaching a circulation of one million. Hefner had wooed and won a serious roster of literary contributors to *Playboy*, including Ray Bradbury, whose *Fahrenheit 451* ran in serial form in the magazine in the spring of 1954. And as a self-described "frustrated cartoonist," Hefner set out to assemble a "stable of cartoonists, very much as the *New Yorker* had done. I took pleasure in finding and directing and guiding some of the best talents." He had already signed up a handful of soon-to-be well-known artists—Shel Silverstein, Jack Cole, and Gahan Wilson among them. "Jules was a very important addition."

In a letter to Feiffer in care of McGraw-Hill, Hefner got quickly to the point: "I think much of what you have been doing for [the *Voice*] is exactly right for us. . . . With even more emphasis on urban living as apart from strictly Village living, work done specifically for us could be a very

Original art for promotional piece, November 15, 1958.

ABOVE *Cue*, a popular entertainment magazine, celebrated Feiffer's run of successes with one of his cartoons on the cover of its March 18, 1961, issue.

OPPOSITE Feiffer's *Playboy* debut of original material, September 1958.

exciting addition to *Playboy*. Does this thought interest you?"

Feiffer had no serious (or unserious) qualms about working for a skin magazine, having already appeared in two of *Playboy*'s imitators, *Rogue* and *Rex*. But the idea of signing on for a regular gig—and having to please the editor who was paying him—made Feiffer uneasy. Ted Riley, his recently acquired agent, conveyed this concern to Hefner in a phone call. Hefner replied by letter.

"He doesn't have to change his point of view for us. All we want him to do is bring the same sensitivity and awareness [he brings to Village life] to young executive urban living. . . . All we need is a little more concern with the upper-level income guys and girls, the sports car set, the hi-fi addicts." *Playboy* readers were not all that different from Feiffer's *Voice* subjects, Hefner said. "Their clothes are just a little neater, their shoulders a little more natural. . . . But they are as sick as anyone in the Village and just as ripe for satire—maybe a little sicker and a little riper."

It was an astute if unexpected observation— one that would have made many readers of both publications howl—and a good preview of an *Odd Couple* relationship that would prove amicable and profitable for decades. "Hefner was the best cartoon editor I ever had," Feiffer says. "He'd go from panel to panel,

giving a detailed analysis of exactly the right way something could be strengthened. Not from the *Playboy* editorial point of view, but in terms of how I could make my point stronger. More times than not, he was right."

"Maybe we can change *and* to *then* in the first phrase so it isn't so similar to the phrase that follows," the delicate editor suggested about an early submission, ending his analysis of the text with "This is a beaut!"

Though Hefner never ventured a topic for Feiffer to consider, he never second-guessed or vetoed one either, and this fulsome editorial treatment was matched by a princely monthly retainer of five hundred dollars. It was an unprecedented sum in Feiffer's experience, and as Hefner explained in a letter to Ted Riley, this was only the "minimum draw." If Feiffer "felt up to doing two, three, or more drawings for us a month," he added, "that's just fine. He can earn considerably more than that if he turns out the work." In exchange, Hefner demanded exclusivity in the men's magazine arena, which meant no more assignments for *Esquire* or any of *Playboy*'s racier rivals.

Hefner introduced his newest find to *Playboy*'s readers in the August 1958 issue with three black-and-white pages of *Voice* reprints, to be followed the next month by an original page of nine black-and-white panels. In a letter to Ted Riley enclosing advance copies of the August

issue, Hefner made his delight in the arrangement clear: "If you think his work has been well received to date, wait until you begin feeling the response of our audience to his humor. Jules is as perfect for our readership as gin and tonic."

In the blink of a bunny's eye, Feiffer's fan base doubled and his monthly draw and his page rate went up by a hundred dollars each. "This and future increases are a reflection of both our satisfaction with Jules's work," Hefner wrote Riley late in the summer, "and also we hope they will serve as a means of reducing the quantity of work he may find it necessary to do for any other market and so more and more become identified in the public mind with our publication."

A few months later, pieces by Feiffer appeared in two small-circulation magazines, *Ivy* and *Madison Avenue*, and one big one, *Pageant*, and the honeymooners hit their first road bump.

"Dear Hugh," Feiffer wrote longhand from 153 State Street in Brooklyn Heights, where his friend and future collaborator Norton Juster had found them both apartments after their Hicks Street landlady told her tenants they had to move out. (Juster's apartment was in the basement, Feiffer's one flight up. David Levine lived a few blocks away on Henry Street.) "I'm certain you must remember that in our recent talk I mentioned that over a year ago I had sold a jazz piece to *Pageant*, which they had

butchered, and which they had been holding for some time, and that I had made efforts to get it back because I thought it was a natural for *Playboy*." There was a similar problem with *Sports Illustrated*, he confessed, which had bought and sat on a cartoon before *Playboy* came along, and was about to run it. "It's something that only now by turning down work (and boy, have I ever!) I am able to control. . . . Some of the magazines bought work a long time ago, got frightened about running it—held it till I became hot, and now are rushing it into print. This doesn't do me any more good than it does you, but it's something on which I can hardly be held responsible.

"I am particularly upset by your letter because in the past few weeks I have turned down assignments, the Sunday *Times* included, that could have been most attractive. But, as we both realized and discussed while you were here, it is easy to lose sight of where you are going and to get caught in a work trap. I have no intention of doing this. It's the quickest possible way to career suicide, and I'm fully aware of it. . . .

"I hope this straightens matters out. If it doesn't, I wish you'd give me a call. It's hard for me to get any work done with something like this hanging over my head."

After another round of back-and-forths by phone, the ever-courtly Hefner put the matter

OPPOSITE Original art later reprinted in the collection *Boy, Girl. Boy, Girl.*, 1961.

Feiffer's work for *Playboy* was but a shade more sexually explicit than his work for the *Voice*. The underlying theme was the same for both publications—gender misreading, seduction, delusion.

to rest gracefully. "My lapse of memory as regards the *Pageant* feature is really incredible, and your reassurances about *Madison Avenue* and *Ivy* were very welcome. Your regular appearance in the *Voice* is an exception that we both agreed to . . . but it complicates matters considerably if *Madison Avenue* or any other publication is permitted to reprint material from the *Voice*.

"I'm actually pleased that all this came up, because I welcome your own view of our association and its meaning to you. Forgive me for being, perhaps, as sensitive an editor-publisher as you are an artist."

Feiffer emerged from his first professional kerfuffle intact, but thinking about it at a distance of fifty years, he raises the possibility that he might have behaved badly.

"I *think* these magazines were holding on to some things. Or it's possible that I was just greedy and lied to Hefner about that. I may have been covering my tracks, because I was so excited to be asked by everybody, after years of being asked by nobody. Though I also might just have done it, having forgotten that I wasn't supposed to, or ignoring it, and then I was very fearful of losing the *Playboy* account, so I had to back off, and realized I made a boo-boo. I can't remember this precisely. But after that I didn't do anything for anyone else.

"I think what Hefner was most concerned about was my not doing anything for *Esquire*,

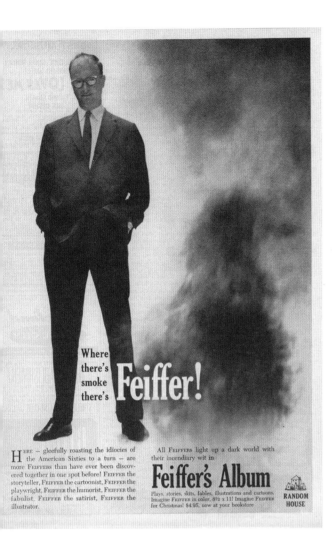

Where there's smoke there's **Feiffer!**

Here — gleefully roasting the idiocies of the American Sixties to a turn — are more Feiffers than have ever been discovered together in one spot before! Feiffer the storyteller, Feiffer the cartoonist, Feiffer the playwright, Feiffer the humorist, Feiffer the fabulist, Feiffer the satirist, Feiffer the illustrator.

All Feiffers light up a dark world with their incendiary wit in

Feiffer's Album

Plays, stories, skits, fables, illustrations and cartoons. Imagine Feiffer in color, 8½ x 11! Imagine Feiffer for Christmas! $4.95, now at your bookstore

RANDOM HOUSE

ABOVE The multitalented Feiffer—cartoonist! playwright! satirist!—played pitchman for his latest book in 1963, *Feiffer's Album*, a collection of seven short pieces with a philosophical twist. Photograph by Philippe Halsman. Feiffer recalls, "My one and only full-page ad ever, and shot by a legendary photographer, who, thank god, did not ask me to jump. I have not been able to stand that straight in fifty years."

OPPOSITE When the *New York Post*—a reliably liberal paper at the time—added a weekly Feiffer cartoon to its editorial lineup on March 29, 1961, Mississippi was burning, and landing Feiffer was the good news appearing above the masthead.

which was a direct competitor—and he had been employed by them. He saw them as his biggest rival, so of course I was not going to do anything for them."

Working for *Playboy* did not require Feiffer to adopt an alien template. The family resemblance between the panels he did for the *Voice* and what he produced for *Playboy* is plain to see. He had to tap deeper into his libidinous stream, certainly, but though the drawings were a bit more explicit, the sensibility was essentially unchanged. He took particular pleasure in insinuating two of his best *Voice* creations, Bernard and Huey, into the *Playboy* format. "I loved doing Bernard and Huey more than anything else I did for *Playboy* because it was the least *Playboy*-like cartoon."

"Jules's work was very good for *Playboy*," says Art Spiegelman. "He was given an area where he didn't have to just make jokes like 'My God, Miss Smith, your breasts, they look like melons.'" In fact, most of the work Feiffer did for *Playboy* looked very much like what he did for the *Voice*—the women eager and woundable, the men cads or cowards. But Feiffer himself was definitely making out well for a change, double-dipping and getting paid for it.

Meanwhile, Feiffer's output for the *Voice*

continued week after week. To mark his second anniversary at the paper, the *Voice* ran his

four-page satire on the atom bomb, "Boom," in the October 29, 1958, issue.

That same fall, Feiffer signed on with the Hall Syndicate, and by early 1959, *Feiffer* the strip and Feiffer the guy who did the strip had officially ascended to literary celebrity status.

"You may feel that a good many psychiatric and psychoanalytical jokes are going around these days," began the lead item in the "In and Out of Books" column from the January 11 issue of the *New York Times Book Review* (the same issue that reviewed John Updike's first novel, *The Poorhouse Fair*). "You may also feel that a young cartoonist named Jules Feiffer has somehow become spokesman for the entire psychiatric jokes movement. This Mr. Feiffer, at least, will deny." The piece went on to cite sales figures for *Sick, Sick, Sick* (ninety-five thousand and still selling), his illustrations for an about-to-be-published compilation of actual quotes from psychiatric patients during sessions with their shrinks, and rather peculiarly compared his growing popularity on college campuses to that of John Held Jr.—an elegant illustrator, best known for his magazine covers of flappers, who had died a few months earlier.

A month later, *Time* ran *its* Feiffer piece, reporting on his rocketlike rise from an unpaid contributor to a "furrowed-brow Greenwich Village weekly" to a literary eminence "up to his clean, button-down collar in offers from

publishers." The wunderkind, the magazine reported, was in discussion with "Stanley (*Paths of Glory*) Kubrick" about a possible screenplay and on track to pay more in income tax for 1958 than he had earned in all of 1957. On the basis of his recent signing with the Hall Syndicate, *Time* confidently predicted that the "slight, introspective" Feiffer— "(rhymes with knifer)"—would gross in the six figures in the coming year. They were close.

"Jules was a once-a-week feature as opposed to a six-daily, one-Sunday one," recalls John McMeel, the young rep for the Hall Syndicate who signed Feiffer up, "but by golly, you took that out and you put it on an editor's desk—it was not only the content of [the strip]; it was the look sometimes on the editor's face.

"His was one of the very few transitional features that could go in both the daily and in the college market," says McMeel. At its peak, *Feiffer* would run in more than one hundred newspapers in the United States and in dozens more in Europe and Latin America, most of which paid for the privilege.

"While visiting Castro's Cuba in the early seventies," Feiffer remembers with anarchist delight, "I met a writer who told me that he was the one who stole my cartoons and translated them into Spanish for the Cuban newspaper *Granma*. Over drinks at lunch, he took out the cartoons he had translated and read

...om Page 30)

...ght closer to-
...ems most nat-
...ographer."

...rend is for the
...e in to see, be-
...a good piece
...adds Robbins.
...l yak-a-doodle
...nes didn't have
...nows are about
...s with realer

...in certain the-
..., notably those
...t aging, infre-
...d directors, is
...e boys don't
...y are going to
...elves right out
...edy."

...so. Producer
...says he "never
...chael Kidd in
...ography only. I
...great director.
...estry' I offered
...to direct. It
...cal, but rather
...y. He turned
...play was done
...e and it failed.
...idd's approach
...the play. I'm
...other straight

...all end? One
...well ask a Tin
...ublisher what
...; a hit and an-
...America's first
...musical, "The
...was a peculiar
...insupportable
...more than 100
...French ballet
...Black Crook"
...formances. Yet
...vn," the slavish
...h followed it,
...ly.

...now? The au-
...ver have fore-
...ppin'" in 1938
...n" in 1951. Yet
...ntegration with
...n. Bold is the
...efore, who in
...ertain climate
...ct the future.
...arden, producer
...Man," hazards

...of the musical
...rd cover. Mu-
...e stronger and
...ful books. A
...emands better
...at Bob Preston
...and Rex Har-
...air Lady' have
...sound barrier
...tly proved the
...expendable, we
...actors as sing-
...the opposite.
...cs will spring
...book. Though
...how, they will
...story.

...or the dances,
...e top choreog-
...gnes de Mille,
...and Fosse, who
...e *barre* have
...he prompter's
...han ever they
...book — before
...ap."

...Mr. Bloomgar-
...make them

DO YOU DREAD THE SUMMER SOLSTICE?

The children go to camp. Mother dons a low-backed sun dress and fixes salad for dinner. Dad? Dad goes to the office as though noth-ing were happening. It's hot, but life in the office goes on. Are you looking for solace at the summer solstice? We have some for you. **Raeford 2⁷80's!** This is the coolest, lightest, finest 2-ply tropical ever woven; a superb blending Dacron* with rarer-than-cashmere wool. The Dacron is for strength and press-retention. The wool (known as "eighties grade" to the trade) is for a cool, smooth feeling against the skin. **Raeford 2⁷80's** is now loomed in more distinctive colors and pat-terns than any other fabric in the world. Because the 2⁷80's yarn is so slender, these colors and pat-terns have a new and smarter ap-pearance never before achieved in a worsted fabric. **Raeford's 2⁷80's** is tailored by a who's-who of American suitmakers. Grieco Bros. Timely, Worsted-Tex and Heller Slacks to name but a few. At just about any fine men's store in town.
*Dupont's Polyester Fiber

them back to me in English, and they were word-for-word perfect. He had also carefully lettered the Spanish translation in my style."

Another measure of Feiffer's growing fame was the company he was now keeping. Standing in line to buy tickets for a Nichols and May show in New York one afternoon, Feiffer recognized Kenneth Tynan, the theater critic for the London *Observer*, and introduced himself. Tynan promptly invited Feiffer to join him and some friends for dinner. The group turned out to include George Plimpton, Peter Matthiessen, Michael Arlen, John P. Marquand Jr., Donald Ogden Stewart Jr., and Nelson W. Aldrich Jr., among the best-connected writers in New York.

Later that year, the *Observer* invited Feiffer to England for the publication of the British edition of *Sick, Sick, Sick*. Terrified by the thought of a transatlantic flight, Feiffer instead sailed first class on the *Queen Elizabeth*, which had an ambience "straight out of a Fred and Ginger movie." Ted Riley, "the most English-sounding American I knew outside of George Plimpton," went with him, as did a brand-new tuxedo from J. Press, the epitome of conservative Ivy League style. The first night out, the two men watched a preview showing of Alfred Hitchcock's *North by Northwest* in the ship's screening room before retiring for a nightcap to a nearly empty bar

on the topmost level, where the guy in the tux playing Duke Ellington on the piano turned out to be the Duke himself.

It was a voyage appropriate to the welcome he received when he landed. "It was simply amazing. The parties, the treatment, the Old Guard intellectuals who were praising me and devoted to the work. I went to dinner with them, I went to lunch with them. In this country, there was always a bit of tarnish about being a cartoonist, because cartooning is looked down on in America—in this classless society where people are afraid of things that might be in bad taste without them knowing it. So serious people were a little skittish about liking a cartoonist as much as they liked me. But there was no such snobbery in Britain, because their class system was already in place and they weren't endangering themselves by liking me."

In fact, no one back home seemed to be having trouble confessing affection for Feiffer. In the spring of 1959, McGraw-Hill brought out *Passionella and Other Stories*, its second Feiffer collection in two years, in an elegant leatherette edition with swirling art deco endpapers that simultaneously evoked a chorus of Feiffer dancers and a cozy Bloomsbury sitting room, and an introduction by John Crosby, the radio and television critic, who called Feiffer "a wickedly witty observer of our time and our screwy problems, but even more of our screwy

Feiffer's people were everywhere to be found in his unpaid *Voice* years: helping Burlington sell Raeford summer suits (opposite, left, 1958) and *Time* magazine boast of its high-end suburban readership (opposite, right, October 1, 1958), and fronting Broadway shows such as *The Nervous Set* (above, 1959), the first "Beat musical," starring a pre–*I Dream of Jeannie* Larry Hagman.

rationalizations." The collection included the title story, which had run in *Pageant* two years earlier, but with the illustrations, which Feiffer had never been happy with, completely redone; "George's Moon"; "Boom"; and, five years after he'd completed it, "Munro," the breakthrough narrative that reset the course of his career and his ambition. 'MUNRO' HAS CAPTURED AMERICA! was the headline of a story in the *Herald Tribune*'s Sunday magazine, which reproduced several panels. "'Munro' may not win medals in the army," the *Trib* cooed, "but

critics are pinning a lot on Feiffer. Sample: 'One of the best cartoonists now writing, he is the best writer now cartooning.'"

Financially solvent for the first time in his life, and with a live-in girlfriend (Judy Sheftel, whom he would marry two years later), Feiffer moved out of the duplex he'd shared with Norton Juster on State Street to a tonier address on Montague Terrace, an elegant brownstone row a few steps from the Brooklyn Heights Promenade and its thrilling view of lower Manhattan. On State Street, the two friends had divided the utilities, with Juster paying the phone bill every month and Feiffer paying gas and electric. "In the process of arranging things for the move," remembers Juster, "Jules moved the contract into my name. It must have slipped by me in the bills, and one day the bell rang downstairs. It was the guy from Con Ed to read the meter. I was standing in the hall and the lights went out. I finally figured it out.

"A few days later, a strip comes out in the *Voice*; someone's lights are cut off. The Con Ed guy called me, and he said, 'That strip of Mr. Feiffer's? It was about you.'"

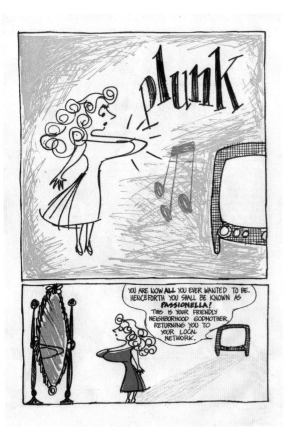

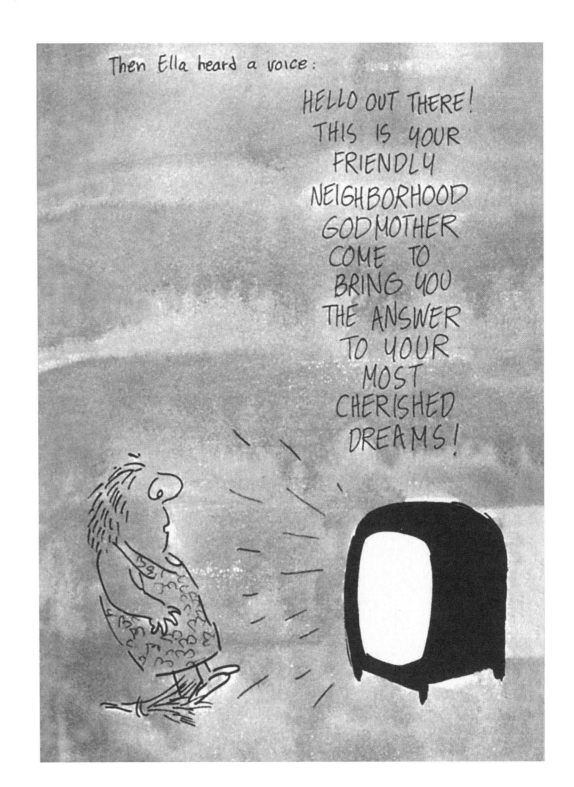

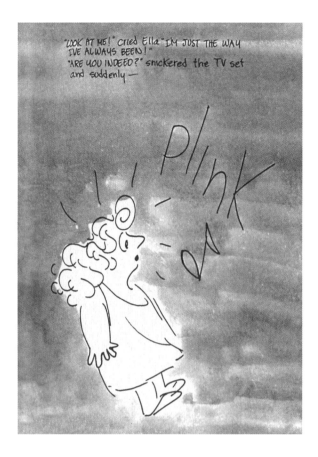

"LOOK AT ME!" cried Ella "I'M JUST THE WAY
I'VE ALWAYS BEEN!"
"ARE YOU INDEED?" snickered the TV set
and suddenly—

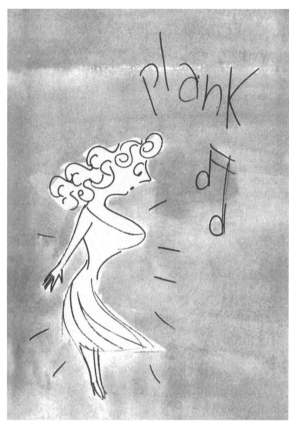

plank

plunk

YOU ARE NOW ALL YOU
EVER WANTED TO BE.
HENCEFORTH YOU SHALL
BE KNOWN AS
PASSIONELLA!
THIS IS YOUR FRIENDLY
NEIGHBORHOOD
GODMOTHER RETURNING
YOU TO YOUR
LOCAL NETWORK.

Ella could not believe her eyes. She was dazzling.
"NOW I SHALL BECOME A BEAUTIFUL, GLAMOROUS MOVIE STAR!"
she said and she ran off to El Morocco—

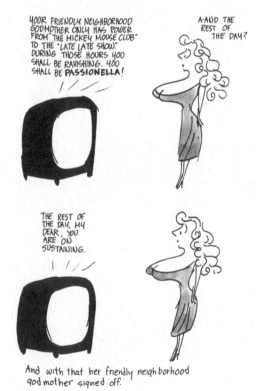

YOUR FRIENDLY NEIGHBORHOOD
GODMOTHER ONLY HAS POWER
FROM "THE MICKEY MOUSE CLUB"
TO THE "LATE LATE SHOW."
DURING THOSE HOURS YOU
SHALL BE RAVISHING. YOU
SHALL BE PASSIONELLA!

A-AND THE
REST OF
THE DAY?

THE REST OF
THE DAY, MY
DEAR, YOU
ARE ON
SUSTAINING.

And with that her friendly neighborhood
godmother signed off.

in the months
that followed
a new star
was born:
the mysterious
exotic
bewitching
temptress...

Passionella

Branching Out

**So many things are possible just as long
as you don't know they're impossible.**

NORTON JUSTER, *The Phantom Tollbooth*

The first person to tell Jules Feiffer he could be a "real" writer was Robert Benton, an art director at *Esquire* in the 1950s and early 1960s, and later a successful screenwriter and director. "It was something that made a big impression on me," Feiffer recalls, "because no one had ever said that before.

"My mind-set was always that my sister Mimi was the writer in the family and I was the cartoonist. It would be an act of hubris on my part to attempt to write. Yet I always felt that however good a cartoonist I became, that would never be as good as being a writer. Writing was a higher-status undertaking."

By the early 1960s, such agonizing might have seemed better suited to one of Feiffer's self-doubting characters than to someone getting the kind of attention he was. By now, Feiffer was a genuine cultural touchstone, whose distinctive worldview and characters were regularly invoked to describe other writers' work, as in a pair of reviews written by Edgar Z. Friedenberg that appeared in the *New York Review of Books* two years apart: "This has both good and bad effects. It makes the reader feel like a phony Jules Feiffer liberal" (1964), and "What he develops is a marvelous carica-ture—a Jules Feiffer portrait in depth—of the academic liberal pursuing his career" (1966).

Feiffer's fanciest intellectual friends were fond of telling him that his strips were "little essays," "miniplays," "plays on paper"—a form of flattery he took as proof of their unease at having such powerful responses to mere cartoons, and a rebuke to his pride in being a cartoonist, a profession

Detail from *The
Phantom Tollbooth,* 1961.

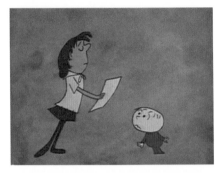

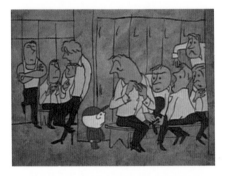

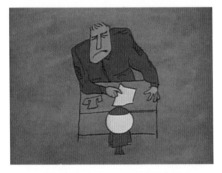

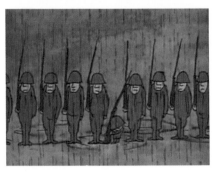

he held in the greatest esteem. In order to legitimize their appreciation of the work he was doing, "they social-worked me into a profession they respected.

"I think there was a degree of discomfort there. George Plimpton was a friend of mine and asked me to contribute to books of his, but he never asked me to do a *Paris Review* interview. We talked about it once. He brought it up, and he said he wanted to talk with me about being a playwright, not a cartoonist. So there it is."

But the view that Feiffer was both a writer and a cartoonist, the two titles unranked and complementary, was, in fact, widespread—largely because of his genre-breaking work. "It may sound [like] an odd tribute to pay a cartoonist," wrote Kenneth Tynan in an introduction to the British edition of *Sick, Sick, Sick* in 1959, "but I doubt whether Feiffer has a more valuable attribute, as a graphic artist, than his ear. . . . It would be no exaggeration to say that his dialogue is as acute as any being written in America today."

"It was easy to think of Jules as a writer at that point," says Lee Lorenz, a longtime *New Yorker* cartoonist and for twenty-five years the magazine's art editor. "And it didn't surprise me at all when he started writing plays. I always thought gag cartoons, even the kind I do, are like a pivotal moment in a play,

suggesting what led up to that point and what might follow. It is very much a narrative form. You can reduce a cartoon to a single panel, but you can also extend it to what Feiffer was doing. And he was already working with characters. He had all the ingredients."

Feiffer's admirers turned out to be right. Between 1961 and 1971, he would complete his first novel, *Harry, the Rat with Women*; his first extended work of nonfiction, *The Great Comic Book Heroes*; his first play, *Little Murders*; and his first movie, *Carnal Knowledge*. In its variety and apparently serendipitous unfolding, this most versatile and prolific stretch of Feiffer's career laid down a rough template for the remainder of his creative life. Beneath the seeming randomness of form and subject matter ran parallel currents of political and cultural insights, now and then intersecting much as they did in the abbreviated form of the weekly strip.

The opening shot of this period was not a new piece of work but a nine-minute *succès d'estime*, a cartoon version of *Munro* directed by Feiffer's old boss at Terrytoons, Gene Deitch, which wound up winning an Oscar in the category of Animated Short Film in 1961. (Because Deitch was living and working in Prague at the time, *Munro* turned out to be the first short created outside the United States to win the Academy Award.) Neither Feiffer nor Deitch

attended the awards ceremony—"I was so naive I didn't even know I *could* go," says Feiffer—and Bill Snyder, who headed Rembrandt Films, the small company Deitch had moved to after Terrytoons, accepted the award. "I remember he said, 'I want to thank Gene, Jules, and Al [Kouzel, who did production design].'" Feiffer did make it to *Munro*'s first public screening a month earlier, however. It shared the bill with *Breakfast at Tiffany's* at Radio City Music Hall, and he was a bit embarrassed "seeing it up there on the big screen. I kept thinking, I'm an off-Broadway cartoonist. I don't belong here."

By that time he was technically an off-Broadway playwright as well, by way of a revue mounted by Playwrights at Second City in Chicago, a satellite theater the improv group had started as a venue for presenting scripted material, and Feiffer's was the first. Working with Playwrights' director, Paul Sills, Feiffer stitched together several short bits from the *Voice*, which were bookended by "Passionella"—for the title role of which Sills promised him Barbara Harris, a Second City regular Feiffer greatly admired—and "George's Moon," the third story in *Passionella and Other Stories*, about a lone man stranded on the moon. Paul Sand, another original Second City player, played George, and Feiffer credits him with giving the short piece more life onstage than it had on paper, even though Feiffer thought the overall show fell short. He felt that Sills had done too little to shape the material into a convincing theater piece. The result, *The Explainers*, was a stilted show of "people off the paper talking their lines. I felt let down because it didn't seem to be an improvement on the paper. Plain paper was better." Adding insult to injury, Sills reneged on his promise of casting Barbara Harris.

Later in 1961, looking for a project with which to launch his career as a director, Feiffer's friend Mike Nichols, who had seen the Chicago production, told Feiffer he wanted to bring the show to New York and, "in the undying tradition of show business," says Feiffer, "change most of it." Out went the short bits from the *Voice* strip, replaced by *Crawling Arnold*, a one-act Feiffer had written for the Second City version that Sills rejected. Stephen Sondheim, who had just written the lyrics to *West Side Story* and *Gypsy*, was enlisted to write a few songs for "Passionella," and the remade show was retitled *The World of Jules Feiffer*. As production got under way at a summer stock theater in southern New Jersey, Feiffer's mood began to fibrillate between delight and remorse. He was simultaneously thrilled by the brilliance of his collaborators and convinced that they were "propping up" inadequate work—that "dramatized cartoons did not constitute real theater."

OPPOSITE Selected frames from the nine-minute film version of *Munro*, directed by Gene Deitch, which won Feiffer (who wrote the screenplay and storyboards) an Academy Award for Animated Short Film in 1961.

The Apple Tree, a three-act musical directed by Mike Nichols, brought "Passionella" to the Shubert Theatre on Broadway, opening on October 18, 1966. The play ran for 463 performances, closing on November 25, 1967. The first act was an adaptation of Mark Twain's The Diaries of Adam and Eve, and the second was based on Frank R. Stockton's short story "The Lady or the Tiger?" The three acts share a theme of wish fulfillment, cautioning that desire does not always yield the outcome one expects. Music was by Jerry Bock and lyrics by Sheldon Harnick; the play starred Barbara Harris (who won the Tony Award for Best Actress in a Musical), Alan Alda, and Larry Blyden. Five years before, Feiffer had gotten cold feet about an earlier Nichols mounting of the play, with music by Stephen Sondheim. In addition to Harris's win, the play received Tony nominations for Best Composer and Lyricist, Best Direction of a Musical, and Best Choreography, and the show itself was nominated for Best Musical.

"I felt like the least qualified person on the show," Feiffer said. "It wasn't that I thought the show wasn't good. I thought Mike's work was wonderful, I thought Steve's work was wonderful. It was that I felt no visceral connection to the show. That while everything in the show, every piece of script, was mine, I didn't feel pride of ownership. And I felt a little embarrassed that all this great talent was going to waste on what I thought was material that was designed for paper, worked better on paper, and wasn't really theatrical enough. The feeling I had was this ironic one of being reduced, in my own head, to a secondary level in this production that was based on my stuff.

"I felt that I was the least important figure in this production. And I couldn't bear the idea. So I thought, screw it. If I'm ever going to be in the theater, it will be something I write for the theater and not an adaptation of the cartoons."

Before the show opened for previews in New Jersey, Feiffer told Nichols and Sondheim he did not want it to continue on to New York. Neither tried to talk him out of it, although five years later, Nichols—who by then had won a Tony for directing the Neil Simon hit Barefoot in the Park—succeeded in bringing "Passionella" to Broadway as the last act in Jerry Bock's and Sheldon Harnick's three-act musical, The Apple Tree. Fifty years later, Nichols's recollection of the New Jersey production was that "Steve [Sondheim] had incredible songs, but because it was only 'Passionella' and one other short ['George's Moon'], it was not a full evening. There was no way to go further with it at the time. We all learned a lot, and by the time, much later—I was already a Broadway director, that's how much later—when Bock and Harnick came up with The Apple Tree, it worked."

The "Passionella" segment got a lukewarm reception from the critics, but when Feiffer saw

Barbara Harris playing the lead role at last, he was hit by regrets at having pulled the plug on a Broadway production the first time around.

It was not the last time Feiffer would feel that he had somewhat perversely shot himself in the foot because he was afraid of losing control or because of doubts about the quality of the work (and fear of it being publicly trounced)—a tendency that belied the extraordinary self-assurance he brought to most of his own work and his willingness to take risks.

"He knows the thing that all artists know," observes arts writer Judith Goldman, a longtime friend, "which is that by staying inside the box, doing what's expected of you, you never get anywhere. What's interesting is how when he undertakes to do something for which he thinks he might not have talent, he goes into it very confidently. He reads a couple of screenplays and writes *Carnal Knowledge*." In those first years, it was seldom anything to do with his solo work that knocked him off balance; rather, it was the act of collaboration. Not long after he axed the Nichols-Sondheim production, Feiffer heard from Stanley Kubrick, who wanted to talk about him writing the screenplay for what would become *Dr. Strangelove*.

"I probably made a stupid decision with Nichols and Sondheim," Feiffer says now, "but with Kubrick, whose work I loved, and who I liked personally, it was clear to me, once we had conversations on the two films he wanted me to be involved with—one was about a dancer in the Village, the other was *Dr. Strangelove*—that I would essentially be his stenographer, and that our sensibilities were very, very different. On *Strangelove*, he clearly wanted a *MAD* Magazine approach, which is what he did in the movie, but that's not the way I write. I think the movie was extraordinary, but I could not have written that screenplay. Stanley got Terry Southern, and Terry was the right person to do it."

BELOW Penultimate images from "Passionella," 1959.

FOLLOWING SIX PAGES Feiffer's view of the art he did for *The Phantom Tollbooth* is at odds with that of his critics and his fans. Though he thought Norton Juster's text marvelous, Feiffer dismisses his own work as the result of "imitating illustrators who were better than I was." He did indeed borrow like crazy from many of his heroes—Winsor McCay, James Thurber, John Tenniel, and George Grosz among them—but for most readers, the result was thrilling, and remains so. The book is a widely acknowledged classic of children's literature and in 2012 was named one of the Top 100 Children's Novels of all time by *School Library Journal*.

As we were working on this monograph, a cache of drawings Feiffer did on tracing paper more than fifty years ago turned up unexpectedly in his studio. The original art on pages 148 (bottom), 149, and 152 (bottom left) appear in *The Phantom Tollbooth*; the others are unpublished preliminary sketches, model sheets, and alternate character illustrations (pages 150–52). The line art on pages 148 (top) and 153 are from the book.

Another collaboration he had mixed feelings about during this period was *The Phantom Tollbooth*, written by his good friend Norton Juster. When Juster began writing *The Phantom Tollbooth* in 1960, he asked Feiffer if he would illustrate it. Feiffer agreed, but as Juster recalled fifty years later, he was on-and-off a persnickety collaborator.

"There are a lot of things Jules doesn't like to draw or can't," Juster says. "Either he thinks he can't—or he just doesn't want to do it. When we were working on *The Phantom Tollbooth*, one of the things I wanted to do was maps. Feiffer could not or would not draw a map. So I drew the map, and he put a piece of tracing paper over it and did it in his line.

"When it came to doing the armies of Wisdom, who are supposed to be mounted on horseback, the first time he showed me the sketch they were all mounted on cats because he doesn't like to draw horses. We finally compromised, and he drew two lines that simulated the idea of a horse."

In fact, says Feiffer, not long after the two friends completed their second project together, after a half-century gap, "I had very little regard for what I did on *The Phantom Tollbooth*. I thought the text was brilliant, and I thought I was imitating illustrators who were better than I was. I did the art on tracing paper.

"Those illustrations are now legendary, apparently. People say they treasure them— they're their favorite part of the book—and I don't respond to any of this. I look back on the work and I think it's good work, but I can't say I have any visceral response to it. Unlike *The Odious Ogre* [2010], the last book I did with Norton. There I take great pride in the work, and I think it's one of the best things I've ever done, and I take it out and look at it with great admiration. But I don't look back at *The Phantom Tollbooth*, except for a few drawings, as an example of my work that I like to be reminded of."

Feiffer's harsh judgment of his work on *The Phantom Tollbooth* aside, the bestselling book remains a beloved classic. "If stylistically the *Phantom Tollbooth* illustrations are not quite all of a piece," writes Leonard S. Marcus, author of *The Annotated Phantom Tollbooth* (2011), "that is because Feiffer was borrowing left and right," from "Winsor McCay, James Thurber, Edward Ardizzone, George Grosz, Thomas Rowlandson, and on and on. Even so, he more than acquitted himself, infusing the drawings with a kind of coiled-spring energy and blitheness of spirit that perfectly suit Juster's outlandish tale."

P 508
Vol 2

The
Gateman

Vol 2
531

According to Leonard S. Marcus, author of *The Annotated Phantom Tollbooth*, the drawings on page 150 (left) are studies for the courtiers of Dictionopolis, with the sketch on the far left a variant of the finished art that appears in chapter 3, page 41 of the book. Joining with the author's clever decision to have the king's yes-men speak entirely in synonyms, Feiffer ultimately rendered all five courtiers as indistinguishable from one another as members of a chorus line. The drawings on the right are studies for Short Shrift, the police officer from chapter 5, page 61 of the book, who randomly arrests Milo and company in the market square of Dictionopolis, then hauls them off to prison. Feiffer seems to have amused himself by trying out different ways to decorate the officer's helmet.

The drawings on page 151 (left) are most likely more early studies of Dictionopolis courtiers and townspeople. On the right is an early sketch of Milo. The story's hero looks younger here than he does in the finishes and also appears to have a lot less on his mind.

On page 152, the sketch at top left is a variant on the illustration from chapter 2, page 18 of the book—Feiffer's teasing homage to his friend and collaborator Norton Juster, here cast as the insufferable, toga-clad Whether Man. In the afterword to the British paperback, Juster remarked that the depiction was "quite unfair, since everyone knows I never wear a toga." At right, top and bottom, are two studies of the Lethargarians from chapter 2, page 23 of the book, the sedentary elfin creatures from the Doldrums who help Milo realize the downside of giving in to a life of boredom.

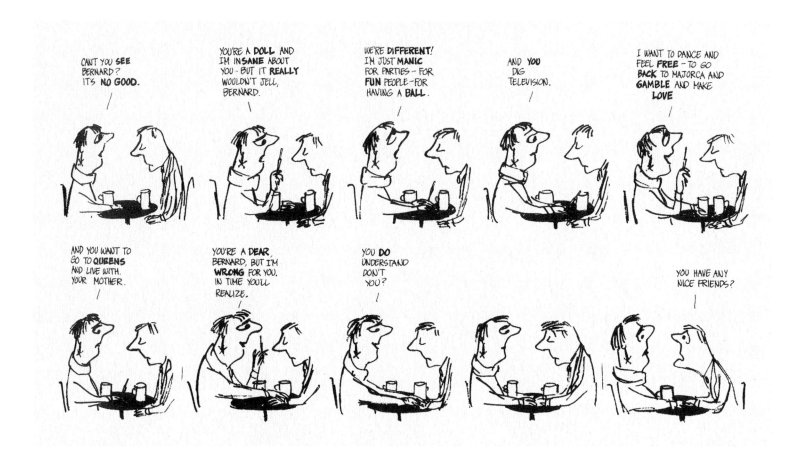

ABOVE Bernard Mergendeiler entered Feiffer's *Voice* repertoire on November 13, 1957.

OPPOSITE, TOP Huey, the ladies man, joined the lineup on March 12, 1958.

OPPOSITE, BOTTOM On August 13, 1958, Bernard and Huey appeared together in the *Village Voice* for the first time, predating their appearance in *Playboy* by twenty-five years.

The *Voice* strip, meanwhile, continued to appear week after week. The drawing style and the framing and spacing of panels continued to shift, though with less frequency than in earlier years, as Feiffer cycled through a growing ensemble of familiar characters who shared the spotlight with politicians, advertising types, generals, culture hounds, children, mothers, hustlers, the married and the unmarried, the miserable and the deluded, and the bomb and bomb shelters—favorite subjects he would mine for years.

Feiffer's nameless dancer, based on his girlfriend at the time, Judith Goldsmith (later known professionally by her married name,

Judith Dunn), danced her first dance to spring on March 27, 1957, and would continue to appear every few months for the duration of the strip, even as her physical contours shifted to reflect each successive girlfriend. The hangdog nebbish Bernard Mergendeiler made his first appearance on November 13, 1957, in a panel that foretold the decades of abjectness and failures with women to come. Huey, the self-loving cad, joined the cast on March 12, 1958, and on August 13 of that year, Feiffer brought the schlemiel and the braggart together in a strip that reads like a dry run for a scene in *Carnal Knowledge*, a story he would not begin to write for another decade.

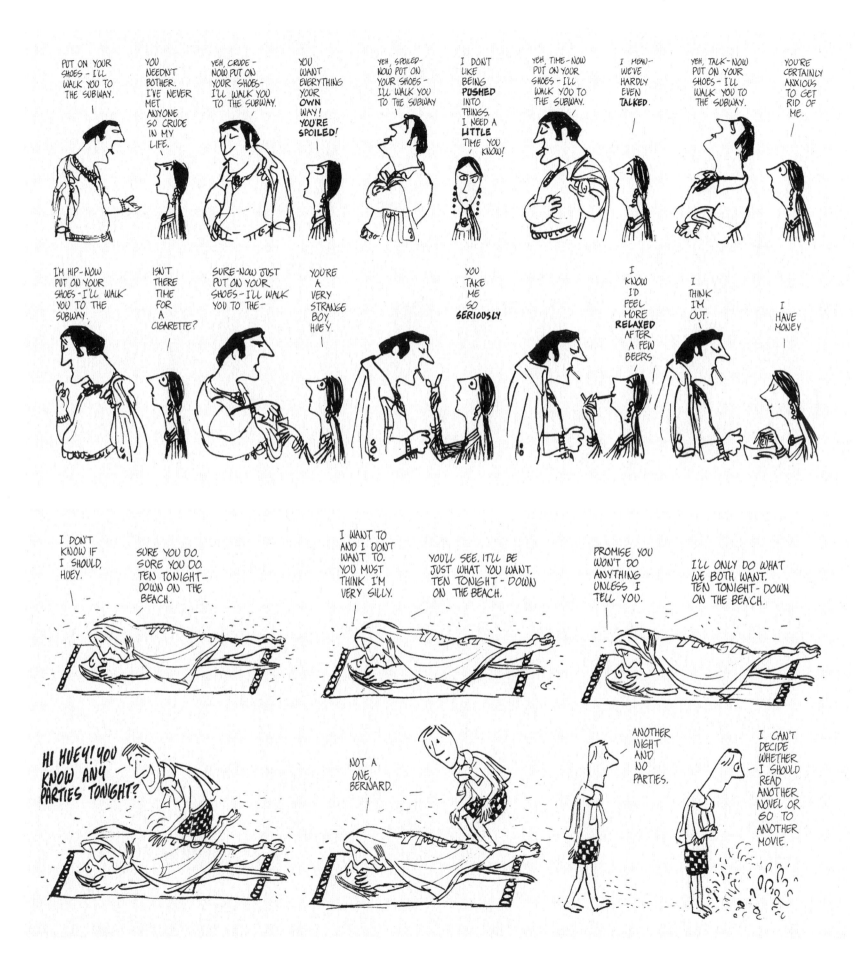

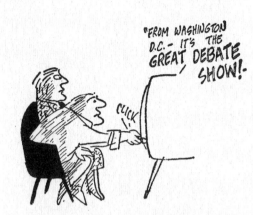
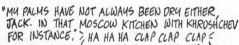
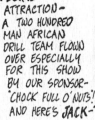
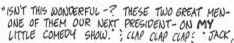
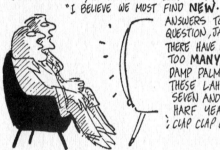
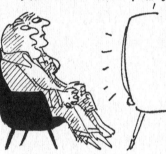
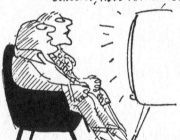
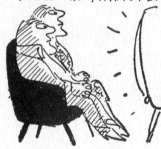

Feiffer had fun with the bomb and America's love affair with fallout shelters. Some *Voice* strips were linked to specific events; others were everyday reflections of nuclear-age queasiness: September 1, 1960 (above); August 24, 1961 (opposite, top); and November 30, 1961 (opposite, bottom), nearly a year before the Cuban Missile Crisis.

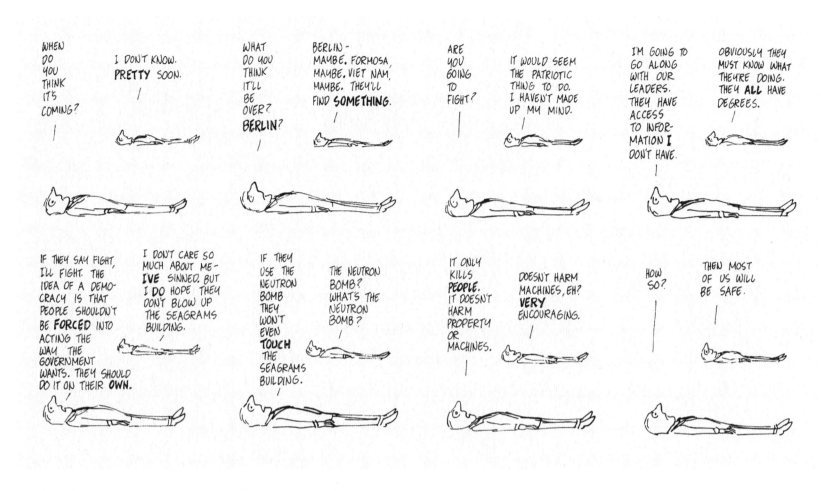

WHEN DO YOU THINK IT'S COMING?

I DON'T KNOW. **PRETTY** SOON.

WHAT DO YOU THINK IT'LL BE OVER? **BERLIN**?

BERLIN - MAYBE. FORMOSA, MAYBE. VIET NAM, MAYBE. THEY'LL FIND **SOMETHING**.

ARE YOU GOING TO FIGHT?

IT WOULD SEEM THE PATRIOTIC THING TO DO. I HAVEN'T MADE UP MY MIND.

I'M GOING TO GO ALONG WITH OUR LEADERS. THEY HAVE ACCESS TO INFORMATION **I** DON'T HAVE.

OBVIOUSLY THEY MUST KNOW WHAT THEY'RE DOING. THEY **ALL** HAVE DEGREES.

IF THEY SAY FIGHT, I'LL FIGHT. THE IDEA OF A DEMOCRACY IS THAT PEOPLE SHOULDN'T BE **FORCED** INTO ACTING THE WAY THE GOVERNMENT WANTS. THEY SHOULD DO IT ON THEIR **OWN**.

I DON'T CARE SO MUCH ABOUT ME - **I'VE** SINNED. BUT **I DO** HOPE THEY DON'T BLOW UP THE SEAGRAMS BUILDING.

IF THEY USE THE NEUTRON BOMB THEY WON'T EVEN **TOUCH** THE SEAGRAMS BUILDING.

THE NEUTRON BOMB? WHAT'S THE NEUTRON BOMB?

IT ONLY KILLS **PEOPLE**. IT DOESN'T HARM PROPERTY OR MACHINES.

DOESN'T HARM MACHINES, EH? **VERY** ENCOURAGING.

HOW SO?

THEN MOST OF US WILL BE SAFE.

WILLIE - **COME OUT OF THERE!** YOU'VE BEEN IN THERE **LONG ENOUGH!**

SOON MA. SOON -

NOT SOON, WILLIE. **NOW!** WHAT ARE YOU DOING IN THERE ALL BY YOURSELF **ANY**HOW?

READING, MA. READING -

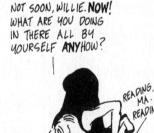

YOUR FATHER DIDN'T GET A **BANK** LOAN TO BUILD **YOU** A **LIBRARY**, MISTER! YOU DO YOUR READING SOMEWHERE **ELSE** THAN HIS FALLOUT SHELTER!

IT'S **MY** FALLOUT SHELTER **TOO**, MA!

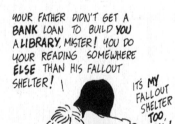

ARGUMENTS! ARGUMENTS! YOU SAY IT'S **YOURS** - YOUR **SISTER** SAYS IT'S HERS - IT'S **EVERYBODY'S** FALLOUT SHELTER BUT **MAMA'S!**

YOU NEVER YELL AT SISTER WHEN **SHE'S** IN HERE.

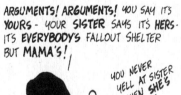
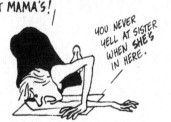

YOUR SISTER DUCKS EVERY TIME SHE HEARS A **PLANE!** YOU HAVE TO MAKE **ALLOWANCES** FOR YOUR SISTER!

I'LL BE OUT IN A MINUTE -

WELL, CONGRATULATIONS, MISTER. YOU WEREN'T PLAYING WITH THE **MACHINE GUN** AGAIN WERE YOU?

HONEST, MA I WAS READ-ING. I DIDN'T TOUCH **ANY-THING** OF DAD'S.

READING - READING - WHAT'S SO IMPORTANT THAT YOU WERE READING?

"YAHOO WORLD WAR III HOORAY COMICS."

THE **THINGS** THEY'RE ATTRACTED TO! WHAT CAN YOU **DO** WITH KIDS TODAY?

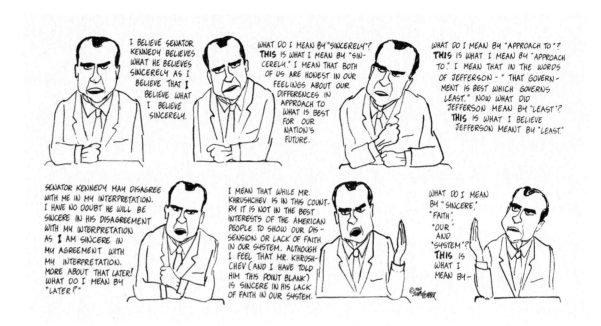

Richard Nixon—who would become one of Feiffer's most satisfying and enduring subjects over the years and merit his own Feiffer collection in 1974, the year he resigned from office—got his first mention as a presidential candidate, along with John F. Kennedy, on September 1, 1960. Feiffer's first caricature of Nixon ran a month later, in a strip that sent up his awkward debating style. Three weeks later Kennedy got the same treatment. In these early drawings, both men are rendered in an unformed, almost embryonic style, and everything of significance Feiffer has to say is captured in the words, not in the line. While his later drawings of Nixon would be among the best political work of his career, his drawings of Kennedy would never get much better.

A tepid enthusiast of the New Frontier, Feiffer was nonetheless "absolutely fascinated"—hypnotized, as everyone was at the time—by the Kennedy administration, and the change of tone from Eisenhower to Kennedy.

"I thought these guys were very, very slick, but not very effective," he says now. "I loved their style." Feiffer was amused by the young president's skill at spinning the press, "to beat them, not by lulling reporters to sleep but by making them chuckle and genuflect. He was nothing but charm. Style engulfed substance. Not that he didn't have beliefs; they started with his self and flared outward."

In *Jules Feiffer's America*, a collection of political cartoons from the *Voice* organized by presidents from Eisenhower to Reagan that was published in 1982, he dubbed Kennedy "our first

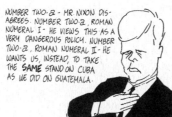

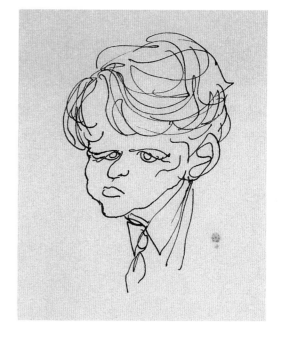

The comic strip shows illustrations of Kennedy with the following handwritten text:

Panel 1: NOW THE QUESTION IS **THIS**: NUMBER ONE - ARE WE DOING ALL WE CAN ABOUT CUBA? NUMBER ONE-a - **I** DON'T BELIEVE WE **ARE**! NUMBER TWO - IN A WHITE PAPER LARST WEEK I SUGGESTED THAT WE SHOULD DO **ALL** IN OUR POWER TO OVERTHROW THE CUBAN GOVERNMENT BE-CAUSE ITS AN UNFRIENDLY DAGGER JUST OFF OUR COAST.

Panel 2: NUMBER TWO-a - MR. NIXON DIS-AGREES. NUMBER TWO-a, ROMAN NUMERAL I - HE VIEWS THIS AS A VERY DANGEROUS POLICY. NUMBER TWO-a, ROMAN NUMERAL II - HE WANTS US, INSTEAD, TO TAKE THE **SAME** STAND ON CUBA AS WE DID ON GUATEMALA.

Panel 3: i.e. - DO **ALL** IN OUR POWER TO OVERTHROW THE GUATEMALAN GOVERNMENT BECAUSE IT WAS AN UNFRIENDLY DAGGER JUST OFF OUR COAST. NUMBER THREE, ROMAN NUMERAL II, I, AND III - I BELIEVE THIS TO BE AN **EVASIVE** POLICY.

Panel 4: **BUT** - NEW PARAGRAPH, NUMBER ONE-a - MR. NIXON **DOES** AGREE THAT WE **SHOULD** DEFEND FORMOSA - WHICH IS OUR **FRIENDLY** DAGGER JUST OFF THE CHINA COAST. NUMBER ONE-b - I DON'T BELIEVE THATS **ENOUGH**.

Panel 5: NUMBER TWO STROKE THREE, PART ONE - I BELIEVE WE MUST DO FAR **MORE**. WE MUST GAIN FOR OURSELVES THE FRIENDSHIP OF ALL THE **EMERGING, UN-COMMITTED** DAGGERS IN ASIA AND AFRICA. HERE, ROMAN NUMERALS M THROUGH MCV, IS OUR AREA OF DISAGREEMENT.

Panel 6: IN MY NEXT REBUTTAL, FOLLOWING THE COUNT DOWN, I'D LIKE TO DISCUSS MY PROGRAM FOR THE AGED.

movie-star president" and made a shrewd reading of the side effects of the Young Turks' elevated testosterone levels. "Stevenson liberals, the Kennedy people said, couldn't get it up. If they could get it up, it certainly wouldn't stay up long enough to stick it to the enemy. The New Frontiersmen not only got it up, they talked about how up it was. No accident that sexual liberation and Lenny Bruce's comedy came in at this time."

Many of these sorts of observations made their way into Feiffer's *Voice* strip, but because he found the handsome president hard to caricature, his drawings of Kennedy are among his least evocative, particularly in contrast to the sophisticated work he was doing on almost every other subject during the period.

In fact, Kennedy turns up as the direct subject of *Feiffer* just four times: a pre-election strip poking fun at his debating style (October 27, 1960); a mild send-up of Kennedy's difficulty managing the CIA (March 15, 1962); an imagined back-and-forth between Kennedy and his press secretary, Pierre Salinger, about his poll ratings (January 24, 1963); and another, on May 23, 1963, that captures the dazzling sleight of hand Feiffer saw as the administration's signal accomplishment, with JFK leading a Gene Kelly–style dance number called "The Frontier Drag."

When Kennedy was shot, Feiffer's response (which did not run until January 2, 1964, because of the syndicate's long lead time) had, for him, a rare elegiac tone that played off the fairy-tale aspects of Kennedy's presidency.

Nixon, on the other hand, would be Feiffer's to kick around for decades to come.

GENTLEMEN, IF YOU WILL, PLEASE TURN TO PP.42 OF THE APPENDIX: WHITE PAPER NUMBER 6521, PAR.14. DO YOU ALL HAVE IT?

RE: RIVALRY— CIA VS. STATE? IS THAT IT, CHIEF?

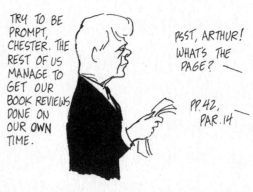

YES. NOW, PIERRE, IF YOU WILL SUMMAR-IZE—

EXCUSE IT, CHIEF. HERE'S CHESTER.

SORRY I'M LATE, CHIEF. I WAS FINISHING UP A BOOK REVIEW.

TRY TO BE PROMPT, CHESTER. THE REST OF US MANAGE TO GET OUR BOOK REVIEWS DONE ON OUR OWN TIME.

PSST, ARTHUR! WHAT'S THE PAGE?

PP.42, PAR.14

NOW THEN, THE PROBLEM IS THE IMPROVEMENT OF INTELLIGENCE OPERATIONS BETWEEN OURSELVES AND RUSSIER, OUR-SELVES AND ASIER, AND (MORE DIFFICULT BECAUSE IT'S A CLOSED SOCIETY) OURSELVES AND CIA. YES, ED—

WELL, WE'VE HAD SOME SUCCESS IN TRACKING CIA'S AC-TIVITIES BY MONITORING THE ENEMY'S RADIO ACCUSATIONS, CHIEF.

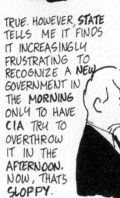

TRUE. HOWEVER, STATE TELLS ME IT FINDS IT INCREASINGLY FRUSTRATING TO RECOGNIZE A NEW GOVERNMENT IN THE MORNING ONLY TO HAVE CIA TRY TO OVERTHROW IT IN THE AFTERNOON. NOW, THAT'S SLOPPY.

IN TERMS OF LONG RANGE PLANNING CIA SHOULD, ON OCCASION, HAVE THE SAME FOREIGN POLICY AS STATE, WOULDN'T YOU SAY, CHIEF?

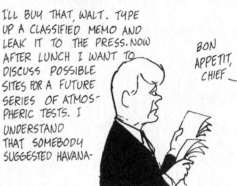

I'LL BUY THAT, WALT. TYPE UP A CLASSIFIED MEMO AND LEAK IT TO THE PRESS. NOW AFTER LUNCH I WANT TO DISCUSS POSSIBLE SITES FOR A FUTURE SERIES OF ATMOS-PHERIC TESTS. I UNDERSTAND THAT SOMEBODY SUGGESTED HAVANA—

BON APPETIT, CHIEF

HOW DOES IT LOOK?

NOT TOO BAD, CHIEF. GALLUP HAS YOU DOWN 3% ON FISCAL RESPON-SIBILITY, UP 2% ON GETTING TOUGH WITH LABOR, DOWN 4% ON GETTING TOUGH WITH BUSINESS.

HOW ABOUT ROPER?

ROPER HAS YOU UP 2% ON ATMOS-PHERIC TESTING, DOWN 3% ON MEDICARE, UP 4% ON YOUR PHYSICAL FITNESS PROGRAM.

MMM— WHAT DOES HARRIS SAY?

HARRIS HAS YOU UP 2% ON OUR FAILURE TO REACH AGREEMENT AT GENEVA, UP 1% ON OUR FAILURE TO REACH AGREE-MENT IN VIET NAM AND STANDING PAT ON CIVIL RIGHTS.

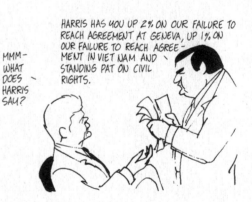

MMM— GOT THE TOTAL ON PRESS COMMENT?

YES SIR— THIS WEEK LIPPMANN WAS CAUTIOUS, RESTON HOPEFUL, ALSOP DISTURBED, LAWRENCE MOROSE, CHILDS WATCHFUL AND KEMPTON PAINED.

HOW POPULAR AM I?

MORE SO THAN LAST WEEK. LESS THAN THREE MONTHS AGO AT THIS TIME.

GET THOSE REPORTS OVER TO PLANNING AND HAVE THEM COORDINATED INTO A POPULAR POLICY. LET'S PUSH THOSE RATINGS UP!

IT'S TIME TO GET THIS COUNTRY MOVING AGAIN, EH, CHIEF?

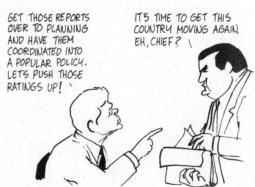

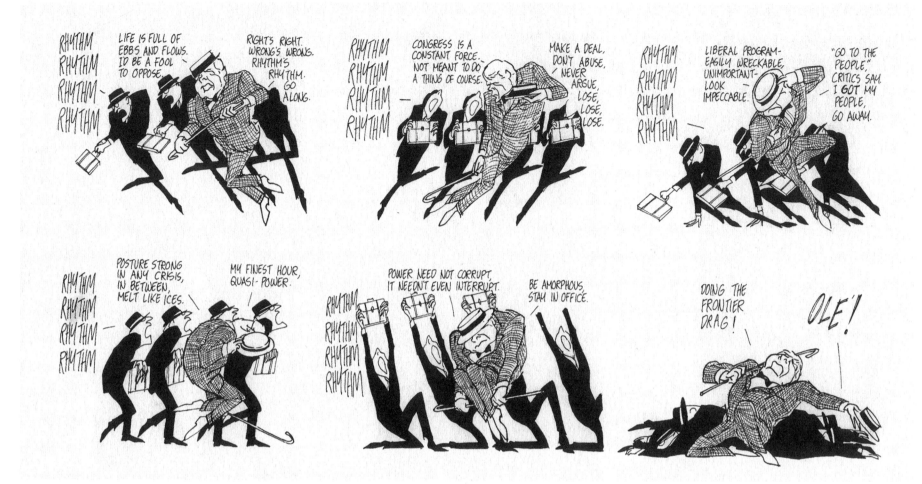

Feiffer's coverage of Kennedy's time in the White House was occasional and frequently indirect: March 15, 1962 (opposite, top); January 24, 1963 (opposite, bottom); May 23, 1963 (above); and posthumously, January 2, 1964 (right).

ABOVE Undated sketch.

OPPOSITE Groucho Marx dancer from *Civilization*, the magazine of the Library of Congress, June/July 1998.

Since 1958, Feiffer had been sending full-page cartoons to *Playboy* on an almost monthly basis per his five-hundred-dollar-a-month contract. Most were single-page, eight- or nine-panel drawings in black-and-white, later punctuated by occasional four-color panels. When a longer cartoon appeared, such as "The Lonely Machine," which ran for seven pages in the December 1962 issue, it was a sure sign that Feiffer was trying to make up for missed pages earlier in the year. *Harry, the Rat with Women* began life as such a catch-up project. "I owed *Playboy* a lot of money because I hadn't been sending them cartoons, so I got this dumb idea. Rather than do cartoons, which would have taken a day or two, I would write a long short story, which paid a lot more, and that way I could discharge my debt. So I came up with this idea, and I thought, this is a really good idea, not something I can hack out. It could be a novel. Like a lot of my work, *Harry, the Rat* started as one thing and then it became something much more serious and important to me."

Before he knew what hit him, Feiffer was being pummeled by a form he had no real instinct for and, aside from money, no motive for writing. "Every sentence I wrote was an attempt to find a way of telling my story while getting around the fact that I lacked the powers of observation and description, not to mention a facility with words, that real novelists seem to be born with."

In desperation, Feiffer escaped with his wife, Judy, to a friend's parents' house deep in the woods in upstate New York, the sort of setting where inspiration is supposed to hatch like mosquitoes. There he discovered a well-stocked left-wing library that included the complete novels of Nathanael West. With a glass of scotch in hand, desperate to avoid the task that had brought him there, he sat down and devoured the entire oeuvre in an afternoon. "After Judy and I had dinner, I retreated upstairs to the little bedroom I was working in and with more scotch suddenly began writing." He felt he was in the throes of "an enormous breakthrough, which brought me answers to all of the questions I had and convinced me I was doing the best writing of my life—coming up with all of the plot points, the wit, and the style that had so long eluded me. I went to bed in a state of high euphoria and woke up feeling the same way." He could hardly wait to reread the extraordinary prose he had laid down the night before. "After eggs and coffee, I ran upstairs, read through everything, and in a state of shock mixed with despair, discovered that what I had done in my euphoric dream state was to rewrite *Miss Lonelyhearts*. Somehow, rather than making me want to kill myself, it gave me a sense of long-absent

humor about the project, which allowed me to go back to the book not as Nathanael West reborn but as myself—whoever that was."

The resulting parable of narcissism—Harry the Rat gets his comeuppance in the end—ran in the June and July 1963 issues of *Playboy* and was published by McGraw-Hill to decent, if not enthusiastic, reviews.

Feiffer felt he had made a respectable showing, but it was an experience he was not inclined to repeat anytime soon. When an aspiring young Broadway composer named Alan Menken came along—years before *Little Shop of Horrors* and *The Little Mermaid*—and said he was interested in *Harry*'s theatrical possibilities, Feiffer said no thanks. "He wanted to do it as a musical, and I just didn't understand what he was doing. Didn't understand modern music at all at that time. And rather than think of this as an exciting new opportunity, I rejected it and disdained it. And didn't give it any more thought. Now, this is a guy who later had these enormous hits. It's quite possible that *Harry* also would have been a big one and I'd have been involved in a musical—which I'd always wanted to be involved in.

"I think—I was about to give a motive here, but I don't know what the motive is. I just don't know why I backed off from so many things that could have been. I think a lot of it was fear of losing control, but there were other

situations where I didn't really want control. I certainly was not going to adapt *Harry, the Rat with Women*. I didn't want to do that. I didn't want to be directly involved in the musical. I was just going to sell him the rights. And why not? Let's see what they come up with. Why didn't I? There was something strangely and prickly snobbish about me in those years, where I was not going to downgrade myself by being involved with people who, 'dot, dot, dot,'" Feiffer says with a smile, "when, in fact, these people were actually first-class and I had no reason to look down my nose at them. But I did.

"It's almost impossible to explain the kind of self-destructiveness and self-isolation that made me act as if I was living on a desert island—unable to gain information or acquaint myself with the work of the people who were courting me. So rather than take the subway downtown—it didn't occur to me to go see *Little Shop of Horrors* when it came out—I found it easier to keep my distance and turn up my nose."

Though fans of Feiffer's syndicated weekly strip appear not to have noticed, by the mid-1960s he had grown weary of the franchise that had made his reputation. "I began to get more and more bored with the drawing, if not the writing, of the cartoons," he told an interviewer a few years after the column

ABOVE The cover for Feiffer's *The Great Comic Book Heroes* features Superman, the iconic DC Comics super hero, as originally depicted by his co-creator Joe Shuster, 1965.

OPPOSITE They didn't call them "graphic novels" back in 1979, but *Tantrum*, an adult fable of male pouting, regression, and escape, was Feiffer's innovative first, following Eisner's more well-known *A Contract with God and Other Tenement Stories* by a year. Shown here: pages 8 (top left), 10 (top right), 12 (bottom left), and 13 (bottom right).

finally ended. "I had no particular visual ideas. I became satisfied with knocking the stuff out by just drawing people in profile. I got tired of the repetitive head shot. If I could have hired anybody to draw it at that point, I would have."

"I think there was a tyranny of the cartoon panel," says Harry Katz, who, as head curator in the Prints and Photographs Division at the Library of Congress, organized a 1996 retrospective on Feiffer to mark the acquisition of a significant selection of his work. "What he did to transform cartoons, to bring in amazing content, was remarkable—in terms of politics, of going into the bedroom, probing the mental states of his characters. But at some point the strip became too static. He was almost a hostage to his own style."

By Feiffer's account, which he has given repeatedly to interviewers over the years, he would not find a way to free his line and rediscover the pleasure of drawing until the cartoon novel *Tantrum* in 1979. "Everything in *Tantrum* is drawn, lettered, created, at white-hot speed," wrote comic book creator Neil Gaiman in the introduction to the 1997 reissue. "One gets the impression of impatience with the world at the moment of creation—that it would not have been possible for Feiffer to do it any faster. As if he were trying to keep up with ideas and images tumbling out of his head, trying to capture them before they escaped."

Tantrum is dedicated to three of Feiffer's childhood idols: cartoonists E. C. Segar, Roy Crane, and Will Eisner, all of whom he had celebrated in his earlier breakthrough work *The Great Comic Book Heroes* (1965).

The idea for *Comic Book Heroes* came from E. L. Doctorow, himself a hyphenated literary man at the time, by day an editor at Dial Press—he would become editor in chief in 1964—and by night a novelist. Born two years after Feiffer, also in the Bronx, Doctorow shared Feiffer's love of comics and thought they merited serious consideration. For Feiffer, the book was "a labor of love"; for comics fans it was a milestone in the history of the art form, a mix of the serious and the sly, the analytic and the provocative, the scholarly and the besotted. He traced cartoon genealogies, artistic influences, and the art of the swipe; dissected the meaning of the Superman–Lois Lane–Clark Kent triangle; parsed the punches and the costuming of his favorite heroes; dissected the varieties of archvillains; and mapped the stylistic overlaps between radio and the comic book, which he judged "the more tangible outlet for fantasy."

Feiffer took on psychiatrist Fredric Wertham's jeremiads against comics with glee and civility, pointing out why Wertham, in his 1954 diatribe *Seduction of the Innocent*, was dead wrong about the comics' effects on innocent

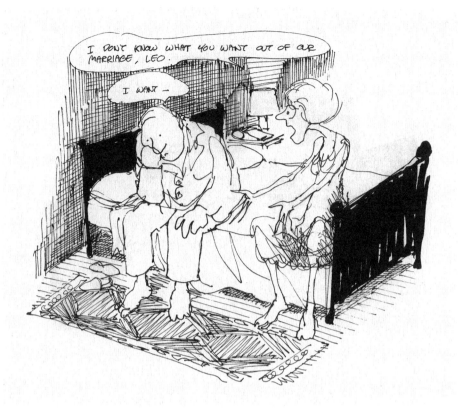

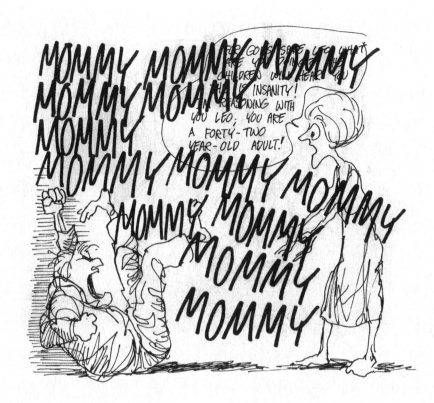

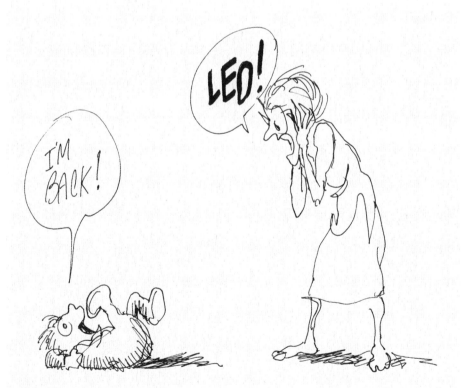

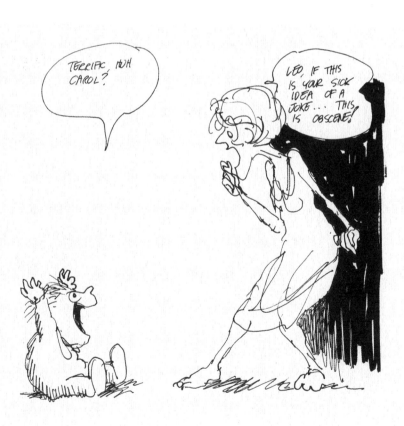

children. Comics, wrote Feiffer from a lifetime of instinct and experience, provided a child with an essential "underground. . . . A place to hide where he cannot be got at by grown-ups. A place that implies, if only obliquely, that *they're* not so much; that *they* don't know everything; that *they* can't fly the way some people can, or let bullets bounce harmlessly off their chests, or beat up whoever picks on them, or—oh, joy of joys!—even become invisible!" With the comics, "we were able to roam free, disguised in costume, committing the greatest of feats—and the worst of sins. . . . For a little while, at least, it was our show. For a little while, at least, we were the bosses. Psychically renewed, we could then return aboveground and put up with another couple of days of victimization. Comic books were our booze."

The Great Comic Book Heroes was the manifesto—or doctoral dissertation—he'd been preparing to write, without realizing it, for thirty years. And for comic book fans, it was a revelation.

"I was maybe nine years old," says Paul Levitz, a longtime DC Comics writer, editor, and eventually president, "and it was the most stolen book in the Brooklyn Public Library. So many of my friends who loved comics borrowed it again and again and again. Some borrowed it rather permanently. At the time, no one had put any of the comics past in context in a generally available format. It's very hard to capture the perspective, but if you walk into Jim Hanley's Universe or Midtown Comics"—famous New York way stations on the comics trail—"today, you literally would need a moving van

to bring home all the books about comics, and the hardcover and permanent collections that exist. For my generation of fans, we all had the same eight or ten books throughout our childhoods, because that's all there were."

"It was really important," says Art Spiegelman, who was seventeen when *The Great Comic Book Heroes* was published. "That was at a time when people didn't do that sort of thing. This art form was *beneath* contempt. So far beneath it that it would have taken ten years of cultural education to make it contemptible to people. Jules found a tone that was really perfect for reintroducing it into the world. For a while I could quote whole sections."

For Feiffer, the book was also very much an act of homage. "One of the main reasons I agreed to do the book," he says, "was to write about Eisner, and the Spirit, who everyone had forgotten about by then." Indeed, Eisner had almost completely faded from the scene after the war, having retired the strip in 1952 in response to the rising cost of newsprint and a barrage of media attacks on comics inspired by Wertham's claims, according to N. C. Christopher Couch, a comics scholar and author of *The Will Eisner Companion* and the catalog *Will Eisner: A Retrospective*. Crouch and many others credit Feiffer with having revived interest in the Spirit and reigniting Eisner's career. "Ironically," Couch wrote, "nostalgic interest

in super heroes helped restore Eisner's antihero to prominence." To Feiffer's delight, "a whole new generation of comics fans who had never heard of Eisner discovered him in the book, laying the groundwork for the revival to come—the graphic novels, beginning with *A Contract with God*, in 1978, and published collections of the Spirit stories."

In the months immediately following President Kennedy's assassination, Feiffer came to feel that the country was in the grip of an extended and collective psychic trauma, marked by "the breakdown of authority at every level—in our culture and our politics— and no one in the media was talking about it. It was probably under way before the assassination, but it speeded up after.

"My argument at the time was that the atmosphere of the Cold War had created in the country a repressed national sensibility, and that the psychic contradictions brought on by living in a state where we were encouraged to think—and we did think—that we were at any moment subject to attack, could not be sustained any longer. All the forms of authority that had been in place and essentially unchallenged since before World War I were now being questioned and falling apart. Nothing was being accepted as a given anymore, and the authority that people had previously ceded

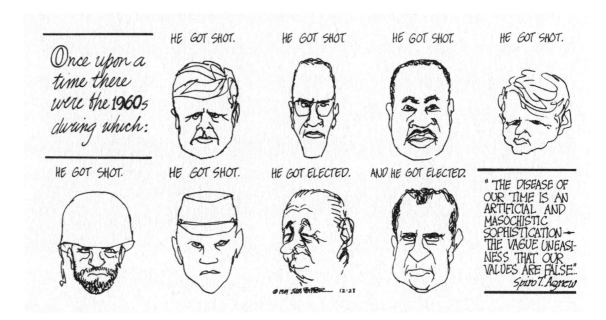

Once upon a time there were the 1960s during which:

HE GOT SHOT. HE GOT SHOT HE GOT SHOT. HE GOT SHOT.

HE GOT SHOT. HE GOT SHOT. HE GOT ELECTED. AND HE GOT ELECTED.

"THE DISEASE OF OUR TIME IS AN ARTIFICIAL AND MASOCHISTIC SOPHISTICATION—THE VAGUE UNEASINESS THAT OUR VALUES ARE FALSE".
Spiro T. Agnew

to their parents, to religion, to education, to the police, to government was no longer in place. My point was never that the random violence was about itself. I thought the random violence was about a society that had been disconnected from itself.

"While no one was looking or paying attention, our respect for traditional authority, which had been in place really since the nineteenth century—'We have our problems, but the one thing we all have is, we respect our parents, we pay attention to our teachers, we venerate our ministers, the cop on the corner is our friend'—all of these things stopped on a dime. The Kennedy assassination didn't cause these things by itself; it made them apparent."

Throughout 1964, while working on other projects, Feiffer nibbled at the edges of the national blight in his strip, but he felt that

neither an eight-panel attack on the subject nor a *Munro*-length narrative could do justice to his sense of America coming unhinged. Late in the year, Feiffer sketched out a story line and a handful of characters for a novel he hoped might. A year and a half later, having filled legal pad after legal pad with diversionary prose that led nowhere, he took himself off to Yaddo, the writers' colony in upstate New York, and rediscovered his original idea and why he couldn't finish the novel he had set out to write. "*Little Murders* announced itself. It was a play. Whether I liked it or not."

As soon as he began work on the first act, the eighteen-month writer's block he'd been hauling around like a medieval penance dissolved. "Within two hours," he writes in his memoir, "I knew that I was a playwright; that whatever its fate, this work was so much fun that it was worth any clobbering the critics

ABOVE *Village Voice*, December 28, 1969.

OPPOSITE Poster for the first Broadway production of *Little Murders*, April 1967.

were bound to hand me." The prospect of a clobbering quickly took on a legitimizing sheen. "If I was going to get busted for this play, then let me outrage the critics in ways that would get them *really* upset. I had been lamenting for months that my cartoons had become too popular, too readily accessible. I wanted to clear up the confusion about my subversive content."

He succeeded. *Little Murders* is a careening dystopian fable that keeps the audience off balance from start to finish, to the accompaniment of wailing sirens, gunshots, exploding trash cans, "intermittent power blackouts sending the stage into unexplained darkness," and the heroine of the piece being killed off in the middle of the play. The work's "atmosphere" was local—New York in the second half of the twentieth century—and only slightly exaggerated. Feiffer showed the play to a handful of friends he admired, including Mike Nichols, who Feiffer felt didn't get it, and Gene Saks, who also passed on it. Which makes sense to Feiffer in retrospect. "When I finished writing the play, in March or April of 1966, much of what was about to happen to the country"—the assassinations of Martin Luther King Jr. and Bobby Kennedy, the escalation of the war, draft card burnings, the rise of the Black Panthers, the American cultural revolution—"had not yet happened."

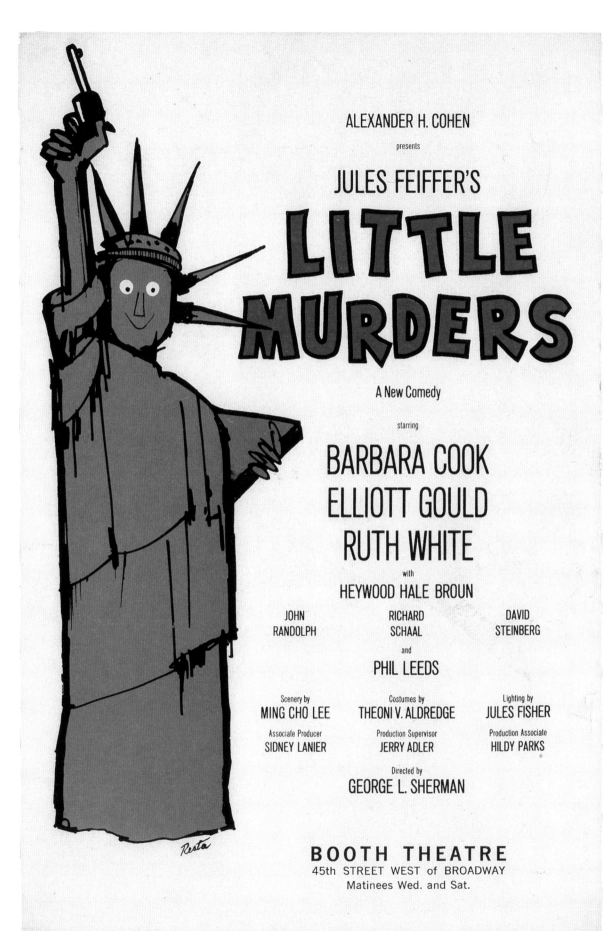

Feiffer commemorates the opening
of *Little Murders* for *New York*
magazine, then a supplement to the
World Journal Tribune, April 23, 1967.

PLAY ENTITLED "LITTLE MURDERS" AS PUT DOWN BY THE
TO PERFORMANCE IN ORDER TO KEEP A RECORD FOR
PHERS AND (HOPEFULLY) SYCOPHANTS . . . BY JULES FEIFFER

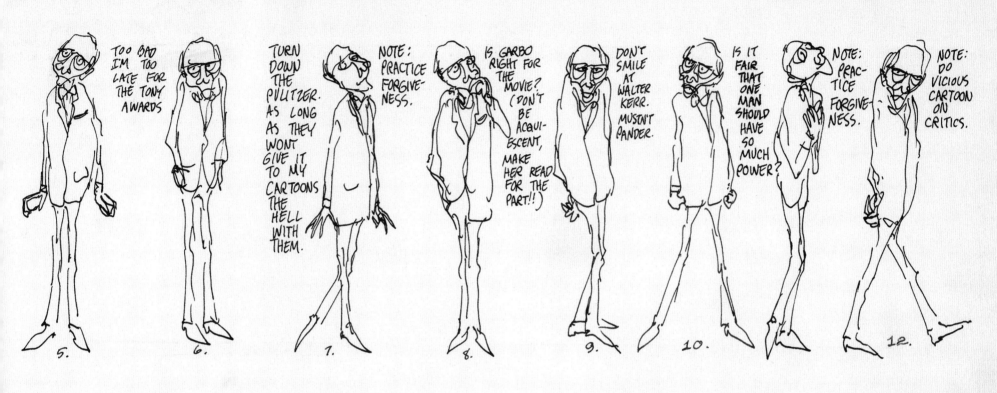

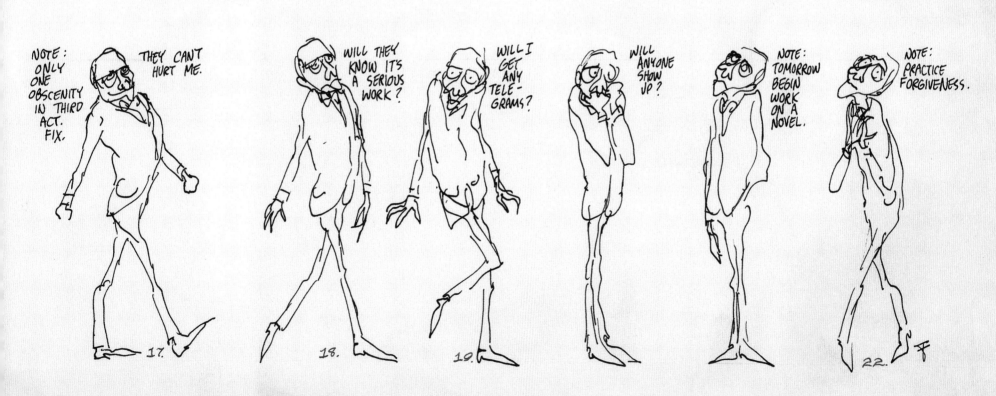

THE YALE SCHOOL OF DRAMA REPERTORY THEATRE PRESENTS

GOD BLESS

A NEW PLAY BY

JULES FEIFFER

Directed By
Harold Stone
October 10–26, 1968

Monday–Saturday Evenings 8:30
Saturday Matinee 2:30
Phone 562-9953

Yale University Theatre, 222 York Street, New Haven

Asked whether he didn't get or didn't like the play, Nichols said, "I liked it very much, but I also thought it wasn't for me. With Alan Arkin, it got its perfect director—and it was wonderful. Dark. Perfect."

The regional director Feiffer hired in lieu of Nichols or Saks, on the wild assumption that such a person would better grasp his absurdist material, turned out to have not a clue about how to stage the play, and as a novice himself, Feiffer had little ability to shape things once they were in production. "Actors were saying, 'I can't say *that*,' or 'I can't say *that*.' It was my first play, and when my actors asked if they could simplify their lines, I thought I was the problem. I gave them what they wanted, not realizing I was dismantling my play. What finally ran in New York was a shadow of the play I had in mind."

Despite a frenzied month of rewrites and Elliott Gould playing the lead role of the nihilist photographer Alfred Chamberlain, the Boston tryout was a train wreck. The regional director was fired and an accomplished British director, John Dexter, was brought in with just one week to pull things together in time for the New York opening on April 25, 1967. In Feiffer's opinion, Dexter came close. The performance on the last night of previews, before an audience made up mostly of theater people,

was so thrilling, he recalls, that he knew the miracle could not possibly repeat itself on opening night. Though the breakthrough use of the word "shit"—a first for Broadway—and the hilarious, non sequitur–rich dialogue drew howls of laughter from the audience (including from *New York Times* theater critic Walter Kerr), it didn't last. Four days later, after seven performances and a pummeling by Kerr and every other critic who came to see it, *Little Murders* was dead.

Two months later it was back on its feet and dancing in a hugely successful Royal Shakespeare Theatre production that discarded all the "fixes" made to the U.S. script and, after a failed appeal to the Lord Chamberlain's Office, substituted "dog crap" for "shit." The play's reception in London made an impression, or—as Feiffer puts it—it "reawakened the innate snobbery of American producers." Shortly after, Circle in the Square, one of New York's principal off-Broadway theaters, decided to mount a production, with Alan Arkin as director. Arkin recast the play entirely, staging it as an "all-out, over-the-top farce," but with a recognizable family at the center that made it possible for audiences to see themselves in the play, exactly as Feiffer meant them to. "They were watching their own families, and what they were seeing was insanity."

The play had its second New York opening on January 5, 1969, and this time around at least some critics got it. Among them was the *New York Times*'s Clive Barnes, the paper's British-born and Oxford-educated critic, who gave it a rave. He found the play "fantastically funny. But as you laugh—and perhaps I should warn you of this—your guts drop out."

A few Sundays later, Walter Kerr gave the play a mild thrashing that focused on technical failings, suggesting that even the "funniest of Mr. Feiffer's jaundiced visions" were somehow a distraction. But the same edition carried a celebratory piece on the play and the playwright by entertainment reporter Tom Burke that gave Feiffer a flashy forum to hold forth on what he had been aiming for. Characteristically, he didn't hold back, laying out his view of how the vast changes that had taken place in the twentieth century had left Americans confused and angry. Post-assassination, the country was "no longer the world they had been brought up to live in," he said. "And the men who hated the changes had to go out and shoot the men, the leaders, who were making them. So I wanted to take . . . a nice, Andy Hardy–type family, who depend on the old traditions . . . and show how, without ever questioning their own sense of rightness, they can become a tribe of killers. Just like Lyndon Johnson, without ever questioning his own sincerity or his Gary Cooper ideals,

can become a war criminal." In its second New York incarnation, *Little Murders* ran for almost a year and won an Obie; Linda Lavin won an Outer Circle Critics Award for Best Performance. A movie version starring Elliott Gould followed in 1971. Arkin returned as director, and Feiffer wrote the screenplay, adapting his play by adding new scenes and characters. The film received tepid reviews, although Roger Ebert in the *Chicago Sun-Times* wrote, "One of the reasons it works, and is indeed a definitive reflection of America's darker moods, is that it breaks audiences down into isolated individuals, vulnerable and uncertain."

Little Murders was followed within a few weeks by another Feiffer satire, *The White House Murder Case*, also directed by Arkin and staged at Circle in the Square. A political-farce-cum-whodunit that seemed to borrow giddily from the conventions of murder mysteries and Evelyn Waugh's *Scoop*, it posits America waging war against Brazil and tosses in an unfortunate friendly-fire incident that wipes out an American battalion with nerve gas; a cover-up; the murder of the president's wife; and more. In his paranoia-infused send-up of government incompetence, villainy, and self-righteousness, Feiffer anticipated Watergate by two years, and by one, his good friend Philip Roth's even more outrageous *Our Gang*—grizzlier and in considerably worse taste

"FUNNY, SAVAGE, BRILLIANT!"
—CLIVE BARNES, N.Y. TIMES

JULES FEIFFER'S
THE WHITE HOUSE
MURDER CASE
Directed by
ALAN ARKIN

● CIRCLE IN THE SQUARE
159 Bleecker Street, N.Y. Phone: 473-6778
Tues. thru Fri. 8:40; Sat. 7:00 & 10:00; Sun. 3:00 & 8:40

Once he started, Feiffer turned out plays almost yearly. In between the flop debut of *Little Murders* in 1967 and its Obie-winning year-long Circle in the Square run of 1969 came *God Bless* (opposite) in 1968, which had a brief run at the Yale Repertory Theatre in New Haven. *The White House Murder Case* (above) opened in 1970, a few weeks after *Little Murders* closed, and ran for 119 performances. That is, until Nixon invaded Cambodia and the play ceased to be satire.

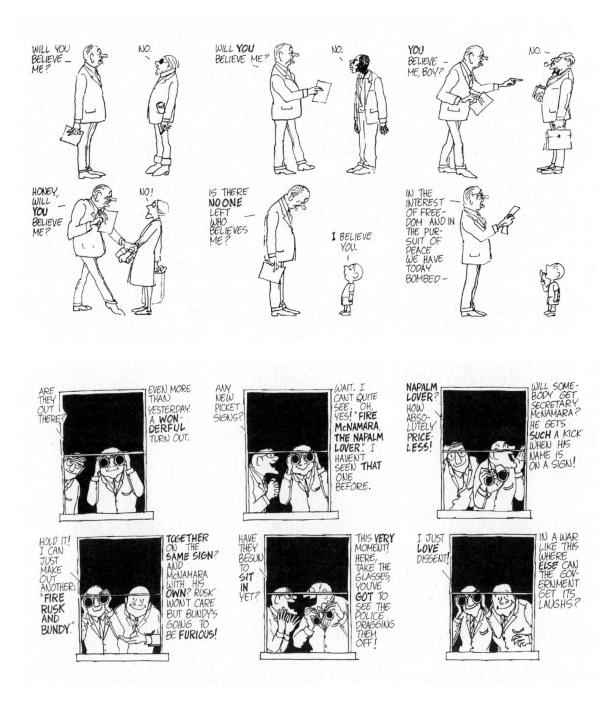

Feiffer did some of his fiercest work during the Vietnam War. Lyndon Johnson never failed to provide him with material (top, c. 1967). Robert McNamara, the Secretary of Defense Johnson inherited from Kennedy, was another favorite target (above, October 28, 1965); Nixon took over in 1969 (opposite, top, c. 1969–70); and the Pledge of Allegiance takes on new meaning in this *Voice* strip from May 19, 1968 (opposite, bottom).

than Feiffer's assault on authority, but also hilarious. The play got mostly positive reviews, and audiences turned up.

"A caustic roundhouse satirical swing at the hypocrisy of American politics and militarism," wrote Richard Watts of the (then) left-leaning *New York Post*.

"Throws a couple of dozen custard pies at that thing called the credibility gap," said a television reviewer.

While Clive Barnes of the *Times*, who had championed *Little Murders*, liked this slaughter play a lot less, his colleague Walter Kerr was newly converted and delivered his official theatrical benediction. "The new woolgathering cartoon that is spinning its blissfully corrupt web all over the open floor of Circle in the Square," he wrote, "seems to me to represent a marked advance, theatrically speaking, for the always outraged and occasionally outrageous Mr. Feiffer."

Murder Case looked set for a long run in 1970, but after President Nixon appeared on television the night of April 30 and disclosed that the United States had been secretly bombing Cambodia for months, Feiffer says, "audiences who were treating this as far-out satire stopped almost on a dime, because it had suddenly become too true to be funny." In mid-May, after 119 performances, *White House Murder Case* closed.

It was in some ways the perfect coda to Feiffer's early theatrical adventures, one he might almost have invented for the weekly strip, which had continued uninterrupted and grown more consistently political as U.S. involvement in Vietnam deepened. In the year after Kennedy's assassination, Feiffer had been surprised to find himself liking Lyndon Johnson and regretting the loss of a target. "As a political satirist, my pen only works where it can hurt," he wrote in "Here Lies Lyndon," his chapter on Johnson in *Jules Feiffer's America*. Johnson was crass, but he was also "the nation's number one civil rights leader . . . with the leadership skills to pass the kind of legislation he had buried in the Senate during his years as Majority Leader. . . . He behaved like a reformed gangster; he had the faith. . . . So Johnson was good for the country but killing my business. Until he started bombing North Vietnam."

From early 1965, when the bombing campaign—titled Rolling Thunder—began, until Johnson left office in January 1969, Feiffer never let up. The Vietnam War inspired some of his best, most stinging work, but Johnson was never his only target, and Feiffer never ran out of ammunition. And when Johnson was replaced in the White House by Nixon, the change didn't put him out of business.

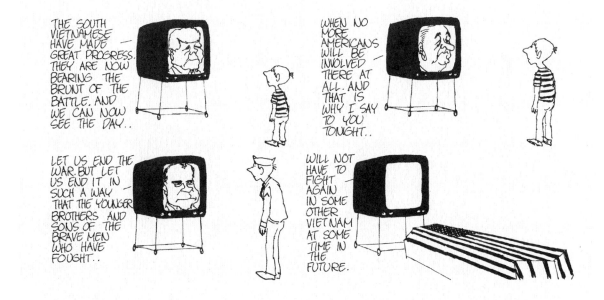

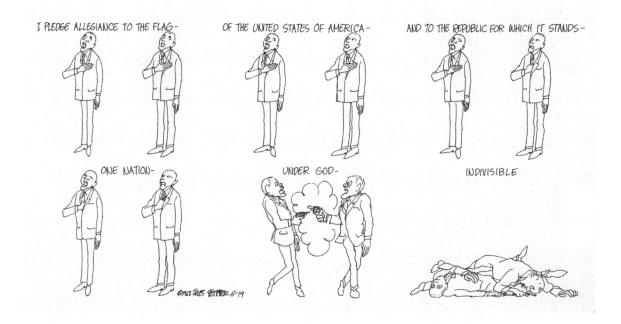

By early 1969, after his second trip to Yaddo, Feiffer had completed his third original play, *Carnal Knowledge*, a deeper, darker exploration of a subject he had been plumbing since his earliest strips—sex.

"I was conscious that I was trying to straighten out misconceptions. People were talking about sex in the Kinsey Report and Masters and Johnson. I wanted to get at what people were *not* talking about. That's what got me into *Carnal Knowledge*. Heterosexual men of my generation loved getting laid, and they loved the power of conquest over a woman, loved being seen with a gorgeous woman. And they loved tits and they loved ass, and what they didn't love was conversation. What they didn't love was strong women. They didn't want somebody who was smart, or could dominate the conversation, or who knew more about their subject than they did, or as much about their subject as they did. And these were the women that they fled from. And if they had sex with that woman because she might have been beautiful, and they might not have known what they were getting into in the bar, once they became aware that she had to be dealt with and she couldn't be condescended to, it put them on the defensive. Then she was a ballbuster."

Feiffer sent the play to his friend Mike Nichols, who had just won an Oscar for *The Graduate* and with whom he was once again on speaking terms after a cool stretch over *Little Murders*. Nichols responded the next day. "He said, 'I think it's a movie. I'd like to do it as a movie,' and I said, 'Give me thirty seconds to think about it.' And we went ahead."

"Making *Carnal Knowledge* was sort of the perfect experience from first to last," Nichols recalled. "From play to screenplay, Jules and I did it together. It was not serious rewriting, more a question of turning the play dialogue into movie dialogue."

"It was like a tutorial on writing and editing," says Feiffer, and he had the time of his life making the film.

Nichols's memories were similarly golden and detailed. Filming began in the fall of 1970 in Vancouver, "which would stand in for various other places in the film. It was warm weather. Everybody loved the script and loved Jules. And Jules loved everybody back.

"I don't think there was a *logical* reason for doing *Carnal Knowledge*," Nichols said. "It was something I knew about. Jules's sense of comedy and sense of drama is very close to mine, and we both liked the idea of something being funny and startling or scary at the same time. *Carnal Knowledge* was about a certain generation of American men, which Jules and I were both in. We both knew that complex neurosis about women, not necessarily in ourselves, but

in guys we were friends with and basically all around us.

"I was also very interested in making a movie about those who didn't have a voice—the women. Guys carried the movie because it was about guys and sex and love. I wanted to focus on the women even though they didn't have much to say.

"It was a little like what [Matthew] Weiner is doing with *Mad Men*, and very unlike [Clare Boothe Luce's] *The Women*, which I hated—women expressing the capitalist contest [through rivalry and backbiting].

"I saw that period as more like an underground railroad of women, who helped each other when they could. The women in *Carnal Knowledge* didn't know one another and couldn't help one another, but they were really the ones the movie was about."

After seeing an early cut of *Easy Rider*, Nichols offered Jack Nicholson the part of Jonathan Fuerst. Nichols also cast musician Art Garfunkel as Sandy; twenty-four-year-old Candice Bergen as Susan, the smart college girl who takes up with Jonathan and later marries Sandy; and the voluptuous Ann-Margret, a veteran at playing sex kittens, as Bobbie, the heartbreaking "ballbuster."

Carnal Knowledge was released in the summer of 1971, in the midst of multiple and overlapping cultural upheavals—the antiwar

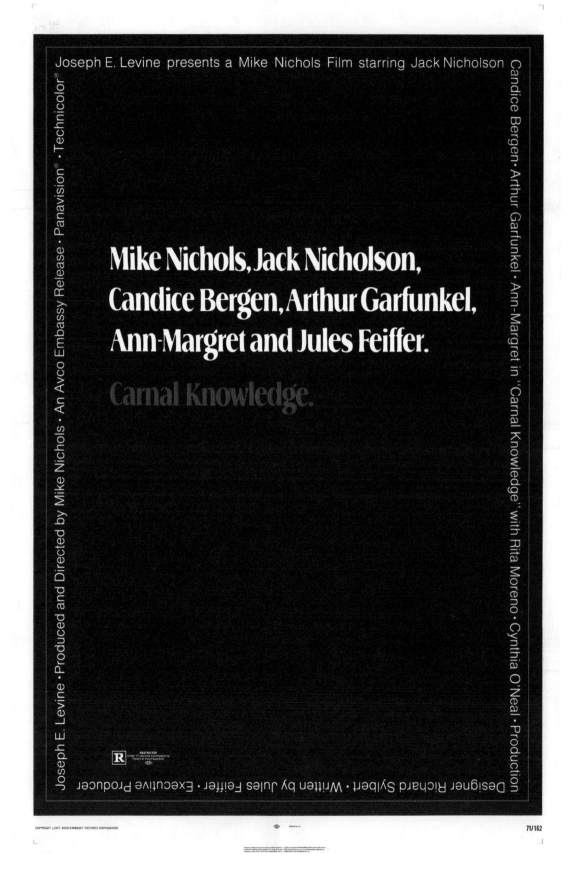

movement, the intensifying black power movement, a sexual revolution that was turning families and generations upside down, and a recently revived women's movement that was just gaining strength. It received overwhelmingly favorable reviews from critics, who took the film seriously.

"*Carnal Knowledge* represents a nearly ideal collaboration of directorial and writing talents," wrote Bosley Crowther in the *New York Times* on July 1, 1971. "Because the sexual fantasies shared by Jonathan . . . and Sandy . . . have their origins in post–World War II middle-class America, their defeats and their confusions, and their very occasional adjustments, are also a reflection of forty years of social and political history." Crowther went on to compare Feiffer's

screenplay to his strips, but even Feiffer understood that this was meant not as a slap-down in the least, but as high praise. Bad news lurked in the background, nevertheless.

"*Carnal Knowledge* got great reviews," says Feiffer. "The New York critics loved both movies [*Carnal Knowledge* and *Little Murders*]. And the LA critics loved both movies. *Carnal Knowledge* did very good business. But the movie industry hated the movie, and when awards time came, it didn't exist. [In fact, Ann-Margret was nominated for Best Supporting Actress but lost to Cloris Leachman in *The Last Picture Show*.] After *Carnal Knowledge* and *Little Murders*, I did not get a single offer to do a screenplay until Robert Evans called me ten years later to do *Popeye*."

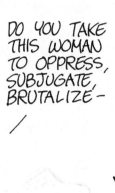 DO YOU TAKE THIS WOMAN TO OPPRESS, SUBJUGATE, BRUTALIZE—

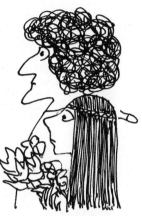 AND REDUCE TO A STATE OF ABJECT GUILT AND CHILD LIKE DEPENDENCE? I DO.

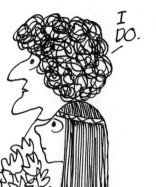 AND REDUCE TO A CONDITION OF SERVITUDE AND SECOND CLASS CITIZENSHIP? I DO.

 I NOW PRONOUNCE YOU HUSBAND AND WIFE.

 DO YOU TAKE THIS MAN TO ALIENATE, DOMINATE, EMASCULATE—

 NOW WE WORK IT OUT.

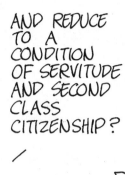

The war between the sexes had been playing out in Feiffer's strips since the beginning. In the seventies, its vocabulary shifted from the psychological to the political, but Feiffer didn't miss a beat, as in this *Voice* classic from December 13, 1970.

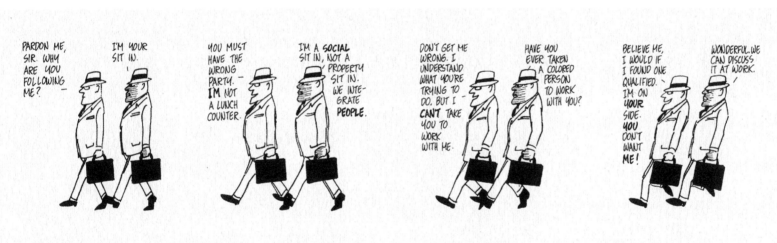

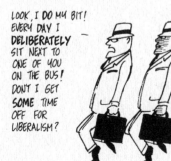

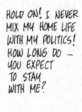

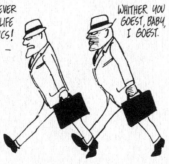

"AND NOW, THE FINAL CHAPTER IN TONIGHT'S SHOW." "LADIES AND GENTLEMEN!"

"I'VE JUST LEARNED WE HAVE SOMEONE VERY SPECIAL IN OUR AUDIENCE – MR. BERNARD MERGENDEILER! PERHAPS WE CAN COAX HIM UP HERE TO FAVOR US WITH ONE OF HIS IMMORTAL SONGS AND TAP DANCES!" "WELL, GEE – YAY! PHWEET! BERNARD!"

"LET'S GET HIM UP HERE, BOYS, PLAY HIS THEME!" "OH, I'M PUTTING ON MY HOMBURG, PUTTING ON MY REP TIE, PUTTING ON MY – YAY! HERE HE COMES!" "WELL GOSH-GEE, GOSH-" PHWEET!

"AND AS A BONUS SURPRISE – SITTING OUT FRONT UNBEKNOWNST TO BERNARD IS HIS FORMER DANCING PARTNER, MISS GINGER MURCH!" "GINGER! GINGER! PHWEET! "GINGER!" "BERNARD!"

"I WAS A FOOL, GINGER!" "WE WERE BOTH FOOLS, DARLING! BUT WHAT DOES IT MATTER? WE'RE TOGETHER AGAIN!"

" TOGETHER AGAIN! TELL THE WORLD THAT WE'RE TOGETHER AGAIN! THROUGH THE STORMY WEATHER AGAIN, FOREVER AGAIN, TOGETHER AGAIN!" "RAY! PHWEET! RAY!

"THAT CONCLUDES TONIGHT'S 'LATE, LATE FANTASY.' TUNE IN TOMORROW WHEN YOU WILL BE HUMPHREY BOGART."

GREAT IDEA FOR A SHOW.

ONE NIGHT, DRIVING HOME TO EVENING COCKTAILS, I WAS – SUDDENLY STRUCK THROUGH THE WINDSHIELD BY THE RAYS OF THE FULL MOON.

AND I GREW BODY HAIR, POINTED EARS – CLOVEN HOOVES, AND A TAIL.

AND I THOUGHT "AT LAST! IT'S THE REAL ME!" AND WITH FEAR SECRETLY MINGLED WITH DELIGHT I ARRIVED HOME –

WHERE MY WIFE SAID, "YOUR DINNER'S COLD – AND STOP LOOKING AT ME IN THAT ACCUSING WAY!"

AND MY SON SAID, "ALL THE OTHER – DADDIES ARE GOOD AT FIXING THINGS, YOU'VE GOT FINGERS LIKE CLAWS!"

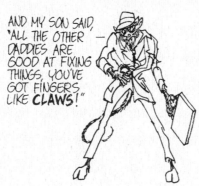

AND MY LITTLE GIRL SAID, "WHY DO I HAVE TO HAVE THE ONLY FATHER ON THE BLOCK WHO'S DIFFERENT?" –

SO I ATE THEM ALL UP. –

WEREWOLVES REALLY SHOULDN'T MARRY. –

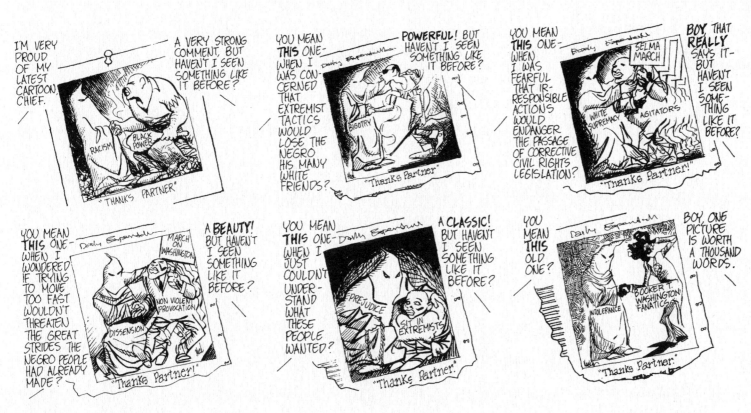

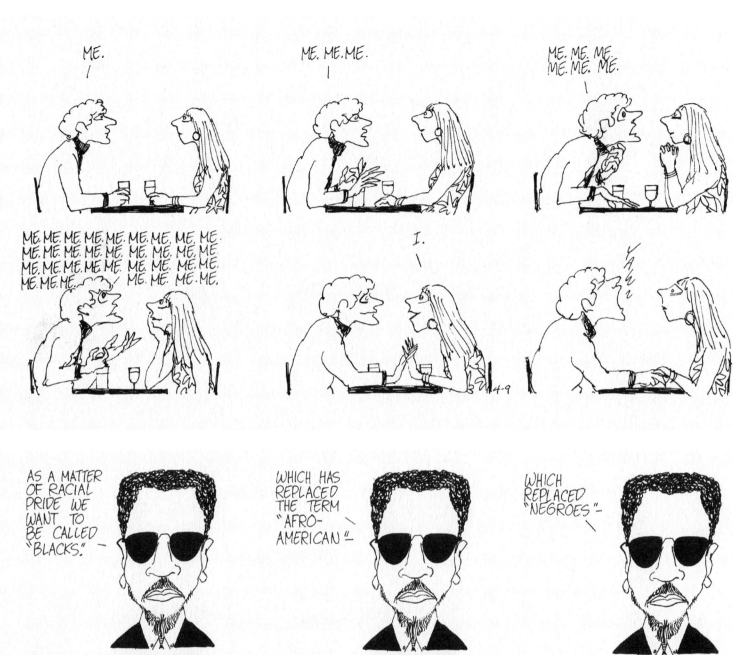

OPPOSITE, TOP
April 21, 1966.

OPPOSITE, BOTTOM
August 18, 1966.

ABOVE RIGHT C. 1967.

RIGHT C. 1968.

In March 1969, eight antiwar activists who had participated in protests at the Democratic National Convention in Chicago the previous August were indicted on charges of conspiracy and incitement to riot. The eight defendants—Rennie Davis, David Dellinger, John Froines, Tom Hayden, Abbie Hoffman, Jerry Rubin, Bobby Seale, and Lee Weiner—were originally known as the Chicago Eight, until Bobby Seale (one of the cofounders of the Black Panther Party, whose protests in court led judge Julius Hoffman to order him physically constrained and literally gagged) requested a separate trial, after which they were referred to as the Chicago Seven. Feiffer spent more than four months (between September 24, 1969, and February 18, 1970) observing the trial and sketching the defendants, the lawyers, Judge Hoffman, and others present in the courtroom. Feiffer's drawings, with quotes from the subjects and a transcript of the trial, were published in book form in 1971 as *Pictures at a Prosecution: Drawings & Texts from the Chicago Conspiracy Trial*.

Featured here is a selection of Feiffer's more than two hundred and fifty trial sketches.

CLOCKWISE FROM TOP LEFT Jerry Rubin, Bobby Seale (gagged), Abbie Hoffman, judge Julius Hoffman (appears twice, far right), Bobby Seale (pointing), Abbie Hoffman, and Allen Ginsberg (observing, not on trial).

Hoffman

I have literally known thousands of
what we used to call Negro people.

I don't want to hear another thing
about the black man.

I'm about as good a friend of the
black people in this community
as they have.

That is a lie. I never attacked anyone and you know it. I never struck
anyone and you know it.

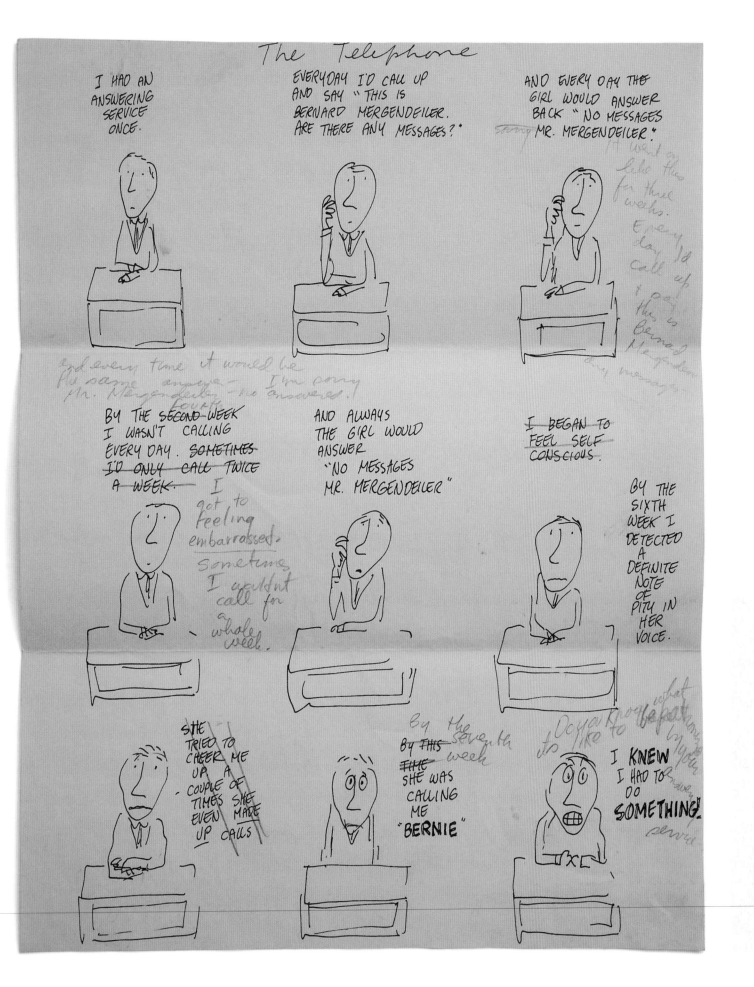

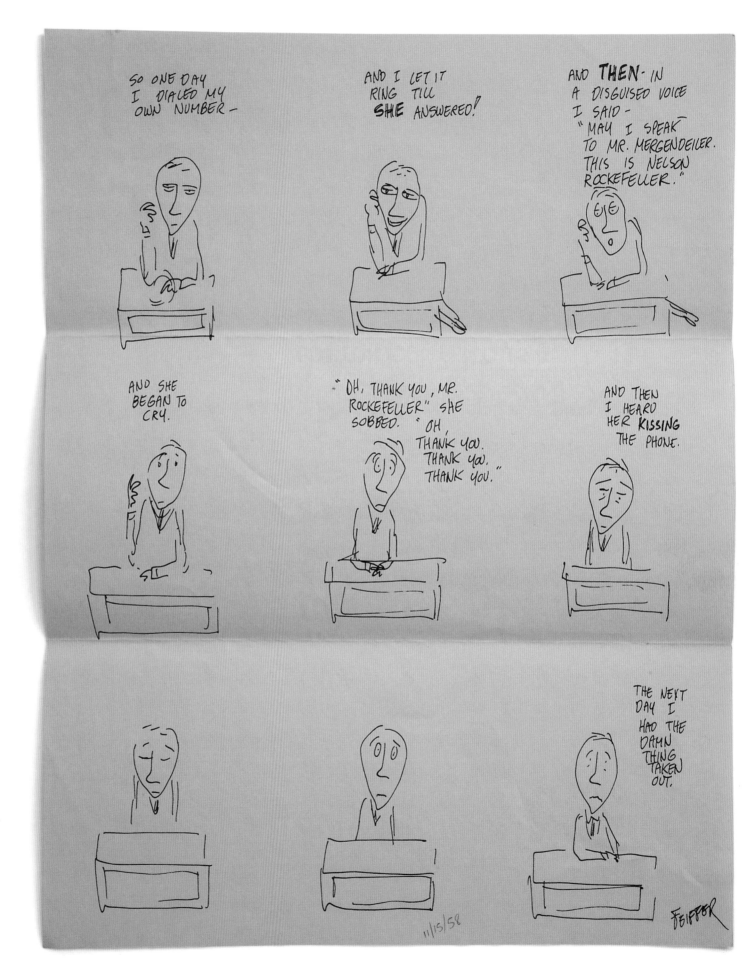

"The Telephone." Feiffer recalls these annotated roughs for a Bernard strip as having been rejected by *Playboy* (the notes are possibly from Hefner). Feiffer later shortened the two-page gag to use in the *Voice* (detail, opposite), where it ran on November 19, 1958.

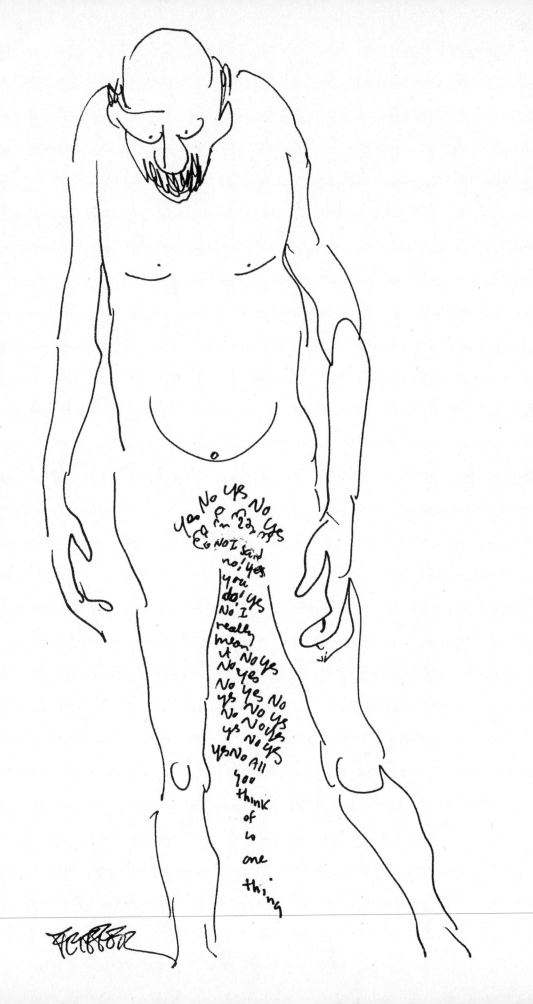

The Grown-up

The only reason I ever wrote a play was because I felt the need to write a play. And then I would find a subject to write about. The only reason I ever wrote a screenplay—apart from Little Murders *and* Carnal Knowledge—*was because a producer approached me and wanted me to write a screenplay and there was a lot of money involved.*

JULES FEIFFER

nyone paying only intermittent attention to the arts in the quarter century that encompassed Feiffer's "middle period" could be forgiven for wondering whether there were several New York–based artists signing work with the same name. So prolific and varied was the output—political cartoons, social satire, plays, straight novels, nonfiction, illustrated novels, film scripts, and children's books—that it seemed as if a team of Feiffers was hustling assignments, not one lone Bronx boy who had made good.

The themes remained largely consistent—the childishness of adults, the joy-throttling effects of marriage, the venality of politicians, and the smugness of the middle class—even as the formats and the balance between drawing and prose varied. Feiffer would conceive and carry out some of his strongest work in this period, and some of his favorite, including his first graphic novel (*Tantrum*) and his third screenplay (*Popeye*). Though Feiffer often felt he was repeating himself in his *Voice* strip, his fans didn't, and the zeitgeist never failed him.

Heading into his fifties, Jules Feiffer remained as devoted an icon buster as he had been at twenty-five, holding fast to his early reputation as a perceptive assessor of American culture and taker of exception to received wisdom in the arts, in public mores, and especially in politics.

As a political satirist, he could not have asked for better targets than those America offered up in this period. From the late 1960s through the mid-'70s, the cast of characters he had to play with was of Shakespearean dimensions: Richard Nixon, Henry Kissinger, the White House Plumbers,

Feiffer's self-portrait, rejected by *Playboy,* c. 1990.

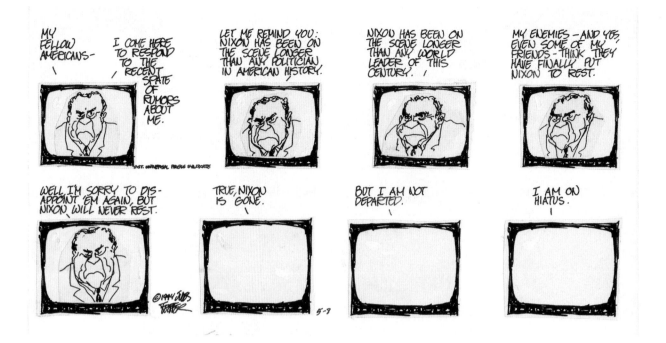

The Nixon years were golden ones for cartoonists, comics, satirists, and the press. Feiffer made the most of them, start to finish. Above, original art for the *Village Voice*, May 8, 1994, a month after Nixon died. Opposite, while still in office, c. 1974.

H. R. Haldeman, John Ehrlichman, Chuck Colson, and John Dean. For the remainder of the decade, Feiffer had Gerald Ford and Jimmy Carter to kick around. In 1980, the cartoon gods presented him with Ronald Reagan, Manuel Noriega, Iran Contra, and the collapse of the Soviet Union. Feiffer's political work grew sharper and his pen more pointed, but the close resemblance of his political villains to the rest of the self-deceiving human race remained.

"His politics were coming from the left," says Steven Heller, a former art director for the *New York Times* and a prolific author on graphic art and design, "but they were never ideological or programmatic. He saw both the humanity *and* the folly.

"For the book we did together [*Jules Feiffer's America*], it was his idea to break it up into presidents. It was natural for him to break the subject into human units rather than political themes."

Victor Navasky, a longtime editor of the *Nation* and founder of a short-lived political satire journal in the 1950s called *Monocle*—which he tried, and failed, to get Feiffer to contribute to—makes a point of the evenhandedness in Feiffer's satire. "What he could never accept," says Navasky, "was hypocrisy. So he would ridicule the people who were saying things that he believed in, when they were being pretentious, when they were being self-regarding, and when they were reacting reflexively, so you could sort of predict what their position would be. When Jules took on national figures, again what he zeroed in on was the hypocrisy, rather than a political analysis of their position on a subject.

"The combination of the apparent simplicity of the line with the very clear-sighted

I STONEWALLED THEM ON THE WAR.

I STONEWALLED THEM ON THE COVER-UP.

I STONEWALLED THEM ON THE TAXES.

I STONEWALLED THEM ON THE TAPES.

I STONEWALLED THEM ON THE COURTS.

I HAVE NOT YET BEGUN TO STONEWALL.

Henry Kissinger was another favorite target of Feiffer's: 1975 (left); c. 1969–70 (opposite, top); and c. 1973–74 (opposite, bottom).

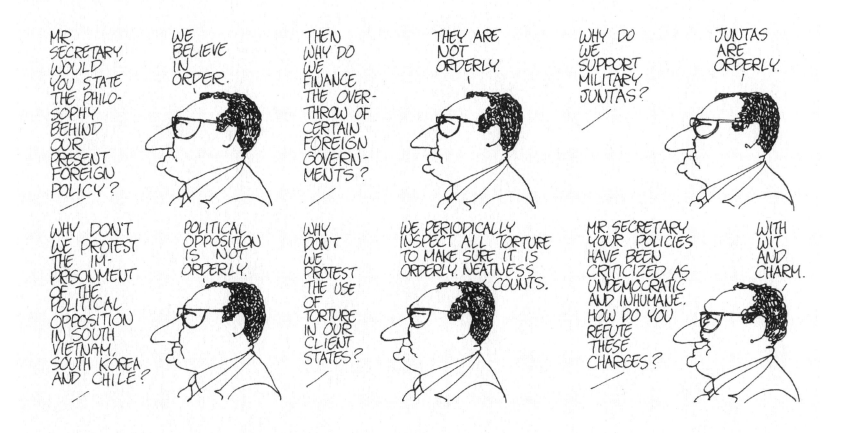

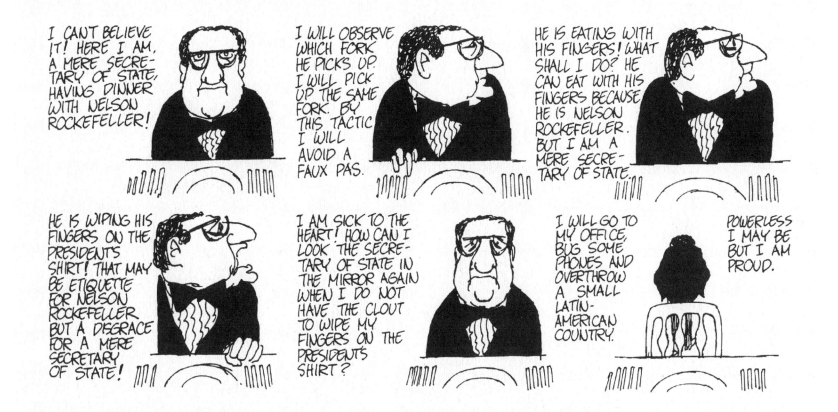

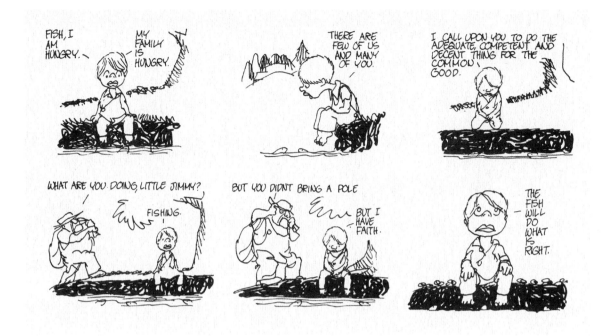

radical questioning of what is at the heart and the root, the fundamentals of a subject—whether it's human relationships or political absurdity or the arms race—is part of what gives his work its power. Jules has the power to reduce everything to its essence."

In a speech Feiffer gave in the fall of 2006, in connection with a retrospective of his work at the School of Visual Arts in New York, he characterized his early political and social commentary at the *Voice* as a matter of simply trying "to reflect what was going on. How do I put this politely? They"—adults, politicians, ad men, the army—"were lying to us. What I got in response after just five weeks at the *Voice* was not 'how interesting!' but 'how do you get this into print?' College-educated middle-class kids didn't think they *had* First Amendment rights. What they really felt, they said in private."

How Feiffer got his work into print was by stealth and craft—sneaking up on readers and making canny use of "the device of the six- or eight-panel strip that led to the final punch. I was dealing with violent subject matter in a quietly seductive way."

It was not so much hypocrisy that he was going after all those years—hypocrisy being a given in political life—as much as "the abuse of language, in a world where it became the norm to say one thing and mean another. The job has always been finding a way to say—amusingly—what's really going on, to figure out for the reader what is really being said."

In 1986, six years into his "Reagan period," Jules Feiffer won the Pulitzer Prize for editorial cartooning. Though he was not

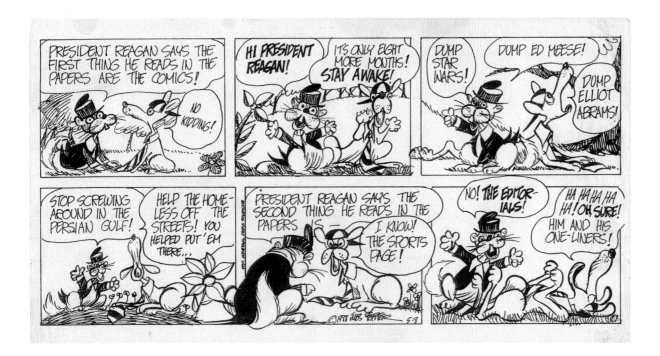

surddenly that he hadn't won previously—he was nominated in 1981—he privately felt he should have, and so did many of his peers.

"Years earlier, when I was doing a lot of strips critical of the Vietnam War, before it was respectable to be against it, I ran into Roger Wilkins, and he said, 'You'll never get the Pulitzer—you're just too hot for them.'" Wilkins was a civil rights lawyer, a former assistant attorney general in the Johnson administration, and one of four *Washington Post* staffers who jointly won a Pulitzer Prize in 1972—the others being Bob Woodward, Carl Bernstein, and the cartoonist Herbert Block—for the *Post*'s role in uncovering the Watergate cover-up. "In 1986, Roger was on the Pulitzer board with Russell Baker, and I got it. Also in my corner that year would have been Oz Elliott, Jim Hoge, and a couple of others.

"It may also have been one of those occasions when the Pulitzer board decides to play catch-up and gives awards to mavericks. The year before, Murray Kempton had won it for commentary. In 1986, Jimmy Breslin did. But what was as important—or more important—to me than getting the Pulitzer was knowing what I meant to my colleagues. Two or three years earlier, three cartoonist friends of mine—Tony Auth of the *Philadelphia Inquirer*, Mike Peters of the *Dayton Daily News*, and Doug Marlette, at the *Atlanta Constitution* and *Charlotte Observer*—presented me with a mock Pulitzer. All of them had won or would win Pulitzers [Auth in 1976; Peters in 1981, beating Feiffer; Marlette in 1988], so that meant a lot to me. As did [*Los Angeles Times* editorial cartoonist] Paul Conrad's comment, two years before I won. Conrad had just won his third

OPPOSITE, LEFT New York *Daily News Magazine* cover, March 5, 1989.

OPPOSITE, RIGHT Feiffer sent up Jimmy Carter's naive pieties with a missing fishin' pole, *Village Voice*, c. 1977–81. "He was hell to draw," he said of Carter in his notably short introduction to the Carter chapter of *Feiffer's America*. "His image slipped off the page, vanished like the Cheshire Cat."

ABOVE Feiffer consulted his inner Walt Kelly to do justice to Ronald Reagan a decade later, on May 8, 1988.

Pulitzer, and I happened to be in LA when he had a party to celebrate it, and in his response to a toast, he raised his glass and said that he wouldn't consider his Pulitzers legitimate until I'd won one."

When the prize did finally come Feiffer's way, his reaction, quoted in the *New York Times*, was measured and completely in character: "I get one [of these] every thirty years whether I deserve it or not."

From a distance, Feiffer in this period appeared to be the consummate insider—a late-night regular at Elaine's, a householder on Martha's Vineyard, a member of the Century Club—but in his head he remained an outsider, and he husbanded the role faithfully. Though he was eager for his work to be appreciated and praised, as a matter of instinct and experience he was suspicious of the official stamp of approval, and his opinion of critics and their quick judgments was not far removed from his opinion of heads of state or corporations.

Two years after he won the Pulitzer, Feiffer sat for a series of interviews with Gary Groth, editor of the *Comics Journal*, that stands as probably the best record of what he was thinking and caring about at midcareer; the interview included an extended digression on critics, prompted by a recent Groth editorial, "Will Eisner: A Second Opinion," that

criticized Eisner's later work. Feiffer objected to both the "rush" to judgment of an artist who had waited years for a round of applause and to the absurd expectations Groth and others used to measure his mentor's achievements. Why, he asked Groth, was it necessary "to look at Eisner's work and say, 'Was there Hemingway in there? Where's the Fitzgerald here? Where's'—for Christ's sake—'Proust in here? Where was Joyce? Where are his influences?' I guess what I find disturbing about all this goes beyond what you wrote: There is something about the nature of criticism in America, which I find comics imitating in its worst forms. . . . I see more about the Eisner criticism industry than about Eisner, and that seems right in keeping with American criticism, whether it's in literature or theater. It's about each other.

"And what reviewers review are each other's reputations. . . . The work in question becomes secondary. . . . It's essentially raw material to prove that the other guy is a schmuck and you're a lot smarter than he is. I think that very honorable careers, of people who've established themselves and done good work over the years . . . are disposed of here like fast food or old cars, because we have no further use for them, because we fast-track. Because too much has been written about this guy already, and I can't get in on that, so

what I *can* do is take the people who've liked him apart, because I've got my guy. And this internecine warfare lays waste to some serious people who have done serious work, whether it's Will Eisner, Edward Albee, Tennessee Williams, or Arthur Miller. I've seen too much of it, and it really appalls me."

The observation is especially interesting because Feiffer had not yet felt himself the victim of unfair criticism. His position was one of solidarity with other artists, especially in support of their right to experiment and fail—a right he claimed for himself. His novice efforts in both theater and film had been critically successful, but his engagement with theater would prove more important to him and much more fraught—a love only intermittently requited.

Between 1971 and 1990, Feiffer would write six full-length plays and a short sketch for a public television special called *VD Blues* (1972). He got superb reviews for three of the complete plays, including *Knock Knock* (1976), written after the breakup of his first marriage. It was a comic fable that brought together a fetchingly armored Joan of Arc and two crotchety old Jewish men who had been sharing a cabin in the woods for far too long. The story delighted critics, including Mel Gussow of the *New York Times*—"If Saul Bellow had written *The Sunshine Boys*, it might have

The B-movie president was a bonus subject for Feiffer (opposite). In 1986, Reagan's fifth year in the White House, Feiffer won the Pulitzer Prize for editorial cartooning. He lived up to his reputation by regularly dissecting Reagan's successor, George H. W. Bush (above).

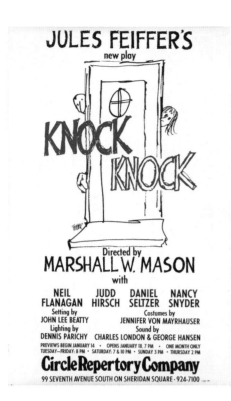

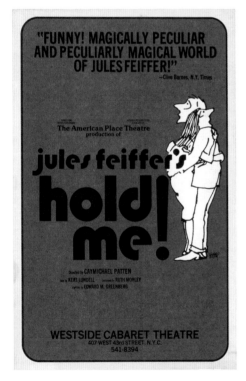

Feiffer had back-to-back theater hits in 1976 and 1977. *Knock Knock* (top) was a comic fable. *Hold Me!* (bottom) was a cabaret revue based on his *Voice* strips.

turned into something like *Knock Knock*"—and *Time* magazine's Ted Kalem, who called it a "laugh-saturated miracle play in the absurdist tradition" and reached for a comparison much like Gussow's: "It's as if someone had merged *The Odd Couple* and *The Sunshine Boys* and peppered the mix with Kierkegaard and the Marx Brothers. . . . The unifying element is Jewish humor—skeptical, self-deprecating, fatalistic, and with an underlying sadness that suggests that all the mirth is a self-protective mask hiding imminent lamentation."

Feiffer himself called his next effort "an entertainment." *Hold Me!* (1977) was drawn from *Voice* strips, but it added up to a play in the way he felt Second City's production of *The Explainers* (also based on his *Voice* strips) had not years earlier. Critics agreed, and he landed a hang-on-the-wall review from Clive Barnes right out of the box: "Remember when Harold Pinter, once asked what his plays were about, suggested, 'the weasel under the cocktail table'? Mr. Feiffer writes about the cockroach under the sink, the daffodil under the heel, and the analysis under the couch."

Walter Kerr, who could run hot or cold on Feiffer, loved the play as well, calling *Hold Me!* a "delectable cabaret-style revue."

Five years later, on July 4, 1982, Kerr would spend five overstuffed paragraphs not getting to the point before finally delivering his verdict on Feiffer's latest play in prose that veered between genuflection and apology. He admires Feiffer, he is reluctant to speak of his play because he so admires his cartoons and because he has liked at least one other Feiffer play, but the tormented critic did not like *A Think Piece* one bit, finding it "unfunny, unpersuasive, and downright trying."

The feeling was close to universal, and three decades later Feiffer concedes that the critics had a point.

A brief hiatus in Feiffer's playwriting schedule followed *Hold Me!*, not because of scalding reviews but because nearly a decade after *Carnal Knowledge*, he finally got an offer to write another screenplay. The call came from producer Robert Evans, whose most recent films included *Chinatown* (1974) and *Marathon Man* (1976) and who wanted to make a movie based on the original E. C. Segar *Popeye* comic strip, one of Feiffer's childhood favorites.

"His executive producer was Dick Sylbert," Feiffer recalls, "who had been the production designer on *Carnal Knowledge*, and we were good friends. Evans asked Sylbert who could write the screenplay, and Dick said, 'The only one who could bring any life to these characters is Feiffer.' So Evans called me up."

The experience turned into a memorable Hollywood farce in its own right: There were endless rewrites, and the Oscar-winning lead,

Dustin Hoffman, whom Feiffer had known casually since Hoffman's early days in New York theater, demanded that Feiffer be replaced as screenwriter. When Evans—who loved Feiffer's script—refused to can Feiffer, Hoffman quit. He was replaced by Robin Williams, the star of the hit TV show *Mork & Mindy*, making his Hollywood feature film debut. Feiffer delighted in both the writing of the screenplay and the wild ride director Robert Altman took cast and crew on in the course of filming—fifty miles south of Sicily, in the middle of the Mediterranean, on the stony island of Malta.

Altman ordered up a rickety Dr. Seuss sort of a set, crosshatched with perilous walkways and tipsy, collapsing houses, and predictably he abandoned the script. The movie that got made bore little resemblance to the one Feiffer had written, but thirty years after the fact, his recollection of one of the better-known debacles of twentieth-century filmmaking is interesting for its almost cheerful dispassion and objectivity.

"No one ever liked working with Altman. He never believed in character; he never believed in motivation; he never believed in story; he never believed in dialogue—or in characters being heard—so why would any writer like him?

"Yet it was fun to see him at work because it was play for him, and he had such wonderful visual ideas. He created some kind of magic on the screen—he made it mysterious and you would follow along. It's certainly improvised. He knew what he wanted to do, but he kept from us what he was really doing. And while he was shooting my screenplay for *Popeye*, he was shooting an alternate version of the movie that he really wanted to make."

Despite *Popeye*'s reputation in the media as a major flop, Feiffer says, the movie made money—"and still does. It's the only film I still get royalties on to this day." It also led to a lot of well-paid work at the time. "Evans was a wonderful publicist for me, telling everyone, 'What a wonderful screenplay Jules Feiffer did for me.' And suddenly I was getting offers. Evans is a big guy out there, and very commercial, so if Bob Evans likes my stuff, then I guess I'm OK.

"What would happen is either Robbie Lantz [Feiffer's theatrical representative] or Nancy Roberts [Lantz's West Coast representative] would be approached by a producer, saying, 'We have a project we'd like Jules to work on.' He or she would call me up and say, 'Is this of interest to you?' I would say, 'Sounds like it might work.' Then the producers would come to New York, and they'd be very charming, and they'd want to do anything I wanted to do, and we'd be friends for life. And then you write the first draft and suddenly the screws are on and the charm is off.

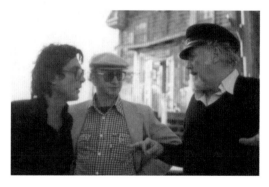

Almost a decade after *Carnal Knowledge*, Feiffer was asked to write a screenplay based on E. C. Segar's original *Popeye* for director Robert Altman. The film starred Robin Williams as the Sailor Man and Shelley Duvall as his girlfriend, Olive Oyl. Altman blithely ignored much of Feiffer's script, but the movie brought him multiple assignments for pictures that never got made. Top, *Popeye* movie poster from Paramount Pictures, 1980. Above, Feiffer on set with producer Robert Evans (left) and Altman (right).

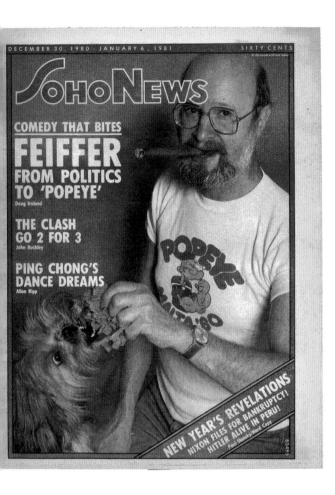

ABOVE Feiffer makes the cover of the December 30, 1980–January 6, 1981, *Soho Weekly News* to promote *Popeye*.

OPPOSITE, TOP *Grown Ups,* directed by John Madden, had its West Coast premiere at the Mark Taper Forum in Los Angeles, March 24–May 8, 1983.

OPPOSITE, BOTTOM Poster for *Elliot Loves,* directed by Mike Nichols, which ran at the Promenade Theatre in New York from December 2–20, 1990. The play, starring Anthony Heald, Christine Baranski, Oliver Platt, and David Hyde Pierce, took such a beating from critics that Feiffer vowed he would never write another play. He did, but not for another thirteen years.

"It's all about control, and this is the way they work. Even the nicest ones work this way. And they're all nice in the beginning, and they know what they want from the beginning. But they also know that if they tell you what they want from the beginning, you're not going to want to write it. So they give you all the freedom in the world in the beginning, knowing that the first draft is bullshit. That's to get the writer's rocks off and get him interested and get him on track. Then they start moving in with their control. Then if you want your swimming pool, or you want your kids to go to a better school, or all of that—they, incrementally, tear apart what you've done and put in what they've done under your name. By the third draft the writer is little more than a stenographer desperate to get it over with and will do anything they tell him just to get the fucking thing out of the way.

"This is an age-old procedure. It's done to everybody, not just me. It's not about quality; it's about control. It's not about doing good work; it's about the producers' egos, and their need to put their imprint, however flawed, on every piece of writing you do. They're not interested in good writing. They're not interested in good work. They're interested in their power, and controlling."

Asked why he thinks he continued to get offers, Feiffer offers a variant on the rejections of his early years: "They love the idea of me. They just don't like the fact of me."

In 1980, just before *Popeye* was released, Feiffer completed *Grown Ups*, a play he had begun in 1974, in the wake of his mother's death, but left unfinished for years.

Feiffer's relationship with his mother was the most complex and formative of his life, and he mined it for gold in this most scalding and personal of his plays—an exorcism of the demons and disappointments of childhood that, for all its venom, had the effect of softening the hard line he had taken on his parents since he first noticed he was smarter than they were. "I don't think I would have had the chutzpah or the callousness to do this radical surgery on my parents while they were alive," he told Michiko Kakutani for a piece that appeared in the *New York Times* on December 15, 1981, the first week of the play's Broadway run. "And it wouldn't have been possible, really—it's only when they're ghosts that you can go back and review it all. And, you know, I found partly that I really liked them."

Feiffer earned not one but two over-the-top reviews from the *New York Times* for *Grown Ups*, both of them written by the paper's very young (at thirty-two) senior theater critic, Frank Rich, who had not yet earned the enmity of a large segment of the theater community or

the nickname by which he is remembered by many still: the Butcher of Broadway.

Feiffer's preferred review was written by Rich in June 1981, after the play's premiere at Harvard's American Repertory Theater. Citing "the pricks of painful truth" packaged within the comedies *Little Murders* and *Carnal Knowledge*, Rich said that in *Grown Ups,* Feiffer had pushed "his seriousness" further still. "By forcing the audience to crawl through an emotional hell to get to his punch lines, Mr. Feiffer has written a drama of wrenching impact without sacrificing one note of his bracing comic voice."

Six months later, Rich raved once again, calling *Grown Ups* Feiffer's "most moving and provocative work. Mr. Feiffer is out for blood in *Grown Ups,* and he won't quit until he gets it."

When attendance faltered and the play was about to close after five weeks, Rich went to bat for it once more. In a piece titled "The Case for Keeping Feiffer's *Grown Ups* Open," he speculated on why the play was about to close—mixed reviews (not his own), the snow (it was January), the absence of promotional jingles blasting from radio and television, and New York theater's overreliance on famous names and "British imports with largely British casts." In contrast, by declining "to resolve the issues he raises and send us home at peace . . . [Feiffer's] *Grown Ups* has more in common . . . with Athol Fugard's *A Lesson from Aloes* and

Harold Pinter's *Betrayal* than with the dramatic hits of recent seasons."

As a playwright in the early 1980s, you couldn't hope to be placed in better company, or have the case for you made in such harmony with your own view of the theater scene, and Feiffer had a friendly if passing relationship with Rich for several years. "We both lived on the Upper West Side, and when we ran into each other, we chatted and were friendly. At the same time, while he was nice to me, I found the way he dealt with other playwrights in reviews disturbing. He took Chris Durang's *Marriage of Bette & Boo,* for example, a major theater work, and just slaughtered it. I think it really undermined Chris's career as a playwright, and Frank did that with many people. There are always things to pick on when you have a new playwright, but when you leave him for dead, there's something terribly wrong. There's not that much talent around; you don't have to take a piece that you don't like and murder the playwright."

Busy with other projects—including a screenplay for Alain Resnais about a cartoonist, *I Want to Go Home,* which won Feiffer a screenwriter's award at the 1989 Venice Film Festival—he did not return to playwriting until *Anthony Rose* (1989), quickly followed by *Elliot Loves* in 1990.

WHEN YOU'RE IN TROUBLE
WHO'S THE ONLY ONE
YOU CAN TURN TO?

MY MACHINE.

"Frank [Rich] reviewed *Elliot*, but he essentially reviewed not the play I thought I wrote or the play other people responded to. The review read as if he had watched *Carnal Knowledge II*. But *Elliot* was not that, and Frank treated it as if it was. I found it was one thing to not like the play I wrote, but he panned the play I *didn't* write. I must say that I ran into Frank after his review and asked him to go see the play again, and he did, and he didn't like it again."

Feiffer's account, twenty years after the fact, is considerably cooler and more amusing than his reaction at the time. Jerry Tallmer, who followed Feiffer's career for years, recalls taking his wife to opening night at the Promenade Theater on upper Broadway, just a few blocks from the Feiffers' West End Avenue apartment. "We loved the play, and after the curtain there was a little gathering of Jules, Mike Nichols, and others at a joint across Broadway. Everyone was in great spirits, exhausted by the play. About eleven thirty at night, somebody came back with the papers. There was a deadening review by Frank Rich, and I looked around, and the room, which had been crowded, maybe twenty-five people, was suddenly empty. I went over to Jules and touched his shoulder. He was very broken, very angry, and he said, 'I am never going to write another play.' And for years he didn't."

One reason Feiffer so loved the theater was that it matched the way he instinctively interpreted real life as it reeled by. But he also loved the camaraderie the theater offered, particularly in contrast to the loneliness of writing fiction. "You write a play in isolation," he says, "but then you have to work with others to get it out. And so you become, by the nature of the craft, socialized. And you discover that you like doing that and you like getting along with other people. And because it's theater, and plays have a less interior vision than fiction—there are not many internal monologues in a play—you have to figure out a way to get it out-front for the audience."

What Feiffer also very much liked was not being bored, and maintaining a sense of play in his working life. He discovered that shifting from one form to another in the course of a week or a day kept him on his toes. It appealed to the delinquent in him, and the iconoclast, and still does.

"I start with what is engaging to me, and in the course of a working day, I go back and forth among three or four different things. I seem to have a short attention span, though while working on my memoir, or in the middle of a play, once I get into it, I work all goddamn day. I often find after two hours that I'm doing crappy work, sloppy work, and

I take a break. And I practice a system of avoidance. If I've got a deadline on one thing, I'll do three other things instead. My nature has always been perverse. You can't tell me what to do."

The seventh decade of Feiffer's life—and the sixth or seventh of his career, depending on whether you judge it to have started with *Comic Caravan* or ghostwriting for Will Eisner—was not all fisticuffs, but the fisticuffs had a way of propelling Feiffer forward. When his good friend Edward Sorel suggested they collaborate on a children's book, and the deal (but not the friendship) soured, Feiffer got even by writing his own children's book, which would be "better than Ed's." *The Man in the Ceiling* (1993) was the short-term result: a charming story about a young boy who wants to be a cartoonist. The long-term result was a new career in children's books, and it presented itself just in time.

In 1995, Feiffer was elected to the American Academy of Arts and Letters. The following year, he became the first cartoonist to be given a retrospective by the Library of Congress. The show, which opened with a big splash of a reception in the fall of 1996 and ran through the end of January 1997, covered his entire career up to that point. Harry Katz, the curator, recalls how exciting it was to be

able to explore Feiffer's work at length. "We made an effort to take him beyond cartooning and treat him as a satirist. We'd done a comic strip show the year before, but this was much more fun." It was both a staff favorite, says Katz, and a great popular success, and it turned out to be a boon to the library. Among the guests at the opening was the political cartoonist Herb Block, whom Katz had been trying to get to agree to a retrospective for years, without success. "Herb was really taken with the show," Katz says, and shortly afterward agreed to a show of his own work, as did another cartoon eminence there that night, Pat Oliphant.

So perhaps it was inevitable that less than a year later, in May 1997, the toast of the town received a call from Donald H. Forst, the new editor of the *Village Voice*, who told Feiffer that the paper no longer wanted to pay him seventy-five thousand dollars a year for his strip—the strip that had helped to define the paper for forty-two years—but planned to buy it for two hundred dollars a week from Universal Press Syndicate instead.

Feiffer was sixty-eight years old, with a wife and two young children to support, and no idea how he was going to replace the only steady paycheck he'd ever had.

In the end, he says, "it was one of the best things that ever happened to me."

OPPOSITE, TOP Detail from "The Lonely Machine," a seven-page cartoon that ran in the December 1962 issue of *Playboy*.

OPPOSITE, BOTTOM Feiffer with a prop from the theatrical adaptation of the story, which was part of his play *Hold Me!*, 1977.

ABOVE Invitation to a joint seventieth-birthday party given for Feiffer and Edward Sorel in 1999—Bronx boys who had made good, born two months apart.

"Jules and I have remarkable similarities," says Sorel. "We were not separated at birth, because we had essentially the same life … born in the same time…. Both of us got married two hours after the sex revolution began. We had to marry the girl we were screwing. The difference between us is Jules seems to have enormous confidence. He works out of his confidence; I work out of my insecurity."

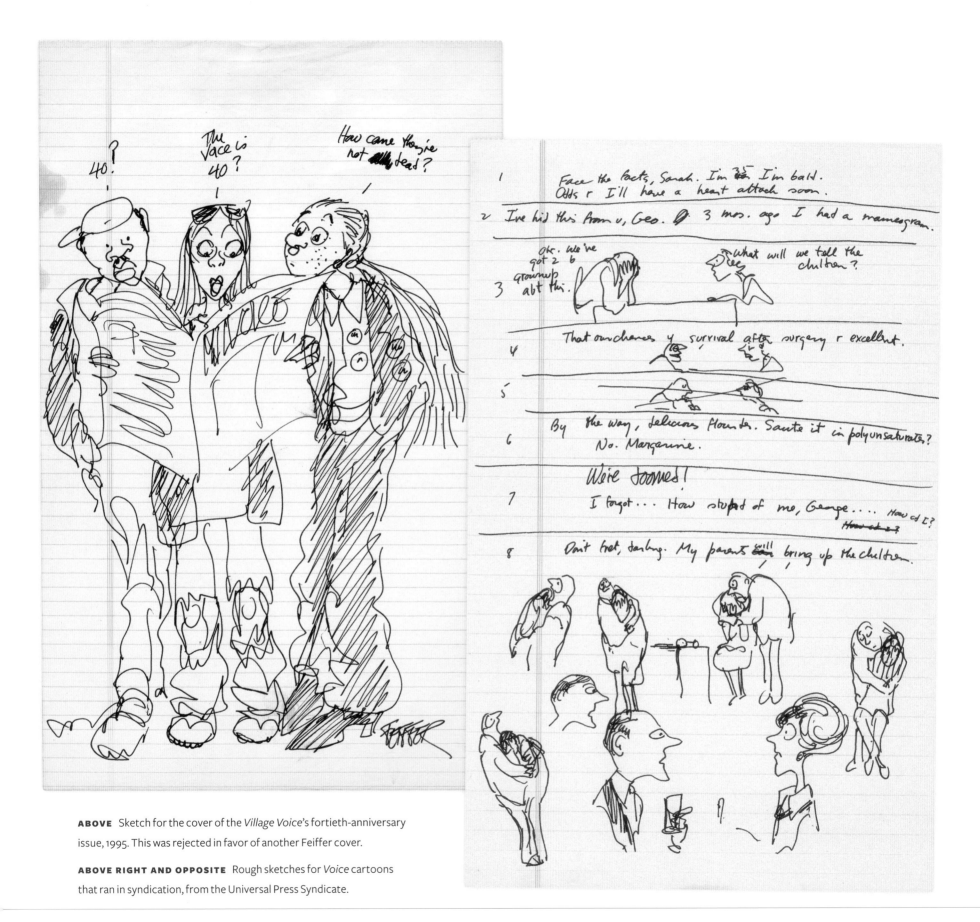

ABOVE Sketch for the cover of the *Village Voice*'s fortieth-anniversary issue, 1995. This was rejected in favor of another Feiffer cover.

ABOVE RIGHT AND OPPOSITE Rough sketches for *Voice* cartoons that ran in syndication, from the Universal Press Syndicate.

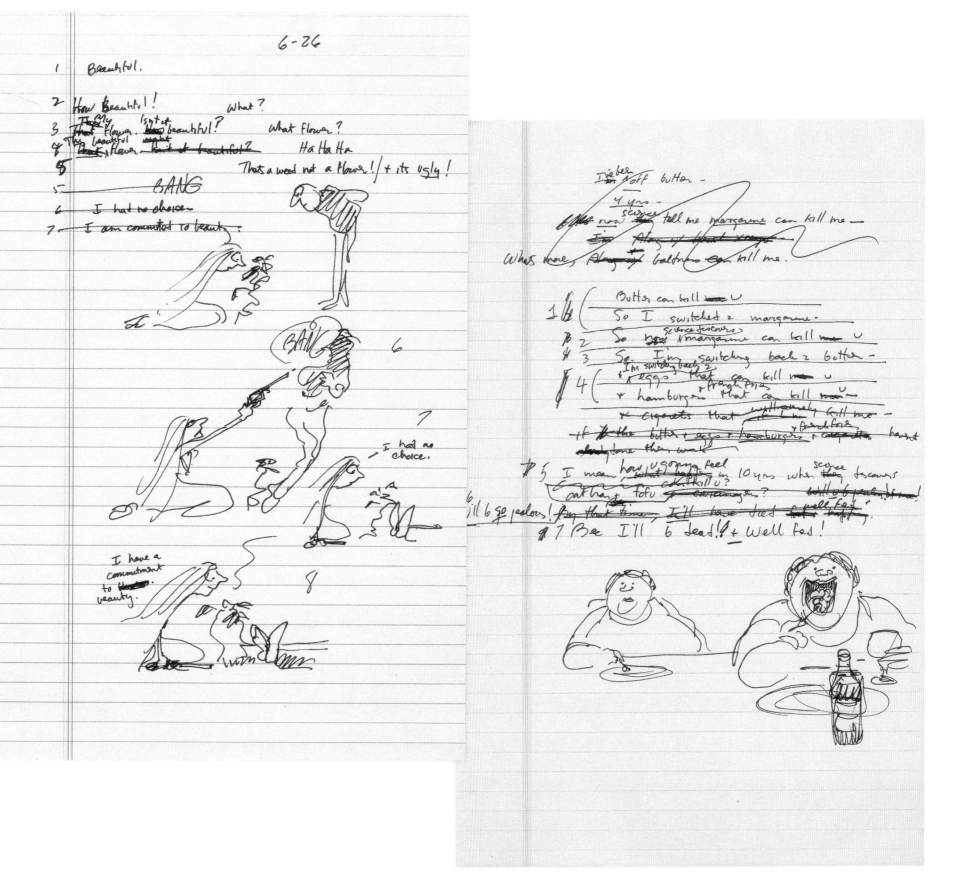

THIS PAGE Early studies of the forty-second president of the United States, before he was elected in 1992—boyish, charming, and opaque. Clinton was a hard subject to nail, and Feiffer found him both fascinating and disappointing.

OPPOSITE "The Boyfriend." One of Feiffer's most successful "portraits" of Clinton skipped his face altogether. It appeared in the *New Yorker* on June 14, 1993, five years before the Monica Lewinsky scandal broke, and was one of the few outright political cartoons run by the magazine.

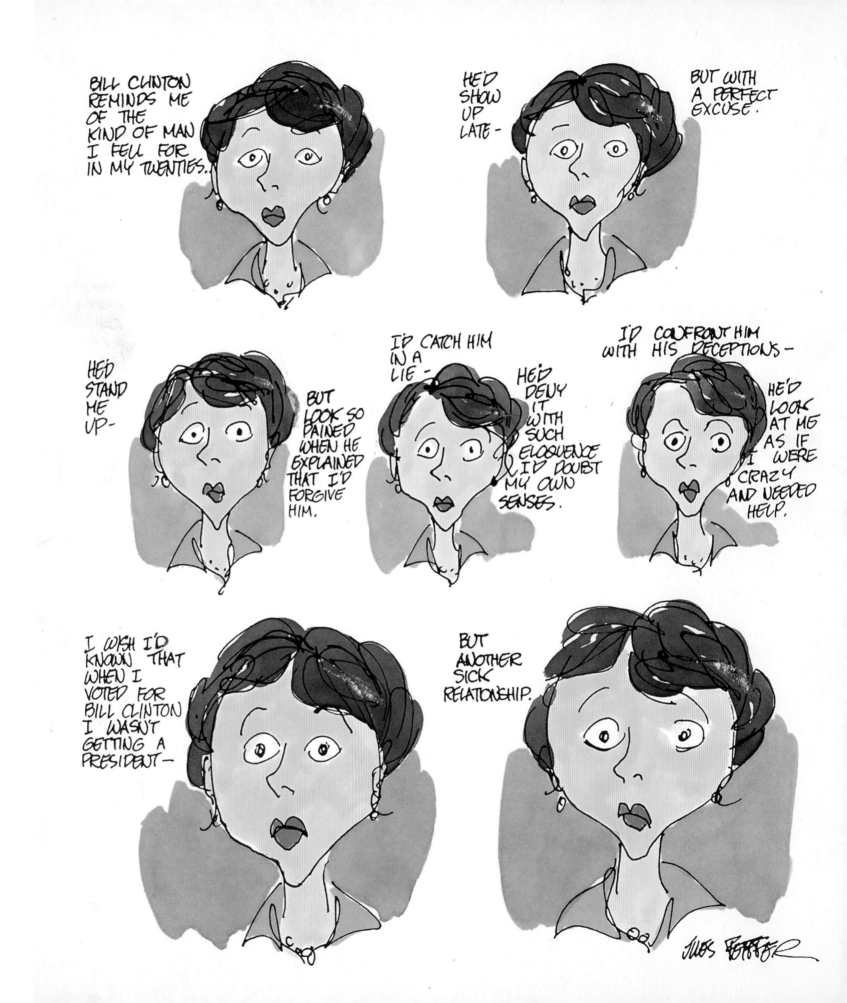

Blunt, no nonsense, no apologies, no explanations, straight-from-the-shoulder, sick-at-heart baldness.

The Sideburn Solution

Bald in the sixties

Conceptual hair at the single strand solution

I-am-not-bald baldness

Baldness deferred

WORD JOB

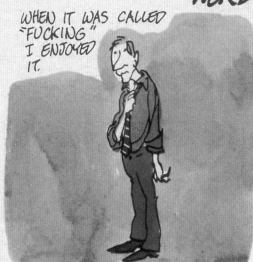

WHEN IT WAS CALLED "FUCKING" I ENJOYED IT.

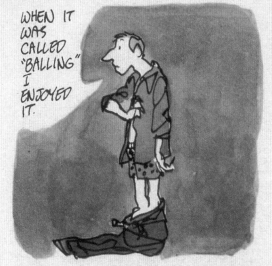

WHEN IT WAS CALLED "BALLING" I ENJOYED IT.

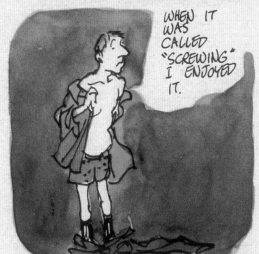

WHEN IT WAS CALLED "SCREWING" I ENJOYED IT.

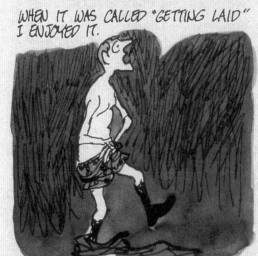

WHEN IT WAS CALLED "GETTING LAID" I ENJOYED IT.

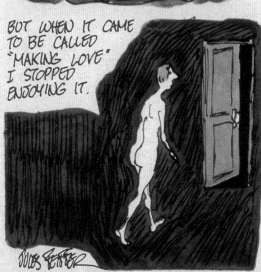

BUT WHEN IT CAME TO BE CALLED "MAKING LOVE" I STOPPED ENJOYING IT.

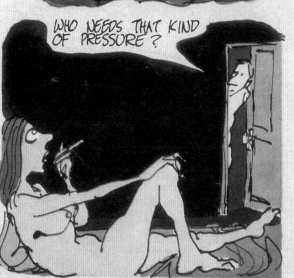

WHO NEEDS THAT KIND OF PRESSURE?

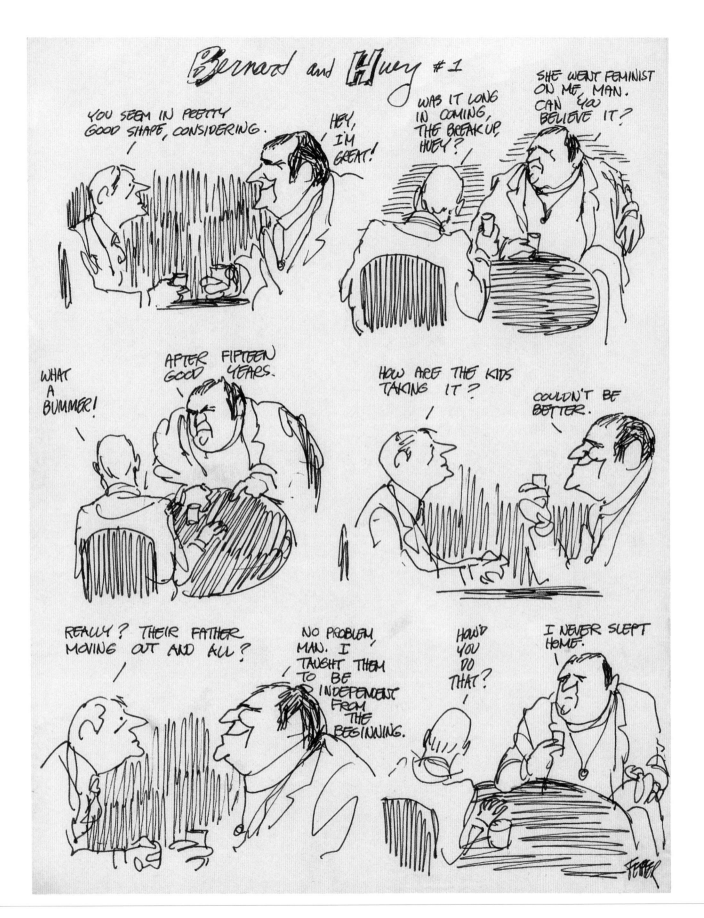

LEFT Roughs for the first *Bernard and Huey*, *Playboy*, April 1983. After a quarter century of Bernard and Huey *Voice* strips, Feiffer airlifted the friends to *Playboy* and rendered their misinterpretations and self-justifications in full color. The dialogue in this cartoon reads like the last scenes of *Carnal Knowledge*.

OPPOSITE *Bernard and Huey*, the first of two pages, *Playboy*, August 1984.

BERNARD and HUEY

IT'S BEEN 20 YEARS SINCE WE WENT TOGETHER, BUT I STILL THINK OF HER.

SHE WAS PERFECT! HER TASTE IN **EVERYTHING** WAS BETTER THAN MINE.

SHE EXPRESSED HERSELF BETTER ON EVERY SUBJECT.

HER JUDGMENTS WERE MORE MATURE.

WE OFTEN SAT UP AND TALKED FOR HOURS. I ALWAYS ENDED UP AGREEING WITH HER.

I BORROWED HER BEST PHRASES TO USE IN CONVERSATIONS WITH FRIENDS.

I WOULD CALL HER 6 TIMES A DAY TO GET HER ADVICE ON MY PROBLEMS AT THE OFFICE.

WE WERE INSEPARABLE.

THEN YOU TOLD ME I WAS PUSSY-WHIPPED.

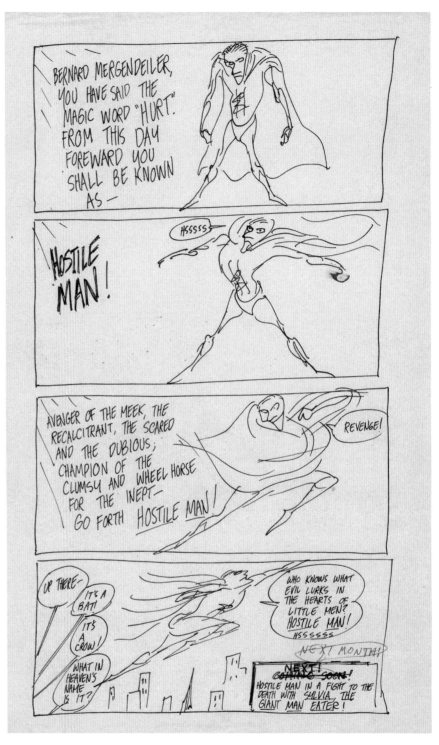

Roughs for Hostileman, a character and feature Feiffer invented for *Playboy* in December 1964 and returned to periodically until June 1969. Note Hefner's "OK" on the bottom panel of the page on the left. "This series was probably the most popular work I did for *Playboy*," Feiffer recalls. "But I never felt at ease having to design it in traditional comic book format, one I hadn't touched in more than thirty years, since my days on *The Spirit*. While it looks fine to me now, I felt at the time that I was dealing with the form inadequately."

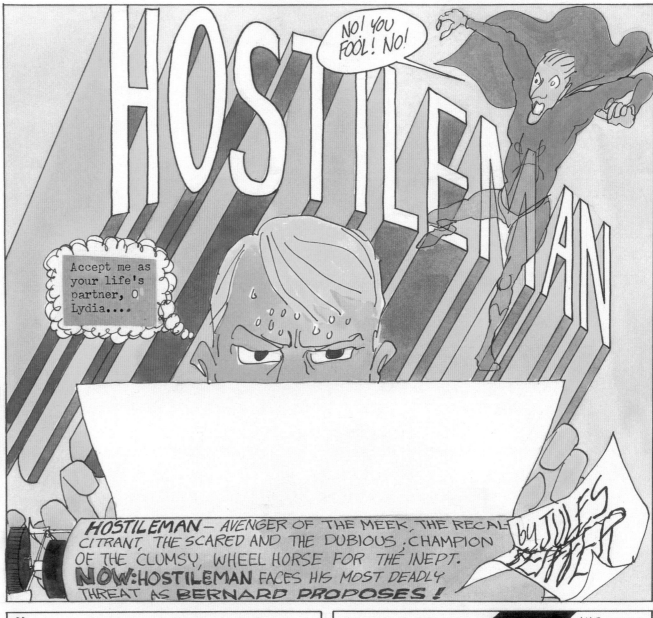

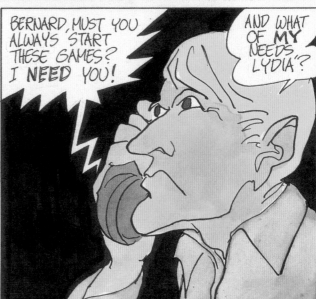

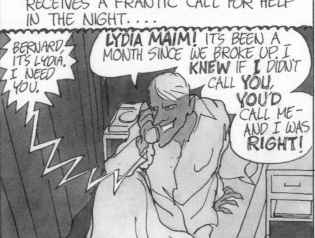

RIGHT AND FOLLOWING FOUR PAGES The first five pages of a six-page Hostileman story, *Playboy*, May 1969.

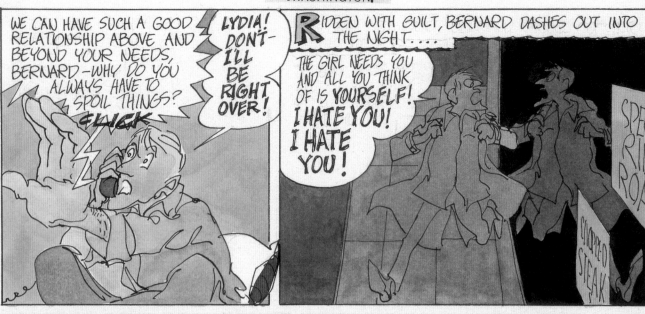

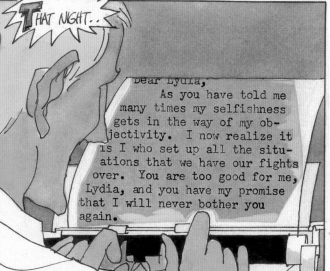

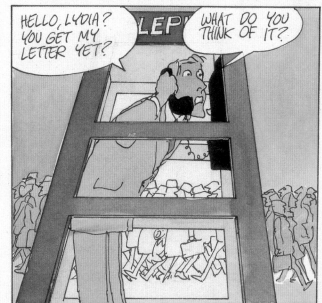

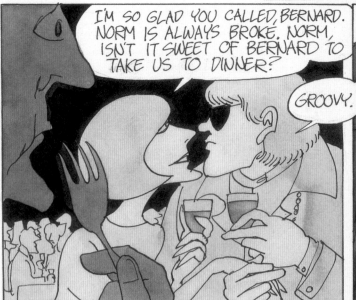

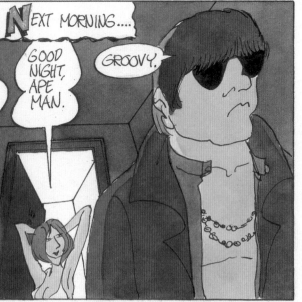

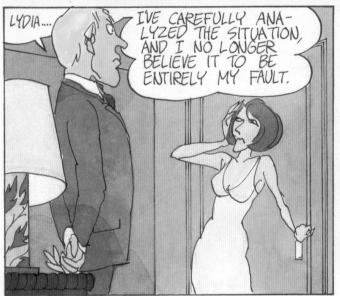

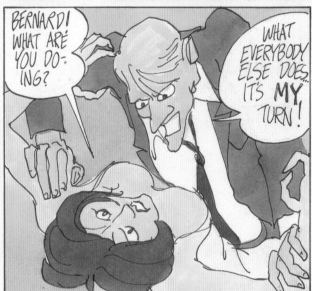

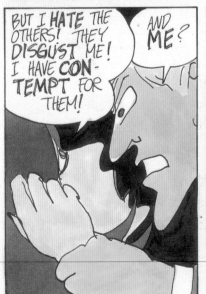

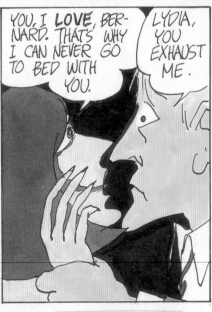

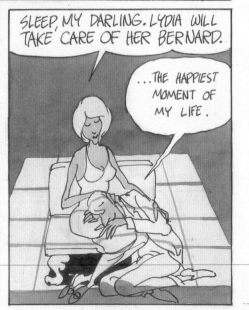

THAT NIGHT....

...I floated home loving you for being so forgiving, despising myself for being so demanding. Yet, I have one last demand, Lydia....

No! Not a demand--a prayer. A prayer that you will become my wife!

Accept me as your life's partner, O Lydia, knowing that though I am often cruel and thoughtless I would sooner cut off my right arm than ever hurt

INADVERTENTLY, BERNARD HAS TYPED THE *SECRET WORD:* "**HURT**"

...THAT TURNS HIM INTO

HOSTILEMAN!

NOW TO MAKE SHORT WORK OF THAT BITCH!

UP, UP AND AWAY!

SPLAT!

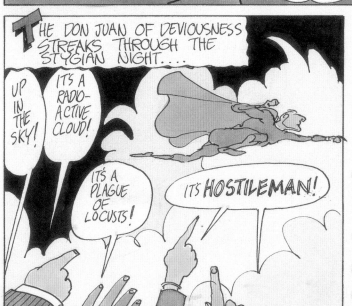

THE DON JUAN OF DEVIOUSNESS STREAKS THROUGH THE STYGIAN NIGHT....

UP IN THE SKY!

IT'S A RADIO-ACTIVE CLOUD!

IT'S A PLAGUE OF LOCUSTS!

IT'S HOSTILEMAN!

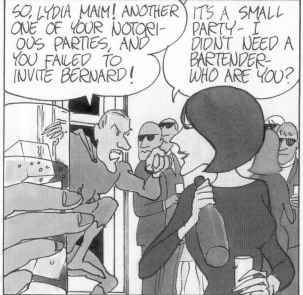

SO, LYDIA MAIM! ANOTHER ONE OF YOUR NOTORIOUS PARTIES, AND YOU FAILED TO INVITE BERNARD!

IT'S A SMALL PARTY-I DIDN'T NEED A BARTENDER-WHO ARE YOU?

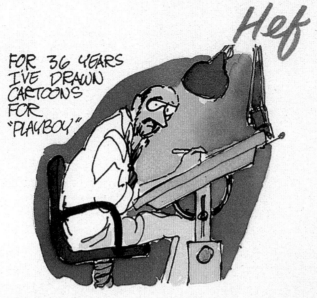

Hef by JULES FEIFFER

FOR 36 YEARS
I'VE DRAWN
CARTOONS
FOR
"PLAYBOY"

AND FOR MOST
OF THAT TIME,
I'VE ENVIED
HEFNER.

NOT FOR HIS MAGAZINE.

NOT
FOR
HIS
WOMEN.

NOT FOR HIS WEALTH.

NOT FOR
HIS
BRILLIANCE.

NOT FOR HIS MANSIONS
AND CARS AND
ELECTRONIC GADGETS
AND GAMES AND
POOLS AND
JACUZZIS
AND TENNIS
COURTS —

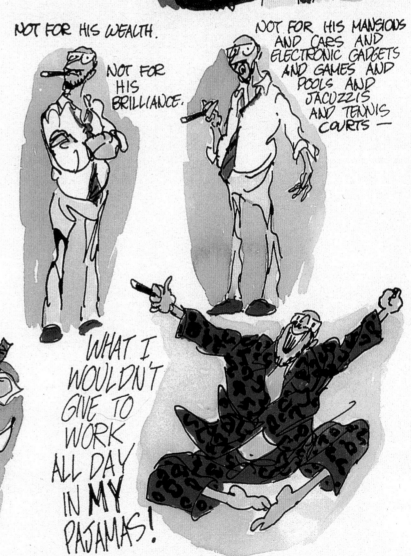

I
ENVY
HEF
FOR
HIS
PAJAMAS!

WHAT I
WOULDN'T
GIVE TO
WORK
ALL DAY
IN MY
PAJAMAS!

F.

DOES A TREE KNOW I CLIMB IT?

DOES A BROOK KNOW I FORD IT?

DOES THE GRASS KNOW I TRAMP ON IT?

DOES A FLOWER KNOW I SMELL IT?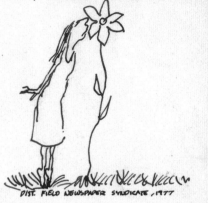

DIST. FIELD NEWSPAPER SYNDICATE, 1977

AM I THE SINGLE UNIFYING LINK BETWEEN THE TREE I CLIMB, THE BROOK I FORD, THE GRASS I TRAMP AND THE FLOWER I SMELL?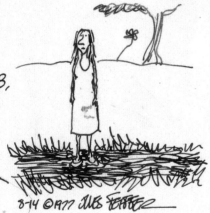

8-14 ©1977 JULES FEIFFER

THEN I TOO AM OF ECOLOGICAL SIGNIFICANCE.

SAVE ME!

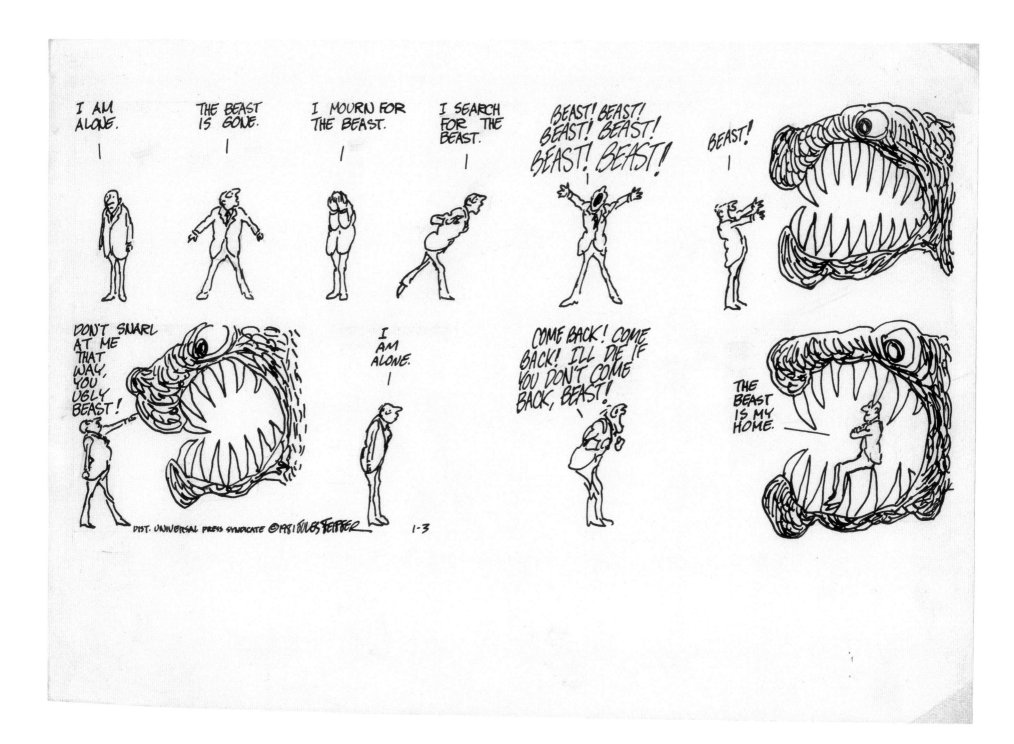

OPPOSITE Original art for *Voice* strip, August 14, 1977.

ABOVE Original art for *Voice* strip, January 3, 1981.
As Feiffer was reviewing the proofs for this book, he
remarked, "Can't help but rewrite. If I were to publish that
cartoon today, the last panel would read, 'The Beast and I,
at home.'"

The Man in the Ceiling

"Why aren't you drawing?"
"What do you mean?"
"What do you mean, what do I mean?"
"I don't know what you're talking about."
"You know very well."
"No, I don't."
"Yes, you do."

JULES FEIFFER, *The Man in the Ceiling*

owever shocked Feiffer's friends and admirers were by the unceremonious way his long run at the *Village Voice* ended, he saw the boot out the door as a blessing in disguise. "Basically, after four decades, I felt I had been forgotten by my fans. I'd been around for such a long time that even when my work was good, which it wasn't always, I felt it had lost a lot of its energy. I had wanted to get out of the *Voice* for quite a while. The problem was, where would I go?"

During his friend Pete Hamill's brief stint as editor of the *New York Post* in 1993, they talked about the possibility of Feiffer moving the strip there, but the window closed on the idea when Hamill fell out with the paper's new owner, real estate developer Abe Hirschfeld. At another point, Feiffer and a couple of entrepreneurial friends talked about starting a four-page subscription paper, along the lines of I. F. Stone's *Weekly*, that readers would get in the mail. "I'd be responsible for two pages and invite other cartoonists I liked to contribute. It would have been interesting, but it would have required so much work and organization that it would have stopped me from doing anything else.

"But after forty years or so, it became clear that nobody but the *Voice* was going to publish me every week. I think the market I had for the *Voice* downtown was the only market that existed for what I was doing. There was never a time when the *New Yorker* was going to run this stuff, and as

Detail from the cover of
The Man in the Ceiling, 1993.

ABOVE Three months after the *Times* gave Feiffer's latest children's book, *By the Side of the Road*, a rave review, it assigned him the entire holiday issue of the *Book Review* to illustrate. December 8, 2002.

OPPOSITE "Misdemeanors of the Heart," a Feiffer valentine. The *New Yorker*, February 14, 2000.

long as I stayed on at the *Voice*, that was going to be it. *Playboy* was going to run the sex stuff, but not the politics.

"If you're in the business of satire, which runs counter to prevailing sensibilities both in journalism and the cartoon medium itself, if you have more or less an outlaw sensibility, you can't expect it to be easy. And—I think this has been understated—how amazing it is that I got away with it at all for all those many years. But when I got fired in so brutal a way— they wouldn't even discuss a settlement, or an extension of my health coverage—it suddenly made me hot again."

Within a week of his break with the *Voice*, the Columbia University Graduate School of Journalism made Feiffer a senior fellow in its arts journalism program, a semester-long appointment that came with a proper monthly check, an office, and a research assistant. Simultaneously, his friend David Halberstam put in a call to the *New York Times*, whose editorial page editor, Howell Raines, later its executive editor, called Feiffer with another nice offer.

"Raines brought me in," Feiffer recalls, "and in typical shit-kicking, Southern boy, my-gosh manner that didn't cover up how smart he was, he started by saying, 'We may not be up to your speed,' but he'd like me to do a monthly op-ed drawing, and they would pay me a thousand dollars whether they ran it or not. So the

exciting thing was, not only had the *Voice* fired me, but in my opinion, the strip had substantially been going unread for a while by the very audience that had made me famous. I was working in a medium where I felt I was no longer at the top of my game, in part because I was really more interested in my other writing. Suddenly I got this offer of a huge amount of space—sometimes they ran me for two columns down the entire page. I'd never had that kind of exposure in my life. So within weeks of being cast out of my home paper, I was getting more attention than I had been. And I rose to the occasion and got reinspired to start doing good work."

The honeymoon with the *Times* op-ed section lasted for more than a year, but fizzled out when Raines became executive editor and a new editor took over the section. Feiffer continued to do work for the paper for years, however, sometimes at extraordinary length, illustrating the entire holiday issue of the *Book Review* cover to cover, at the request of art editor Steven Heller, in December 2002. He also did a handful of drawings for *Vanity Fair* in this period, another first, and forty years into his career he finally got a call from the *New Yorker*.

"What happened was Tina Brown took over. She solicited both Ed Sorel and me. Ed to do covers, and me to do what I do. It's interesting to me that *that's* when I got a call. I had expected to hear from the *New Yorker*

when Bob Gottlieb took over in 1987, but even though Gottlieb had published my books, he had no interest in me." Feiffer, being Feiffer, didn't last long at the *New Yorker* either. When most everything he submitted failed to register, he caught on and stopped submitting his own ideas. At which point he heard from the magazine's art director, Chris Curry, who asked him to do illustrations for various pieces in the magazine, something he continued to do occasionally for years.

Pushing seventy, Feiffer was, among other things, suddenly everyone's favorite guest artist, a Frank Sinatra of the cameo sketch, instantly recognizable and very much in demand. Though you wouldn't have known it in his hometown, Feiffer continued to turn out his strip for another few years for syndication, finally throwing in the towel in 2002 in order to focus on writing and illustrating children's books.

"It was the most amazing thing I'd ever seen," recalls Harry Katz. "Here was an American icon, being treated as badly as I've ever seen any great American be treated, and he turned around and made lemonade from lemons. He basically said, 'Fine. I'm just going to keep going.'"

"What he did," says Steven Heller, "was create his life over. He could have continued doing comic strips. But going into children's books was a regeneration. And *The Man in the Ceiling* [1993] is the perfect autobiographical piece."

Original art for "Dog Story," a personal history by Adam Gopnik on how the dog became our master. The *New Yorker*, August 8, 2011.

ABOVE Interior art from *The Man in the Ceiling*, Feiffer's autobiographical novel about a boy who wants to become a world-famous cartoonist.

ABOVE RIGHT Two-page Mini Man strip by Jimmy Jibbett, Feiffer's alter ego from *The Man in the Ceiling*, 1993.

Within months of leaving the *Voice*, Feiffer published *Meanwhile . . .*, his first proper picture book for children. Filled with exuberant full-color drawings that splash across the page spread after spread, the book is an escapist tale about a boy who is transported by his comic book adventures and resists being yanked back to reality. It also has an autobiographical element to it, displaying the author's clear allegiance to the child's point of view. It was followed by *I Lost My Bear* (1998); *Bark, George* (1999); and another four original works for children, in addition to a series of collaborations—with his then wife, Jenny Allen (*The Long Chalkboard*, 2006); with his oldest daughter, Kate Feiffer, for whom he has illustrated four books, including *Henry the Dog with No Tail* (2007) and *No Go Sleep!* (2012); and, after a fifty-year hiatus, with his old friend and earliest collaborator, Norton Juster (*The Odious Ogre*, 2010). With each outing, the artwork seemed to grow more confident, the colors more lush, the line freer.

"Everything changed," says Harry Katz. "Jules had a family; his priorities changed.

He was tired of the anger, tired of the fight. Nobody seemed to care about the old battles. He said he was working for a new generation, and I took him at his word. He began doing these beautiful freehand drawings, on different themes, in different areas. It was so exciting to see what he would come up with next."

Visitors to Feiffer's studio on West End Avenue from the late nineties on were likely to be greeted with a new drawing or a new set of book proofs to admire: spreads of leaping, back-flipping animals; porpoises splashing in backyard pools; warring siblings hollering down long hallways; raucous, manic images of children flailing through life against the odds and outsmarting adults. His heroes and heroines were true to both life and the comics tradition, their creator as delighted as a novice showing his work off for the first time—work he never anticipated doing or didn't know he had a gift for. "When I speak about the children's work," he says, "I always talk about the absolute pleasure of it. Taking it up returned me to the themes and subjects that started me off, and I modeled the artwork on the master cartoonists I studied from the age of five."

Critics took his work for children as seriously as they had taken his earlier departures, or extensions. Sometimes more so: "If Feiffer's earlier stuff—his strip, and screenplays

like *Carnal Knowledge*—helped define a hazy, shifting era," wrote Dwight Garner in a 2001 review of Feiffer's *I'm Not Bobby!*, "it's his late-career move into children's books that is, oddly enough, likely to provide his longest-lasting work."

Garner went on to quote a crucial passage from *The Man in the Ceiling* that seems to parse the mystery of the artist's imagination, as filtered through a young boy who wants to become a cartoonist.

> Drawing a tree from real life (or a car or a dog) had never turned out the way Jimmy intended. The real tree, car, or dog looked distressingly different from what he drew. But when he drew a tree without looking at one, who was to say it wasn't a perfect picture of the tree he had in mind?

Children's books had an equally big effect on Feiffer's writing. "Fiction and comics had always been my first and second loves," he told the *Atlantic*'s Sage Stossel in 2010. "But I never felt comfortable writing fiction. It never came to me naturally, the way writing for theater did, and of course the cartoon. So part of me always felt awkward and like I was faking it. That changed when I started writing novels for children. When I wrote for children, I found a voice, or different voices, that worked perfectly for me . . . a kind of a narrator's voice, as if it were a monologue onstage."

ABOVE Detail from the opening page of *Meanwhile...*, Feiffer's first picture book and his first book in full color, 1997. On the publisher's website, Feiffer explained that "writing for young readers connects me professionally to a part of myself that I didn't know how to let out until I was sixty: that kid who lived a life of innocence, mixed with confusion and consternation, disappointment and dopey humor. And who drew comic strips and needed friends—and found them—in cartoons and children's books that told him what the grown-ups in his life had left out. That's what reading did for me when I was a kid. Now I try to return the favor."

FOLLOWING PAGES Feiffer's fevered output as a children's book author and illustrator bore a close resemblance to his earlier runs as a *Voice* cartoonist and a playwright. He had always drawn on his surroundings for his work; now he poured decades of memories and paternal observation into exuberant color, adventure fantasies, and escape scenarios.

OPPOSITE Interior page from *I Lost My Bear*, 1998.

LEFT Interior page from *I'm Not Bobby!*, 2001.

A masterful mix of things horrible and humiliating, monstrous or merely unsettling, *Some Things Are Scary* (*No Matter How Old You Are*), by Florence Parry Heide (2000), is perfectly pitched to a kid's perspective, and as it turned out, timeless. "To share such fears—at whatever age—and laugh about them is one way of making them vanish altogether," Heide explained in the publisher's press release.

For Feiffer, the book was more than just an adaptation of a work originally published in 1969. "When I first read Florence Parry Heide's text," he recalls, "it reminded me very much of the emotions and materials that I drew on for my early cartoons. Also, the original illustrator of the book, Robert Osborn, was an early influence—a major influence—on my work. We eventually became friends. Taken together, these things seemed like a wonderful omen."

ABOVE Preliminary sketch.

RIGHT Original art for finished interior page, with unused spot art at the top.

First day of Kindergarten

Separation Anxiety

Will have 5 time-outs
by the end of the day.

Just found out
where babies came from.

Getting hugged by somebody you don't like

is scary.

ABOVE LEFT Feiffer must have been channeling
Heide and Osborn when he created these
unpublished sketches. Date unknown.

ABOVE Original art for finished interior page of
Some Things Are Scary.

OPPOSITE Two interior pages from *By the Side of the Road*, 2002.

ABOVE Interior page from *The House Across the Street*, 2002.

Inspired by the sight of his granddaughter, Maddy, climbing her father Chris's legs, Feiffer came up with *The Daddy Mountain*. Original art for four interior pages, 2004.

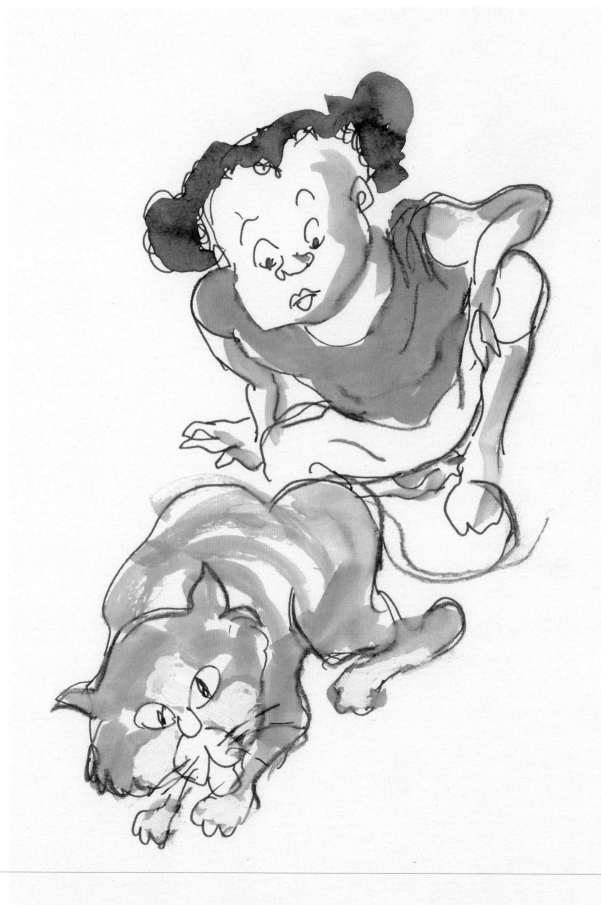

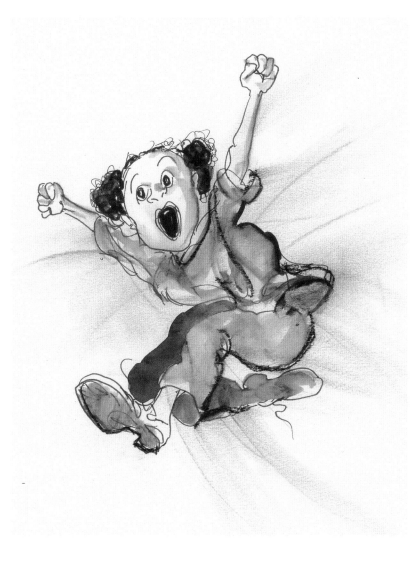

"When [my daughter] Julie saw color proofs of *The Daddy Mountain,* she said, 'You did a book about Maddy before you did a book about me,'" Feiffer explains. "So I promised, on the spot, that I would drop my other work and immediately come up with an idea for a Julie book." The result was a full-blown illustrated novel starring Julie Feiffer—*A Room with a Zoo,* published in 2005.

CLOCKWISE FROM BOTTOM LEFT Two sketches for front cover; original art for back cover; original art for page 71, chapter 18; original art for page 58, chapter 16; and the original art for page 182, chapter 42 (the penultimate image in the book).

LEFT A half century after their first collaboration, *The Phantom Tollbooth*, Feiffer and Norton Juster tried again. *The Odious Ogre* was published in 2010, and this time around Feiffer confessed to loving the drawings he created for the picture book.

ABOVE Studies for *Rupert Can Dance*, 2014.

The play *A Bad Friend*, directed by Jerry Zaks, had a limited New York run at the Newhouse Theater in Lincoln Center, from May 15–July 27, 2003. Poster art by James McMullan.

Set in the McCarthy-era, the play explores youthful idealism, political allegiance, and disillusion. "Nobody turned out to be quite what they said they were," Feiffer told the *New York Times*. "In this difficult time, the people who you put your faith in turned out to be something other than who they claimed to be."

The sense of creative possibility, and ease, that children's books opened up for Feiffer had a long reach. In 2000, he was surprised by a call from André Bishop, the artistic director of Lincoln Center, who asked if he'd be interested in a grant to write a play. He'd given no thought to writing another play since bad reviews of *Elliot Loves* had caused him to swear he'd never write another one, "but the minute he said, 'Do you have a play in mind?' I knew what I wanted to do."

In *A Bad Friend*, Feiffer cuts close to the bone, weaving his childhood experience with his older sister, Mimi, a member of the Communist Party, together with a mysterious figure he got to know while living in Brooklyn as a young man—"who turned out to be the most important spy the U.S. ever uncovered." It's both a haunting coming-of-age play and a prickly political one, with a sensitive sixteen-year-old girl standing in for the author, as alienated from her family of noisily doctrinaire Communists as Feiffer was from his family of origin on multiple grounds. Her tender friendship and eventual disillusion with the quiet painter she encounters on the Brooklyn Promenade runs parallel to the unraveling threads of her family's political faith.

Years after Feiffer had drawn his last *Voice* strip, he returned to his favorite character, the dancer, drawing and redrawing her for his own pleasure with no thought of a fresh audience. So when filmmakers Judy and Ellen Dennis—twins born two years before the dancer first leaped across the pages of the *Voice*—approached him with the idea of bringing a selection of the dancer panels to life, he was surprised and delighted. "We saw Jules just four times in the process," says Judy Dennis, who as a teenager in a Philadelphia suburb directed a high school production of *Feiffer's People*, and a few years later took a dance class at Bennington that happened to be taught by Judith Goldsmith Dunn, Feiffer's long-ago girlfriend and the model for the original dancer.

Judy Dennis recited these and a handful of other six-degree connections when she contacted Feiffer for the first time, but "he didn't care. He was interested in the work." He asked to see a sample of Dennis's previous efforts, and though what she sent him—an episode of *Oz* she'd directed a decade earlier—could hardly have been more distant from Feiffer's fretful optimist, it was enough to convince him that she knew what she was doing. He gave the project his blessing, encouraged the Dennises not to be too literal in their interpretation, and disappeared while they got started. Months later he paid a visit to the Baryshnikov Arts Center to see an early rehearsal and was thrilled to see the dancer they had chosen for the part, Andrea Weber, a longtime member

RIGHT In the first decade of the twenty-first century, two major celebrations of Feiffer's work were mounted in New York. The first, *Julz Rulz: Inside the Mind of Jules Feiffer*, was a three-month retrospective at the New-York Historical Society from February 18–May 18, 2003, in which his Upper West Side studio was re-created. Feiffer, as generally happened, was asked to create the poster.

The second retrospective, *The Master Series: Jules Feiffer*, was a six-week exhibition at School of Visual Arts that ran from October 24–December 2, 2006.

The following decade, a third retrospective was held in New York, this time at the Century Association from March 8–April 21, 2011, with Feiffer sharing the Century Masters honor for "advancing the role of the visual arts" with his friend Edward Sorel, "two of the club's cherished 'living treasures.'" In the program, E. L. Doctorow wrote, "Their cartoons are to paintings as songs are to symphonies."

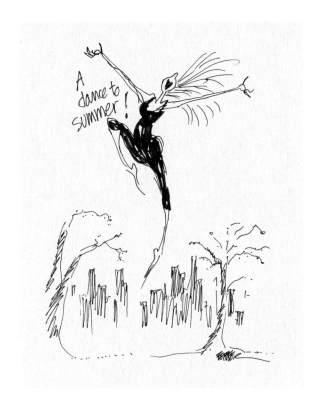

of the Merce Cunningham Dance Company, whirling and leaping across the studio, crouching in fear, throwing her hands in the air, bringing his dancer to life. Feiffer lingered for a while, asking questions and answering some, flattered and reassured by their approach and their interest in getting the sensibility right. "In her head," he said, "there's nothing she can't do, and everything is available to her. We identify with her because she's intense, passionate, and ends up with pie on her face." One of the sisters asked him, "And is she really a good dancer?" "Oh, yes," he said. "Otherwise it wouldn't be funny. It's the second-rate artists who have no doubt. First-rate artists always have doubts."

The Dennises' piece, titled *Extraordinary Moves: The Dancer Films*—six two-minute bursts of dance, with voice-overs of Feiffer's original text—premiered at the River to River Festival at the World Financial Center in Manhattan the weekend of July 9–10, 2011, in conjunction with a monthlong exhibit of more-recent Feiffer drawings. On the second day, Feiffer made an appearance in the center's great atrium to answer questions and talk about his long love affair with the dancer. Then he sat down at a table and drew her again and again, live, with each drawing being simultaneously projected on the giant screen behind him.

"They translated my cartoon dancer into both cartoon and something very poetic and very real, with its own sweetness and innocence," Feiffer told his former employer, the *Village Voice*, in an interview. The *New York Times* agreed, making Feiffer and his dancer the Arts page lead a few days before, noting that the films were part of "a larger celebration of artists, like Feiffer himself, who particularly capture the energy of New York." The eighty-two-year-old boy from the Bronx was in heaven.

It is tempting to suggest that Feiffer's dancer, winsome and dreamy and continually getting whacked by reality in the middle of a grand plié, must in some small measure reflect a well-concealed side of her inventor. Except that these days Feiffer has a thing going with a different dancer altogether, one who predates the modern dancer in his head by decades, and whom he also does not tire of drawing.

Fred Astaire turned up for the first time in a Feiffer strip during the Nixon administration. A decade or so later, trying to break free of the rigid frame his earlier drawings had been forced into to accommodate text, Feiffer took to drawing freestyle, with no dialogue or story line in mind, while on Martha's Vineyard during the summer. "I started bringing a drink or two into the studio, put on some jazz, some Ellington, and would start doing

A Dance To The New President

IN THIS DANCE I CALL UPON YOU, MR. NEW PRESIDENT, TO FIX UP HEALTH-CARE, MEDICARE, SOCIAL SECURITY, PRESCRIPTION DRUGS, CAMPAIGN FINANCING—

EDUCATION, THE ENVIRONMENT—AND LET'S NOT FORGET CRIME, POVERTY TERRORISM... DID I MENTION THE INFRASTRUCTURE, THE INTERSTATES AIRLINE SAFETY, AIRLINE SCHEDULES—

FIXING UP ALL OF THE ABOVE, WHILE DISPLAYING A STRONG, SOBER, CHARISMATIC IMAGE, SO DYNAMIC AND MANLY THAT YOUR OPPO-SITION CRUMBLES—

AND YOUR ENTIRE PROGRAM IS EN-ACTED.

A PROGRAM THAT CUTS TAXES, CUTS THE BUDGET—

REDUCES GOVERNMENT GROWTH AND INCREASES VOLUNTEERISM—

UNITES RATHER THAN DIVIDES US, WHILE PRESERVING OUR RACIAL, ETHNIC AND SEXUAL IDENTITIES— **AND** OUR PRIVACY—RESPECTING **THAT** RIGHT AS WELL AS OUR RIGHT TO:

FREE SPEECH, FREE TRADE, FREE CHOICE, THE RIGHT TO SHOOT—BUT NOT OUR SCHOOLCHILDREN, OR ESTRANGED LOVED ONES, OR OBJECTIONABLE STRANGERS...

IMPROVING THE MORAL CLIMATE, **AND** THE CLIMATE IN GENERAL, RESTRICT-ING FLOODS, DROUGHTS AND FOREST FIRES, WITHOUT RESORTING TO BIG-BROTHER GOVERNMENT OVERSIGHT.

I ASK ONLY FOR ENOUGH OVERSIGHT—

TO GUARANTEE MY PEACE OF MIND.

OR FOUR YEARS FROM NOW I VOTE FOR THE OTHER GUY.

JULES FEIFFER www.julesfeiffer.com

Happy Rebirth Day

LEFT "A Dance to the New President." Feiffer challenges George W. Bush in this strip from *Modern Maturity*, November–December 2000. This marked the first appearance of the dancer since the *Feiffer* strip ended in the *Voice* in June. On the contributors page, the editor wrote, "For more than forty years she was his most beloved character, limbering in one panel, leaping in another, giving voice to Feiffer's rants on government, money, and the sexes. When the end finally came, the dancer wasn't ready for it. 'You're dying!' she shrieked in one of the strip's last installments, after Feiffer gave her the news. No, no, he reassured her—he ended the strip because he's so very much alive. What with teaching, writing plays, drawing for magazines, and 'having a ball' writing and illustrating children's books, the strip had become a burden." Shortly after this, Feiffer would continue to unburden himself, depicting the dancer's twists and twirls in full-blown color portraits.

ABOVE "Happy Rebirth Day." Feiffer welcomes president Barack Obama. Original art for seasonal greeting card sent by Feiffer to friends and family, December 2008.

TOP Fred Astaire and Ginger Rogers, *Carefree*, 1938. According to Benjamin Ivry, reviewing *Backing into Forward* for the *Jewish Daily Forward* on March 23, 2010, "Feiffer's figures aspire to twirl with Fred Astaire–like grace, but instead they are mostly condemned to a St. Vitus's dance of wistful frustration."

ABOVE Art from *The Man in the Ceiling*, 1993.

OPPOSITE "The Curse of Fred Astaire," *Village Voice,* reprinted in *Jules Feiffer's America: From Eisenhower to Reagan,* 1982.

freehand movement, fast drawings, just to give myself a chance to do some drawing independent of my writing."

One of his early subjects was the tap dancer Gregory Hines, then at the peak of his career. "I started playing more and more with line and where line could take me, and then, almost always, in an act of contrariness, once I had what I thought was a gorgeous black-and-white drawing, I screwed it all up by adding color, doing my best to make a mess of it, then doing my best to see if I could save it.

"I enjoyed the act of taking myself further and further out on a limb, then sawing off the limb with me sitting on it, and cushioning myself as I fell to the ground. So that while a black-and-white drawing was very satisfying indeed, it never seemed quite enough to me, particularly since in those years, long before I was doing children's books, all I did was black-and-white—nothing imaginative. Yes, my *Playboy* work was in color, but I was just filling in between the lines.

"So I started adding color to see how it worked with the dancer. Sometimes it worked, sometimes not, but I began to see where I was going. I saw all of it as a form of play and a form of self-indulgence."

Feiffer's attempt to capture Hines's line got him thinking about Fred Astaire, a childhood hero. "Astaire, who began as an escape

mechanism, ended up in a very real way redefining how I drew, my attitude about my drawing, and fulfilling the basic ambition of all my work, which was to make it look, as Astaire did, as if you haven't done anything. That what you've done—graceful, elegant, and if it works, quite impressive—was knocked off in twenty-five seconds.

"Years ago, long after it came out, I went to a movie theater to see *Carnal Knowledge*, and I remember watching the sequence of Nicholson and Garfunkel walking down the street talking, and having the distinct impression that these guys were making it up as they went along. It seemed so impromptu and so natural. It thrilled me that I had done exactly what I had hoped to do.

"With Astaire, it was the effortlessness that appealed to me. Gene Kelly had a muscular, athletic power, which I could never confuse with myself, and he was also handsome. Astaire was funny looking, slight of figure. His whole approach to dance was nonchalant—'Oh, look at this. If I can do this, it must be easy.'

"That effortlessness that had so impressed me, I began to see as the philosophy behind everything I wanted to do, from *Carnal Knowledge* on—I wanted the characters to appear to be making up their own lines. I didn't want to leave any fingerprints."

THE ONE THING I SHOULD HAVE BEEN I'M NOT: FRED ASTAIRE.

BUT I DON'T HAVE THE TALENT OR DISCIPLINE TO BE FRED ASTAIRE. SO I DO THE NEXT BEST THING.

I TAP DANCE MY WAY THROUGH LIFE.

I TAP DANCE MY WAY THROUGH RELATIONSHIPS..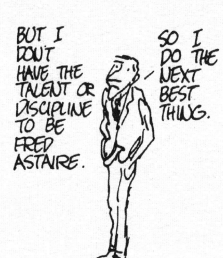

AROUND MY FAMILY—

IN AND OUT OF PERSONAL CRISES—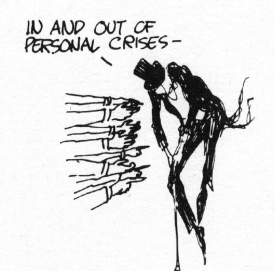

AT TIMES I WISH I COULD SLOW DOWN LONG ENOUGH FOR SOME GINGER ROGERS TO CATCH ME.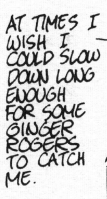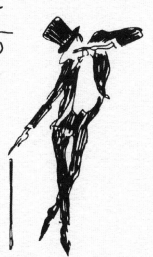

BUT WHEN ONE OF THEM COMES TOO CLOSE I TAP DANCE AWAY.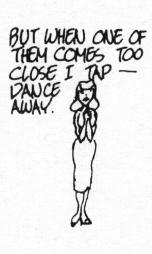

SENSATIONAL BUT ISOLATED I DANCE ON. 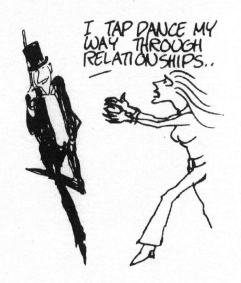 THE CURSE OF FRED ASTAIRE.

"The one thing I should have been I'm not: Fred Astaire. But I don't have the talent or discipline to be Fred Astaire. So I do the next best thing. I tap dance my way though life. I tap dance my way through relationships. Around my family. In and out of personal crises—At times I wish I could slow down long enough for some Ginger Rogers to catch me. But when one of them comes too close I tap dance away. Sensational but isolated I dance on. The curse of Fred Astaire." From *Hold Me! An Entertainment*, 1977.

OPPOSITE "Shall We Dance?," 1998.

RIGHT "By Myself," 1996.

In 1989, in an introduction to the first volume of *Feiffer: The Collected Works* by Fantagraphics, Pete Hamill cited the familiar, if not foolproof, distinction between artists who are "sprinters" and those who are "long-distance runners." Feiffer clearly fell into the second category. "For more than thirty years he has been operating at the highest level of his craft, producing a body of work that ranks with the finest ever produced in this country."

Almost a quarter of a century later, approaching eighty-six as this book goes to press, he has yet to run out of breath. He continues to surprise himself and his readers with new moves and new genres every decade or so, piling title upon title, even as he persists in pretending he is just a lucky stumblebum "backing into forward," an apprentice still looking for a line to call his own.

Except that no finish seems even remotely in view. Feiffer's most recent book for grownups is *Kill My Mother*, his first graphic novel—a more traditional effort than *Tantrum*—in the noir style he last played with while working for Will Eisner, might be said to bring his long run full circle. Or maybe he's just very good at fending off boredom. The layered thriller, illustrated in noirish black and white, accented with hints of blue and brown, was released in August 2014, to rave reviews from the *New York Times*, the *Los Angeles Times*, and other respectable outlets—with the kind of attention young writers half his age would sell their spouses for. "For more than fifty years," Carolyn Kellogg wrote in the *Los Angeles Times*, "Feiffer has been the nation's cool creative older brother—charming, slightly cynical, and a few steps ahead of the culture." For the first time since *Sick, Sick, Sick* and *Passionella*, a Feiffer book leaped onto the *New York Times* bestseller list. Like a wagging tail, his latest children's book, *Rupert Can Dance*, written for an entirely different audience, followed within the month—by which time a prequel and a sequel to *Kill My Mother* were already well under way.

As always, Feiffer had an offhand explanation. "My whole career as a cartoonist was in a sense an accident," he says, "with me making up for the fact that I didn't know how to draw and wasn't good enough at drawing to do the kind of work that attracted me in the first place. This graphic novel is my first and only attempt to be a professional cartoonist. Only in my eighties did I finally learn to work in the form that I first wanted to work in at the age of seven. So finally, in my dotage, my original dreams are coming true. And it's turned out to be as much fun or more fun than anything I've ever done."

OPPOSITE Untitled dancer, 1996.

ABOVE Feiffer and Norton Juster (right) take to the road to promote the fiftieth anniversary of *The Phantom Tollbooth* and are greeted by Milo, in this spot illustration for the October 17, 2011, issue of the *New Yorker*.

OPPOSITE Original art for removable print of *Kill My Mother*, 2014.

RIGHT AND FOLLOWING THREE PAGES
Original art from *Kill My Mother*, page 4, chapter 1: "Little Annie Hannigan"; page 11, chapter 5: "Elsie, Elsewhere"; page 27, chapter 11: "The Risk Factor"; and page 33, chapter 13: "The Dancing Master."

chapter Five : Elsie, Elsewhere

RIGHT AND FOLLOWING THREE PAGES

"Take that!" Four out of five lithographs
from an unpublished series, 2014.

RIGHT With the boxing sequence from *Kill My Mother* (page 256) and the "Take that!" series on the opposite and preceding pages, Feiffer, in his eighties, revisited the pugilistic thrills of his youth, c. 1942, when he was thirteen.

ABOVE LEFT Feiffer with daughters Halley (left) and Julie (right), photographed in his New York City studio by Greg Preston in 2003.

ABOVE RIGHT Feiffer with his daughter Kate, photographed by Mariana Cook in New York City on October 4, 2008.

Sources

Interviews

Unless otherwise noted, all interviews were conducted by the author exclusively for this book.

Jules Feiffer gave generously of his time throughout the process, sitting for extended interviews in January 2007 and on November 5, 2008; December 2, 2008; October 24, 2009; December 17, 2009; May 28, 2010; May 19, 2011, and adding to the story throughout several sessions of art selection and in informal follow-up chats.

Dennis, Judy (independent film director). Phone interview. May 7, 2012.

Fancher, Edwin (cofounder and publisher of the *Village Voice*). Phone interview. March 2009.

Goldman, Judith (author and art critic). Phone interview. April 7, 2009.

Hefner, Hugh (founder and editor, *Playboy*). Phone interview. November 24, 2009.

Heller, Steven (art director, author, critic). Phone interview. November 20, 2008.

Juster, Norton (author of *The Phantom Tollbooth* and *The Odious Ogre*). Phone interview. November 25, 2008.

Katz, Harry (author and former head curator, Prints and Photographs Division of the Library of Congress). Phone interview. December 2, 2008.

Koren, Ed (cartoonist and author). Phone interview. July 10, 2010.

Korman, Alice (Jules Feiffer's sister). Phone interview. November 19, 2008.

Laurie, Bob (painter and high school friend of Feiffer's). Phone interview. October 29, 2008.

Levine, David (artist and cartoonist). Phone interview. December 2, 2008.

Levitz, Paul (writer, editor, former president and publisher of DC Comics). Phone interview, September 23, 2010.

Lorenz, Lee (cartoonist and former art director, the *New Yorker*). Phone interview. December 5, 2008.

McMeel, John (cofounder of Andrews McMeel Publishing and former representative of Hall Syndicate). Phone interview. November 18, 2009.

Navasky, Victor (author, editor emeritus of the *Nation*). Phone interview. February 24, 2009.

Nichols, Mike (film and stage director). Phone interview. August 3, 2010.

Sorel, Edward (cartoonist and author). Phone interview. June 18, 2010.

Spiegelman, Art (Pulitzer Prize–winning author and cartoonist). Phone interview. February 3, 2010.

Tallmer, Jerry (author, theater critic, early editor at the *Village Voice*). Phone interview. March 2009.

The following subjects are not quoted in the text of this book, though their interviews helped inform the narrative.

Bruel, Nick (cartoonist). Phone interview. April 1, 2009.

Hasen, Irwin (cartoonist). Phone interview. November 19, 2008.

Jaffee, Al (cartoonist, *MAD* Magazine). Phone interview. June 15, 2010.

Katchor, Ben (cartoonist). Phone interview. November 24, 2009.

Mitgang, Herb (longtime writer and editor at the *New York Times*). Phone interview. November 3, 2008.

One of a series of promotional pieces newspapers were sent to publicize the *Feiffer* newspaper strip when the Hall Syndicate began its distribution in 1959.

The Complete Works of Jules Feiffer

Collections

Sick, Sick, Sick: A Guide to Non-confident Living. New York: McGraw-Hill Book Company, Inc., 1958. London: Collins, 1959. Introduction by Kenneth Tynan.

Passionella and Other Stories. New York: McGraw-Hill Book Company, Inc., 1959. London: Collins, 1959. Introduction by John Crosby.

The Explainers. New York: McGraw-Hill Book Company, Inc., 1960.

Boy, Girl. Boy, Girl. New York: Random House, 1961.

Hold Me! New York: Random House, 1962.

Feiffer's Album. New York: Random House, 1963.

The Penguin Feiffer. Harmondsworth, England: Penguin Books, 1964.

The Unexpurgated Memoirs of Bernard Mergendeiler. New York: Random House, 1965.

Feiffer on Civil Rights. Foreword by Bayard Rustin. New York: The Anti-Defamation League of B'nai B'rith, 1966.

Feiffer's Marriage Manual. New York: Random House, 1967.

Feiffer on Nixon: The Cartoon Presidency. New York: Random House, 1974.

Jules Feiffer's America: From Eisenhower to Reagan. Edited by Steven Heller. New York: Alfred A. Knopf, 1982.

Marriage Is an Invasion of Privacy, and Other Dangerous Views. Kansas City, MO: Andrews, McMeel & Parker, 1984.

Feiffer's Children. Kansas City, MO: Andrews, McMeel & Parker, 1986.

Ronald Reagan in Movie America: A Jules Feiffer Production. Kansas City, MO: Andrews and McMeel, 1988.

Feiffer: The Collected Works, Volume 1: Clifford. Foreword by Pete Hamill. Preface by Robert Fiore. Seattle: Fantagraphics Books, 1989.

Feiffer: The Collected Works, Volume 2: Munro. Preface by Robert Boyd. Seattle: Fantagraphics Books, 1989.

Feiffer: The Collected Works, Volume 3: Sick, Sick, Sick. Introduction by Robert Boyd. Seattle: Fantagraphics Books, 1992.

Passionella and Other Stories: The Collected Works of Jules Feiffer, Volume 4. Introduction by Gary Groth. Seattle: Fantagraphics Books, 2006.

Explainers: The Complete Village Voice Strips (1956–66). Introduction by Gary Groth. Seattle: Fantagraphics Books, 2008.

Graphic Novels

Tantrum. New York: Alfred A. Knopf, 1979. Revised edition: Seattle: Fantagraphics Books, 1997. Introduction by Neil Gaiman.

Kill My Mother. New York: Liveright Publishing Corporation, 2014.

Novels

Harry, the Rat with Women. New York: McGraw-Hill Book Company, Inc., 1963.

Ackroyd. New York: Simon and Schuster, 1977.

"A Dance to the End of This Book," undated.

COLLECTIONS

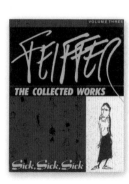

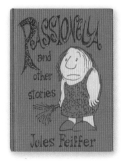

GRAPHIC NOVELS **NOVELS**

Nonfiction/Memoir

The Great Comic Book Heroes. New York: The Dial Press, 1965. Revised edition: Seattle: Fantagraphics Books, 2003. Foreword by Gary Groth.

Pictures at a Prosecution: Drawings & Texts from the Chicago Conspiracy Trial. New York: Grove Press, Inc., 1971.

Backing into Forward. New York: Doubleday, 2010.

Collaborations

Mines, Robert. *My Mind Went All to Pieces*. Introduction by John B. K. Smith, M.D. New York: The Dial Press, 1958.

Juster, Norton. *The Phantom Tollbooth*. New York: Epstein & Carroll, 1961. Special 35th Anniversary Edition: New York: Random House, 1996. With an appreciation by Maurice Sendak. The 50th Anniversary Edition: New York: Alfred A. Knopf, 2011. Essays by Jeanne Birdsall, Michael Chabon, Suzanne Collins, Martha Minow, Maria Nikolajeva, Philip Pullman, Pat Scales, Bev Walnoha, and Mo Willems.

Heide, Florence Parry. *Some Things Are Scary (No Matter How Old You Are)*. Cambridge, MA: Candlewick Press, 2000.

Eisner, Will. *Will Eisner's The Spirit Archives*. 26 volumes. New York: DC Comics, 2000–2009.

Allen, Jenny. *The Long Chalkboard and Other Stories*. New York: Pantheon Books, 2006.

Feiffer, Kate. *Henry, the Dog with No Tail*. New York: Simon & Schuster Books for Young Readers, 2007.

——. *Which Puppy?* New York: Simon & Schuster Books for Young Readers, 2009.

Lowry, Lois. *The Birthday Ball*. Boston: Houghton Mifflin Books for Children, 2010.

Juster, Norton. *The Odious Ogre*. New York: Scholastic, 2010.

Feiffer, Kate. *My Side of the Car*. Somerville, MA: Candlewick Press, 2011.

Juster, Norton. *The Annotated Phantom Tollbooth*. Annotations by Leonard S. Marcus. New York: Alfred A. Knopf, 2011.

Feiffer, Kate. *No Go Sleep!* New York: Simon & Schuster Books for Young Readers, 2012.

Shaw, Beth Kobliner, and Jacob Shaw. *Jacob's Eye Patch*. New York: Simon & Schuster, 2013.

Books for Children

The Man in the Ceiling. New York: HarperCollins Publishers, 1993.

A Barrel of Laughs, A Vale of Tears. New York: HarperCollins Publishers, 1995.

Meanwhile . . . New York: HarperCollins Publishers, 1997.

I Lost My Bear. New York: Morrow Junior Books, 1998.

Bark, George. New York: HarperCollins Publishers, 1999.

I'm Not Bobby! New York: Hyperion Books for Children, 2001.

By the Side of the Road. New York: Hyperion Books for Children, 2002.

The House Across the Street. New York: Hyperion Books for Children, 2002.

The Daddy Mountain. New York: Hyperion Books for Children, 2004.

A Room with a Zoo. New York: Hyperion Books for Children, 2005.

Rupert Can Dance. New York: Farrar Straus Giroux, 2014.

Plays

The Explainers, directed by Paul Sills, 1961.

The World of Jules Feiffer (including "Crawling Arnold" and "Passionella"), directed by Mike Nichols, 1962.

The Apple Tree ("Passionella," adapted by Jerry Bock and Sheldon Harnick), directed by Mike Nichols, 1966.

Little Murders, directed by Alan Arkin, 1967.

God Bless, directed by Harold Stone, 1968.

Feiffer's People: Sketches and Observations (adapted from *The Explainers*), 1969.

Oh! Calcutta! ("Dick and Jane"), directed by Jacques Levy, 1969.

The White House Murder Case, directed by Alan Arkin, 1970.

Knock Knock, directed by Marshall W. Mason, 1976.

Hold Me! An Entertainment, directed by Caymichael Patten, 1977.

Grown Ups, directed by John Madden, 1981.

A Think Piece, directed by Caymichael Patten, 1982.

Carnal Knowledge, directed by Ted Swindley, 1988.

Anthony Rose, directed by Paul Benedict, 1989.

Elliot Loves, directed by Mike Nichols, 1990.

A Bad Friend, directed by Jerry Zaks, 2003.

The Man in the Ceiling, directed by Jeffrey Seller, in production.

Screenplays

Munro (animated short), directed by Gene Deitch, 1961.

Little Murders, directed by Alan Arkin, 1971.

Carnal Knowledge, directed by Mike Nichols, 1971.

VD Blues: "Silverlips" (teleplay), directed by Sidney Smith, 1972.

Popeye, directed by Robert Altman, 1980.

Faerie Tale Theatre: "Puss in Boots" (teleplay), directed by Robert Iscove, 1985.

I Want to Go Home, directed by Alain Resnais, 1989.

Introductions

Rosenblum, Sig, and Charles Antin, editors. *LBJ Lampooned: Cartoon Criticism of Lyndon B. Johnson*. Introduction by Jules Feiffer. New York: Cobble Hill Press, Inc., 1968.

Edson, Gus, and Irwin Hasen. *Dondi, Volume 1, September 25, 1955 to March 17, 1957*. Introduction by Jules Feiffer. Chicago: Classic Comics Press, 2007.

Steig, Jeanne. *Cats, Dogs, Men, Women, Ninnies & Clowns: The Lost Art of William Steig*. Introduction by Roz Chast. Afterword by Jules Feiffer. New York: Abrams ComicArts, 2011.

Auth, Tony, and David Leopold. *The Art of Tony Auth: To Stir, Inform and Inflame*. Foreword by Jules Feiffer. Philadelphia: Camino Books Inc., 2012.

Johnson, Crockett. *Barnaby, Volume 2: 1944–1945*. Foreword by Jules Feiffer. Seattle: Fantagraphics Books, 2014.

Interviews

Meglin, Nick. *Humorous Illustration: Top Artists of Our Time Talk About Their Work*. New York: Watson-Guptill Publications, 2001.

Groth, Gary. *The Comics Journal Library, Volume 4: Drawing the Line*. Interviews with Jules Feiffer, David Levine, Edward Sorel, and Ralph Steadman. Seattle: Fantagraphics Books, 2004.

——. *The Comics Journal Special Edition, Volume 4: Conversations Among Four Generations of Cartoonists on the Shock of Recognition*. Interviews with Al Hirschfeld, Jules Feiffer, Art Spiegelman, and Chris Ware. Seattle: Fantagraphics Books, Winter 2004.

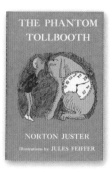

NONFICTION/MEMOIR

COLLABORATIONS

BOOKS FOR CHILDREN

267

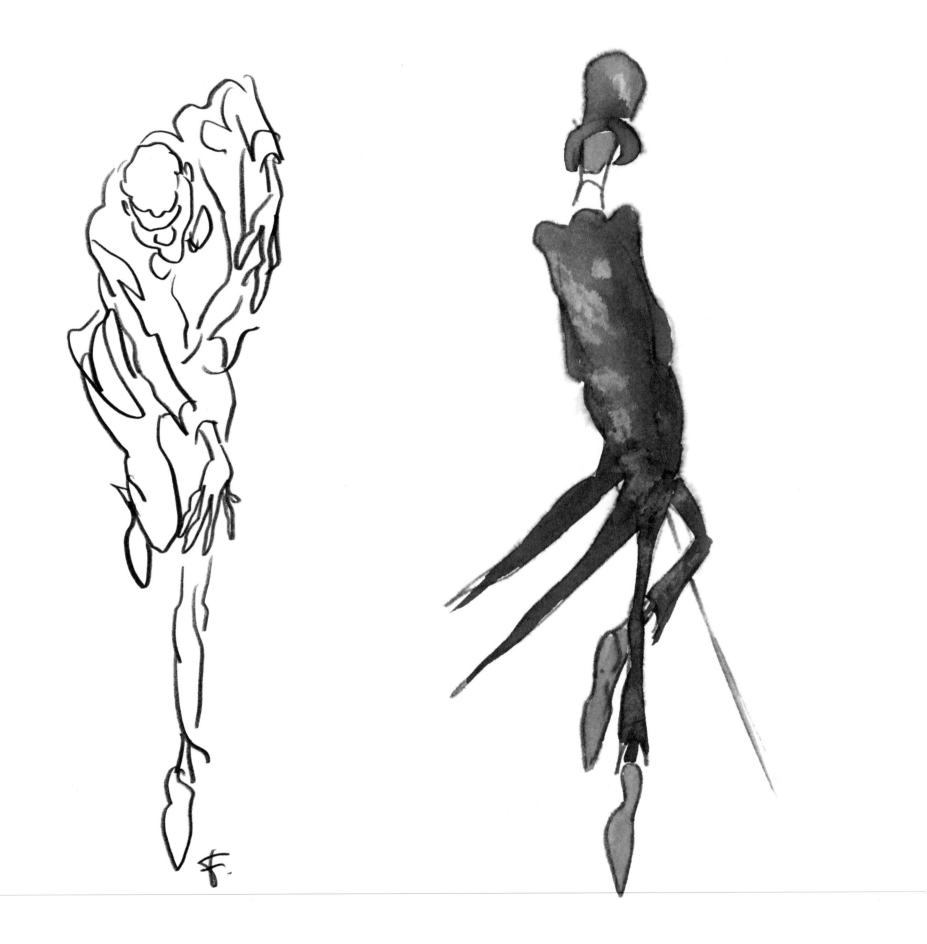

Acknowledgments

*For my father, William Fay,
whose tales of a misspent Bronx childhood
transfixed his eight model children*

This book has been a collaborative effort from the beginning, and I owe equal thanks to Charles Kochman, for conceiving the project, and to Jules Feiffer, for having produced the extraordinary body of work at the center of it. Charlie's encyclopedic knowledge of American comics history and his thoughtful editorial suggestions were invaluable throughout. Jules was the most accessible and cooperative of subjects, with a recall of dates, characters, slights, errors, and states of mind that would put a forty-year-old to shame.

Many thanks also to Katie Korman, whose organizational skills made it possible to search and source selects from a collection of daunting size; to Eric Himmel, for setting this book in motion; to Liam Flanagan, whose elegant and flexible design made handsome companions of disparate works; Chad Beckerman, for art direction; Jonathan Bennett and Neil Egan, for their initial designs and art direction; Sara Corbett, for her cover design; Jen Graham, for her meticulous attention to the text; Alison Gervais, for production; to the many sources whose interviews were essential to this project, especially Alice Korman; and to those friends who read and commented on sections of the manuscript along the way, especially my daughter, Anna Wainwright; Marta Braun; and Jenny Allen. Thanks as always to Amanda Urban.

Martha Fay

OPPOSITE, LEFT "Dancing the Blues Away," inspired by Gregory Hines, 1993.

OPPOSITE, RIGHT "I Can't Be Bothered," 1997.

Index

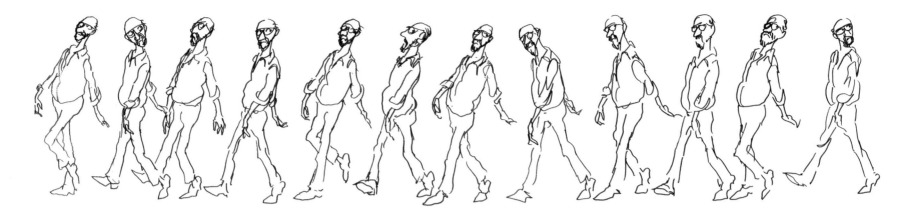

Illustration from the cover of *Backing into Forward*, 2010.

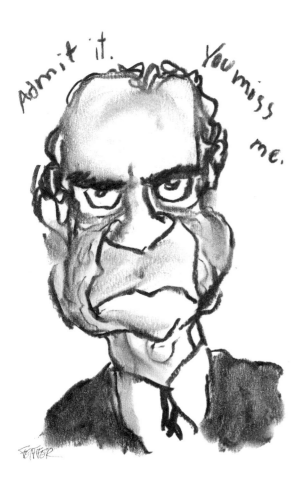

Admit it. You miss me.

ABOVE "Admit it. You miss me." Nixon returns in this Feiffer holiday card wishing friends and family a happy election year, 1996.

CASE Jules Feiffer's art portfolio (front and back), from a class taught by Max Wilkes in Feiffer's junior year at James Monroe High School in the Bronx, c. 1946.

FRONT ENDPAPER Undated illustration from series appearing on page 233, left.

PAGE 1 Untitled dancer, June 2014.

PAGE 2 Jules Feiffer as Fred Astaire, created for Barrett, the Honors College at Arizona State University, to celebrate his visit as Flinn Foundation Centennial Lecturer and Scholar-in-Residence, November 27–December 2, 2006.

CONTENTS Original art for portfolio sample, c. 1957.

BACK ENDPAPER Feiffer completes his line, October 2014.

EDITOR Charles Kochman
DESIGNER Liam Flanagan
ART DIRECTOR Chad W. Beckerman
MANAGING EDITORS Jen Graham, David Blatty
PRODUCTION MANAGER Alison Gervais

Library of Congress Cataloging-in-Publication Data

Fay, Martha.
 Out of line : the art of Jules Feiffer / Martha Fay.
 pages cm
 Includes bibliographical references and index.
 ISBN 978-1-4197-0066-8 (hardback)
 1. Feiffer, Jules. I. Title.
 PS3556.E42Z63 2015
 741.5'6973—dc23

 2014029588

Printed and bound in China
10 9 8 7 6 5 4 3 2 1

Abrams books are available at special discounts when purchased in quantity for premiums and promotions as well as fundraising or educational use. Special editions can also be created to specification. For details, contact specialsales@abramsbooks.com or the address below.

ABRAMS
THE ART OF BOOKS SINCE 1949
115 West 18th Street
New York, NY 10011
www.abramsbooks.com

Ancillary images: **Avco Embassy Pictures:** 12–13, 177; **Booth Theatre:** 169; **Burlington Raeford:** 136 (left); **Circle in the Square:** 173; **Circle Repertory Company:** 198 (top); **Continental Distributing Inc.:** 99; Copyright © 2008 **Mariana Cook:** 262 (right); **Percy Crosby:** 24 (middle); *Cue:* 130; **DC Comics:** 24 (top), 30 (top right), 31 (bottom), 33 (right), 34 (left), 35 (right), 36 (left), and 164; **Philippe Halsman:** 134; *The Herald Tribune:* 68, 76; **IDW Publishing:** 25 (bottom right); **David Levine:** 103; **Lincoln Center Theater:** 242; **Mark Taper Forum:** 201 (top); **Marvel Comics:** 30 (top left); **Mercury Records:** 14; *Modern Maturity:* 245 (left); *New York Daily News Magazine:* 194 (left); **New-York Historical Society:** 243; *The New York Post:* 135; *The New York Times Book Review:* 224; *The New Yorker:* 207, 225–27, and 251; **Robert Osborn:** 82 (bottom); **Paramount Pictures:** 199 (top); Copyright © **Playboy Enterprises International, Inc.:** 131, 202 (top), 209, 211, 213–17, and 219; **Popeye/King Features Syndicate, Inc./Hearst Holdings, Inc.:** 24 (bottom), 25 (bottom right), 199 (top), and 200; **Greg Preston:** 262 (left); **Promenade Theatre:** 201 (bottom); **Random House:** 134; **Rembrandt Films:** 144; **RKO Radio Pictures:** 246 (top); **Rose's Lime Juice:** 104; Courtesy of **Sandcastle 5 Productions, Inc.:** 199 (bottom); **Shubert Theatre:** 146; *Soho Weekly News:* 200; **William Steig:** 82 (top); **Terry and the Pirates/Tribune Media Services, Inc.:** 29 (left); *Time:* 136 (right); *The Village Voice:* 11; **Westside Cabaret Theatre:** 198 (bottom); **Will Eisner's** *The Spirit* copyright © Will Eisner Studios, Inc. All rights reserved: 46, 62 (bottom), and 64–67 courtesy of Denis Kitchen, and 26 courtesy of Paul Levitz and Josh Baker, from *75 Years of DC Comics: The Art of Modern Mythmaking* by Paul Levitz, published by Taschen, 2010; **Yale University Theatre:** 172.

Original artwork and ephemera scanned by the printer in November 2010, February 2011, and June 2012.

Additional photography by Jonathan Beckerman taken at the Abrams offices in New York City on March 16, 2012, and September 26, 2014, and in East Hampton, New York, on November 24, 2014: 17, 19 (bottom), 28, 44, 54, 80, 92–95, 103, 128, 143, 148 (bottom), 149–52, 186–87, 226–27, 243 (left), 245 (left), 248–49, 257–60, 264, 268, and 272.

Ancillary images scanned by Liam Flanagan.

For more about Jules Feiffer, visit the Jean Albano Gallery in Chicago, Illinois, or online at jeanalbanogallery.com